ATHENIAN

B

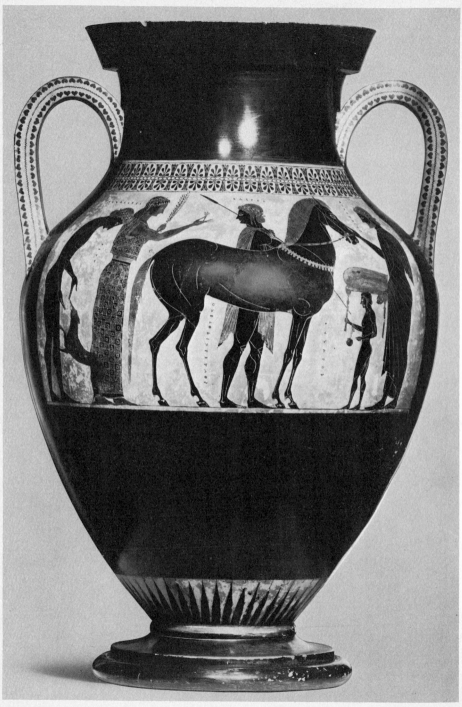

Belly amphora (Type A) signed by Exekias. Return of the Dioscuri. H. 61

ATHENIAN
BLACK FIGURE VASES

JOHN BOARDMAN

383 illustrations

NEW YORK
OXFORD UNIVERSITY PRESS
1974

LIBRARY OF CONGRESS CATALOG CARD NO. 73-89034

© THAMES AND HUDSON LONDON 1974

PRINTED IN SWITZERLAND BY ROTO SADAG

CONTENTS

PREFACE

Something like twenty thousand Athenian black figure vases have been discovered, and many more reach the light of day each year from excavations, controlled and illicit, or from the shelves of dealers and old collections. Of comparable works surviving from antiquity only Athens' red figure vases are more numerous and diverse in shape and subject. The black figure vases present the earliest major corpus of mythological scenes in Greek art, and are the earliest series of works so plentiful and so closely studied that the relationships and identity of artists and studios can be worked out. They have therefore claimed an important part in any study of Greek art or myth, and are conspicuous in museums and collections of Classical art. Nevertheless, publications of the major collections have never also given a comprehensive account of the history of the subject, while monographs on vase painting have never been so fully illustrated that students have not been obliged to turn to many other books for pictures, and there is no systematic account of the subject-matter of the scenes painted on vases. This handbook hopes to remedy these shortcomings – to give a history of the art full and detailed enough for connoisseur and student, supported by pictures numerous enough to demonstrate the quality of the work of the finest artists as well as the appearance of the work by less competent painters, and to add an account of the subsidiary decoration and the figure scenes, since these often have more to convey to the museum visitor or student than simple considerations of style, shape and date. If this has meant that parts of the book are more 'archaeological' than 'art historical' I hope this will prove to general advantage, but it has seemed best to omit from this volume any detailed consideration of the techniques of potting and painting except in so far as they affect the history of the style.

The account of the styles of Athenian black figure painting is based on Sir John Beazley's brilliant work in distinguishing painters and groups. This he had expounded in articles and books, and in his *Development of Athenian Black Figure* (1951) he gives an account of the subject which is more profound than that offered here, but less complete, less fully illustrated and different in its aim, being based on a series of lectures. Other chapters rely in varying degrees on the articles and books of other scholars, but, throughout, the need to

consider all aspects of the works involved – their style, date, shape, subject-matter – has led me to take a more personal view of some problems. So this attempts rather more than a summary of the work of others, and for a subject which is too readily studied piecemeal nowadays, or very briefly and conventionally sketched in the art histories, it is perhaps timely to present a more detailed synoptic view. Even so, it will be incomplete, generalisations abound, and the reader must mildly qualify for himself my use of terms like 'never' or 'always'.

One further point on the subject-matter of this book must be made here. From about 530 BC on the major technique of vase painting in Athens is red figure, not black figure, and some painters practised both techniques. It might seem strange to exclude consideration of the red figure vases here. Convenience dictates the arrangement, but it is supported by the material, since most painters were not 'bilingual' and the further development of black figure deserves consideration on its own for its occasional quality, for its independence, and for its plenty, while even in its iconography, all is by no means shared with red figure. I have done my best to indicate where red figure has its effect and to remind the reader of the importance of the new idiom, but a comparably detailed study of its development must appear elsewhere.

The pictures in the book have been chosen to demonstrate the full development of the style, but also to illustrate the fullest possible range of shapes and figure scenes. Since it seemed most important to keep together works of the same group or artist, the pictures accompany the sections on style, and in other sections the reader's patience will not, I hope, be strained by having to refer back to relevant illustrations. It has sometimes proved convenient to use drawings to display the full spread of a figure scene or decoration which is hard to discern on a poorly preserved surface. It would, of course, have been agreeable to have presented still more pictures, and larger ones, but then this would have been a quite different book, at a quite different price.

My main debt is to Sir John Beazley's published work; then to the writings of more scholars than I can readily name here; then to those museums, collectors and photographers who have permitted me to illustrate their vases and use their prints. The resources of the Ashmolean Museum Library and the Beazley archive of photographs have considerably lightened my task.

Chapter One

INTRODUCTION

The black figure technique of vase painting was invented in Corinth in the years around 700 BC. It involves painting figures in black silhouette, incising all linear detail so that the pale clay shows through the black, and adding, if required, touches of red and white paint, all applied before the vase was fired. It was a revolutionary method of decoration for pottery. Hitherto Iron Age Greece had known only the Geometric style with its angular silhouette figures of men and animals, rarely admitting any detail in outline drawing. This was a style practised best in Athens and not unknown elsewhere, but it may well be that the Corinthian artist's virtual abstention from Geometric figure drawing made it easier for him to evolve the new technique, probably under the influence of imported eastern ivories and metal work with incised decoration, and with it to accept new figure conventions and a new orientalising repertory of subjects. It was Corinthians, then, who developed the technique through the seventh century on vases dominated by animal friezes, with occasional myth scenes, in the meticulous miniaturist style of the Protocorinthian series. Athenian painters, meanwhile, on the vases we know as Protoattic, preferred silhouette and outline drawn figures, often executed on large pots, sometimes adding white and very rarely incising detail [1]. But by about 630 BC Athenian artists were beginning to use the black figure technique for all the figure work on their vases, and in the last decades in the century they used it for the filling ornament as well. 'Athenian Black Figure' had begun and in the course of the following hundred and fifty years it effectively won the markets of the Greek world.

Present-day knowledge and understanding of Athenian vases is based on a multiplicity of studies devoted roughly to the three topics which serve to head the major sections in this book – style, decoration and shape; but the studies have not progressed at equal pace. The vases were not being collected in any numbers until the eighteenth century, usually from Italy where the built tombs often gave up intact specimens. Greece was less accessible and at any rate the circumstances of burial seldom yielded complete vases, so it remains true that Italy is the prime source. This has meant, in the first place, that it took some time for the vases to be recognised as Greek rather than Etruscan, and, in the second place, that the national and private collections of

Europe are richer sources for study than Greece itself, even with the increase in scientific excavation and recording in the country over the last fifty years. From the beginning scholarly and dilettante interest in the vases was directed to the mythological content of the figure scenes upon them. This interest has remained strong and the study has yielded important new evidence about the development of myth, details and variations in various stories, otherwise recorded only in texts which are often far later in date, and a proving ground for theories about the development of iconographic and narrative conventions in Greek art. In this book, devoted to the black figure vases, in relative isolation from arts in other materials and periods, it has proved possible only to summarise the iconographic conventions peculiar to black figure and give a guide to the recognition of figures and scenes.

The shape of the vases appealed from the start to the Neo-Classicist. The modern student is, however, more concerned with function and with the study of shape and proportion which can reveal the identity of individual potters and workshops, or can give a criterion for dating which is independent of decoration. These studies are new, and basically 'archaeological', supported by the rare potter signatures, to which we shall return.

The study of style, especially of the individual painter's style, was slow to develop although painters' signatures were read and collected. By the end of the last century the attribution of unsigned vases began to occupy scholars, but it was left to John Beazley (who died, a Knight and Companion of Honour, in 1970) to face the whole range of surviving vases, and to put order into the study of their painters. His achievement with black figure, attributing to painters or assigning to closely defined groups well over three quarters of the works known to him, is exceeded only by his comparable work on red figure, and expressed in his book of lists, *Attic Black Figure Vase Painters*, published in 1956, and supplemented in *Paralipomena*, published posthumously in 1971. The principles of attribution, based on the combination of an overall appraisal of style and composition, with comparative study of detail, as in the rendering of drapery or anatomy, were well demonstrated in his early essay on a black figure artist, the Antimenes Painter, published in 1927. These principles are the ones which have guided the work of many other scholars who have contributed to this field of study. And Beazley was no art historical snob. He devoted as much care to assigning and collecting the work of poor or hack artists as to that of the masters. As a result, his view and ours can be comprehensive over the full range of the ware, and this has made possible its archaeological use as a yardstick for the relative and absolute chronology of Archaic Greece. The historical importance of this work cannot be argued in detail here, but will receive passing mention where the principles of chronology are discussed.

We know the names of about a dozen Athenian black figure painters for certain, but Beazley has some four hundred artists or groups. The new names

they are given may be taken from that of a potter who signs some of the vases (as the Amasis Painter); from kalos names (explained on p. 201) which appear on some (as the Antimenes Painter); from key vases (as the Painter of Berlin 1686); from the names of owners of key vases (as the Oakeshott Painter); or from characteristics of style (as Elbows Out [158] or the Long Nose Painter). Fortunately the study of style began with the study of painters and we have been spared any such artificial classification of Early, Middle and Late, I, II, and III, such as is imposed on the anonymous works of prehistory or the less well charted wares of Archaic Greece. These are, after all, the works of men, employed mainly in one restricted quarter of the city of Athens, and we understand them by understanding the relationship between them, between potter and painter, master and pupil, as well as by studying them against the social and political history of their day.

Who were these men, painters and potters? We must start from their signatures. A painter who is being explicit signs '... egrapsen' – '... painted (this)'. But against the few names thus offered there are sixty which appear as '... epoiesen' – '... made (this)'. The word for 'made' is that used later by artists signing, for instance, sculptures, gems or mosaics, so on vases it might refer to the painter. But on occasion we find an 'epoiesen' and an 'egrapsen' signature on one vase, either with two names (as with Kleitias and Ergotimos who collaborated on the François Vase [46]) or with one name claiming both functions (as Exekias does twice). Moreover some vases carrying the same 'epoiesen' signatures (as of Nikosthenes) are obviously painted by different artists. Here we are quite clearly dealing with either the potter or the studio owner, and in many instances it is apparent that the common factor is potter work. Where Exekias does not sign with the twin formula he writes simply 'epoiesen', yet it is certain that his hand was on the brush and only probable that it was at the wheel. So 'epoiesen' may often mean 'potted', can imply 'painted' and may imply 'painted and potted' which must often have been true in many workshops. 'Owner-potter' may then be implied. It has been suggested that 'epoiesen' usually means 'owner': then we would expect detectably different potter work with the same owner signature. Nikosthenes' many signatures might seem evidence for this, but the signed vases nearly all have a distinctive originality of shape and we may be misled by his passion for advertisement and his devotion to the export trade which guaranteed a better survival rate for his work. It is difficult to see all the 'epoiesen' names of Little Masters as owners of separate establishments rather than simply potters. In the face of the rare twin 'epoiesen' signatures (as of Archikles and Glaukytes [116], Anakles and Nikosthenes) we must assume collaboration, but surely not in the potting, so here an owner or potter may be involved too. We shall also find examples where we can be reasonably sure that potters' signatures reveal painters' names (as with Amasis). But most surviving signatures seem to be of potters or owners, and that they were

inscribed by painters who by choice or necessity remained anonymous is a reflection upon the importance of the potter in the industry, an importance which we, preoccupied with the decoration, may too easily forget.

In the early sixth century the Athenian law-giver Solon is said to have encouraged the immigration of non-Athenian craftsmen. Apart from some Corinthian-inspired potter work there is no clear evidence from the vases for the work of hands trained elsewhere, but the story does reflect on the important role of non-citizen metics in the practice of the arts in Athens. And we can add to this the evidence later in the century for the presence of island and Ionian sculptors working in Athens. We may catch a little of this in the potter and painter names – Lydos, who signs simply as 'the Lydian'; Amasis who carries the Hellenised form of a common but also royal Egyptian name; Sikelos, the ethnic of a native of Sicily; Thrax, of Thrace; Kolchos, Colchis. To these we may add some names of potters and painters of early red figure – Sikanos, another Sicilian native name; Mys, of Mysia; Skythes, of Scythia; Brygos, of Thrace. But, except possibly for 'the Lydian', we are not bound to look for non-Athenian or servile blood in these men, nor is there anything generally in their work to indicate experience outside Attica. We shall see that Amasis provides a good test of this, and the results are inconclusive but at least suggestive.

There are no signatures on Athenian black figure vases until the painter Sophilos in the 570s. Then they come thick and fast, but there is many a good painter, to whose hand over a hundred vases can be attributed, who seems never to have signed. So the signatures are a matter of personal pride or choice, rather than deliberate advertisement, except for the potter or owner Nikosthenes who saw that most of his work was counter-signed. The status of the artists we can barely judge. That they should praise the dandies of the day with kalos names (see p. 201) need mean nothing. Three potters – Nearchos, Andokides and the early red figure potter/painter Euphronios – could afford costly sculptural dedications on the Acropolis at Athens, and declared their craft in the dedicatory inscriptions. This is not a period in which we can discover accurately the cost of decorated vases, but from later evidence we may guess that a fairly large vase cost a day's wage. It is with the Athenian black figure vases, especially of the later sixth century, that we have some opportunity to study the methods of trading them since many bear incised marks on their bases, usually groups of letters or monograms, optimistically known as 'merchant marks'. Since there is often close correspondence in the marks on vases from a single painter or workshop, it seems that they were inscribed very soon after production and so are not likely to elucidate more than local retail conditions in the potters' quarter. However, there was clearly money in pottery and we find Attic studios carefully studying the market and producing wares to suit it – notably the Tyrrhenian amphorae and imitations of Etruscan vase shapes from the Nikosthenes/Pamphaios studio for the

Etruscan market. So the status of some successful potters may have been acquired through wealth. We have no reason whatever to believe that Archaic vase painters won esteem as artists in the way that sculptors or architects might; but we may suspect that some of our vase painters practised other and senior arts. These are all subjects to which there will be occasion to return at various stages in the narrative.

For Athens' potters' quarter itself we have to await still the evidence of excavation, and that evidence may be scrappy. The quarter lay in the over-built area between the American excavations in the Agora and the German excavations at the Dipylon Gate. It may seem too easy to romance, even unscholarly, but we lose a lot in our understanding of antiquity by letting lists and shapes and alleged affinities dominate study. For these were years when Amasis and Exekias – men, not typological ciphers – sat at their benches in Athens at no great distance from each other, and no doubt passed each other daily; when the dandies, politicians, poets and soldiers of Athens strolled by the stalls, nodded over the bright vases fresh from the kiln, approved a motto praising a fashionable beauty, smiled at many an allusion to the life or politics of the day which eludes us now, enjoyed the first truly popular figurative art of antiquity.

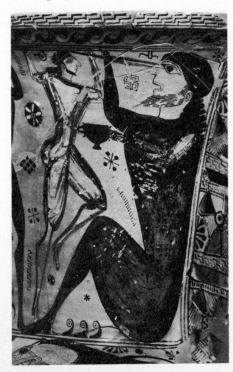

1 Protoattic amphora from Eleusis. Odysseus and Polyphemos

2 Protocorinthian olpe. H. 32

Chapter Two

EARLY ATHENIAN BLACK FIGURE

Athenian vase painters of the middle of the seventh century could achieve a grandeur of scale and composition which the miniaturist black figure techniques of Corinth, although more controlled and precise, could not match. The Athenian painter was well aware of the new technique since, although his own vases never travelled further than Aegina or the Islands, the Corinthian did, and they were well known in Athens itself. Nor did he have any positive abhorrence of incision, and he was prepared to use it for minor details of hair or anatomy, as on the Odysseus and Polyphemos of the famous Eleusis Vase painted just before the mid-century [1]. Later vases admit more incision and add red paint to the white used for incidental detail, in the Corinthian manner, and in the 630's we can discern the first Athenian painters who use black figure for all their figure work.

The dominant decorative style on Corinthian vases had been of animal friezes [2], and acceptance of the black figure technique in Athens seemed to carry with it some of Corinth's obsession with this scheme. Many of the early black figure vases of Athens carry fine large animals, heraldically posed and executed with a command of pattern and precision at least equal to Corinth's, but there is an increasing use of animal friezes to decorate minor vases or major areas of large vases, throughout the first two generations of the use of the new technique in Athens. A few painters could rise above this restriction and offer finely composed narrative scenes, while the quality of potting is always high. It may be again Corinth whose influence was, this time, salutory, introducing new shapes (column craters, cups) and a range of narrative figure scenes which perhaps depended on Peloponnesian narrative arts in other materials, and which encouraged the Athenian painters to realise more fully the qualities of monumental narrative they had never really lost. By the end of the phase described in this chapter, the regime of the animal friezes was coming to an end.

The Pioneers (c. 635 to 600)

One artist illustrates within his surviving attributed work the transition from the idiom of orientalising Protoattic to full black figure. He is the PAINTER OF

14

BERLIN A34 (formerly known as the Woman Painter). Two of his vases are from a find on Aegina (the vases went to Berlin but are now lost or destroyed) from which we learn much about the finest Protoattic vase painting. On them [3] the human faces – including one named hero – are drawn in outline in the old manner, the dress is covered with red, white and rosettes, the background fill is orientalising with zigzags and dot rosettes, and there is still to be seen the old black-and-white pattern of rays. But the rest is black figure with lavish additions of red and white. Examples of his work from Athens show how he abandoned outline for laying white over black in the proper black figure manner – as for his sphinxes' faces [4], and while the fill remains the same the subsidiary patterns are closer to those of the Late Protocorinthian vases of the 630's. He was probably at work by 630, but not as late as 620 since there is no sign of the influence of the full Corinthian style of black figure. His human figures belong still to the Athenian tradition, but his animals, with their new technique and monumentality, are novel, and for their sheer size and presence easily challenge any products of Corinth in these years although there is still some stiffness and rigidity of outline, for instance in the treatment of wing feathers. The Painter of Berlin A34 was a pioneer, and claims an important position in the history of Athenian vase painting, but it was his successors who finally established the new idiom in Athens and set the course to a new style.

The first 'personality' in Athenian black figure to be recognised by modern scholarship was the NESSOS PAINTER, named after his Athens vase [5] showing Gorgons on the belly, Herakles fighting Nessos on the neck (he writes Netos and Beazley came to use the full Attic form of the name, Nettos; I use the commoner Greek form). An earlier master of the animal style was identified from finds in Athens and Aegina and called the Chimaera Painter from the subject he twice painted [7]. More finds in Athens and especially in the Attic countryside cemetery at Vari have made clear that one artist only is involved, and his stature and importance can now be properly judged. Beazley called him the Chimaera and Nettos Painter; I leave him with the first sobriquet he acquired – the Nessos Painter. His earliest vases resemble those of the Painter of Berlin A34, with 'Protocorinthian' filling ornament. But, on the shoulder of his name vase [5] there is a new black figure treatment of the floral chain which the Protocorinthian artist normally drew in outline. On later work the incised rosettes of the full Corinthian black figure style are admitted, and then become the rule, so we may believe his working life to span the last quarter of the seventh century, seeing out the transition from Protocorinthian to the full Early Corinthian style.

His vases, like his figures, are big: the massive skyphos-craters [6] (1.10 m. high), often with domed lid and high conical stand, which are the pride of the Vari find; a big neck amphora – his name vase; and a new invention of the Athenian potters' quarter, the 'belly amphora' with one piece profile which

offers a fuller field for the figures although many early examples keep a separate neck panel [*8*]. The only small vases he painted were of another new shape, the shallow bowl known as a lekane, reserved for animal friezes and with animals or a gorgoneion in the tondo within. He did not wholly eschew outline drawing, for some women's faces, lions' teeth and the gorgoneia (a convention which died hard) but he develops subtle new conventions for black figure using double or treble incised lines to accentuate important features where the smaller Corinthian animals carried single lines only. The double shoulder line for beasts soon becomes a hallmark of Attic painting, as well as the greater detail bestowed on animal features and limbs. He is particularly good at incised surface patterns on bodies, of locks, scales, feathers or circles. He uses little white, except in the lines of dots in the Corinthian manner and for some female flesh, but he likes red in broad masses, or alternating with black for wing feathers, and for male and some monster faces. The 'male = red, female = white' conventions of Egyptian art may have had some direct effect here and are the only realistic features on the otherwise unrealistically coloured black figures. The debt to Corinth in his filling ornament has been indicated, but with it there are black figure versions of the delicate palmette tendrils from Protoattic and Island vases. The heraldic animals on his large vases pose with dignity and are well fitted to the bellying bodies or domed lids which they decorate. They reduce well in the smaller friezes and admit still the grazing horses, rare at Corinth, but familiar on Athenian vases since Geometric. His mythological scenes have all the monumentality of Protoattic but he has learned from Corinth to make his figures move with a new and subtle plausibility and he can devote major areas of vases to myth, even excerpting from a stock scene as with the Gorgon Sisters who lack their quarry on his name vase. He successfully combines the best qualities of the Athenian tradition in vase painting with the new subjects and techniques of Corinth.

Of his contemporaries the PIRAEUS PAINTER's name vase [*9*] is early, with stiff rather primitive figures of which only the animals display a nice sense of size and pattern. Notice the way the lion's cheek folds are stylised into a scroll and palmette. Others, like the BELLEROPHON PAINTER, crowd their big vases with figures and fill which become hard to distinguish, while the LION PAINTER with his balding, worried lions [*10*] has a flair which leaves us regretting that so little of his work survives. But the production of figure-decorated vases in Athens in these years was far from brisk and, but for a Nessos Painter vase in Etruria, we know of none which travelled beyond Attica or nearby Aegina. One Athenian bowl of the 620's apparently painted by an immigrant or visiting Corinthian, reminds us of what was still the dominant vase painting centre of these years.

The Gorgon Painter to Sophilos (*c.* 600 to 570)

The early years of the sixth century see a considerable change in the fortunes of the Athenian potters' quarter. Several new vase shapes and schemes of decoration are introduced, and the example set by Corinth can be observed both in the dominance of animal frieze decoration and by the fact that for the first time Athenian vases begin to compete in the markets of the Greek world and are found from the Black Sea to Libya, from Spain to Syria.

The GORGON PAINTER (*c.* 600 to 580) is the most prolific successor to the Nessos Painter. He is sparing with mythological scenes and human figures [*11*], and they are always accompanied by animals or animal friezes. Other vases carry animal friezes only, or single animals [*12-14*], but many are far reduced in size from those of the late seventh century. The style is still precise and his lions in particular are distinctive for their square muzzles, toothy grins, hatched forelocks, and the end locks of the back mane, often overlapping. Wings are executed with neat rows of secondary feathers. A few of the old dot rosettes linger in the field and the old rosette borders are not forgotten, while a new form of floral chain is evolved, the lotus square, seldom splaying so much now (at least in friezes), the palmettes neatly filling between, the interlace properly placed, and bands of wavy lines on the flowers. His few human figures are stiff and mannered but his name vase offers our first full frieze with figures [*11*] – a fight and the Gorgons pursuing the Perseus whom the Nessos Painter omitted from his name vase. The big dinos bowl (93 cm. high) on a separate stand carries nine friezes of animals and five of florals alone besides the figure frieze. Other new shapes worth noting are the 'Deianira shape' lekythoi with long ovoid bodies, often decorated by painters of the Gorgon Painter's workshop [*15, 16*], whose style is looser than their master's but whose imaginative composition of figure scenes improves on the Gorgon Painter's rather sober repertory. The master paints an early version of the lekythos, with a spherical body [*14*], which, for this feature only, recalls the Corinthian aryballos flask; oinochoai with various shapes of lip (especially the olpai [*13*]), also much favoured by contemporaries; together with plates, kothons and miniature amphorae (amphoriskoi), more clearly derived from Corinth. Although an artist of distinction the Gorgon Painter can be seen to have submitted rather more to the regimen of Corinthian styles, and the dominance of animal friezes boded ill for Athenian black figure. A senior contemporary of his, far less prolific, simpler but more fluent, was the CERAMEICUS PAINTER. The importance of the animal frieze style was well demonstrated on his olpe where even the small vase is divided into registers, and the single myth figure in the upper frieze is flanked by lions [*17*].

In the same circle was born the series of HORSE-HEAD AMPHORAE, of the new 'belly' shape, with a horse's head and neck on each side [*18*], and one, exceptionally, with an outline-drawn woman's head drawn on one side.

Without the separate neck frieze of early belly amphorae these carry their decoration in rectangular panels, with the rest of the vase black, which is to be the commonest scheme for this shape. Several different artists, including bad ones, painted the Horse-head vases (over a hundred are known), whose decoration must have had some special significance, more probably as prizes than funerary since several were exported. One was found with the Nessos Painter's name vase, but there is no clear evidence that any were ever used as grave markers. Beazley thought the series need not outlast the mid-century: possibly it is even briefer since the style barely develops and it is tempting to regard the Panathenaics (Chapter Seven) as in some respect their successors.

The artists of the KOMAST GROUP (c. 585 to 570) follow the Gorgon Painter. There are two leaders, called by Beazley the KX and KY Painters. They decorate new shapes for Athens, and smaller vases are preferred, beside the lekanai and kothons. From Corinth their potters copied the Komast cups [21, 22], and the deeper cup known as a kotyle (but in this period usually called a skyphos by archaeologists), while the KY Painter, the lesser artist and the younger man, introduces the column crater which becomes the most popular shape of mixing vessel for wine and water. Yet another type of cup with vertical handles (the kantharos) also becomes popular. This is an older Attic shape not used in Corinth. But from Corinth come the komasts – the jolly, bottom-slapping dancers with their sunburnt faces and chests, naked or in red tunics, and sometimes joined by women [21-23]. They appeared on many Corinthian vases, but not so often on cups as they do in Athens. Most are on the KY Painter's cups, or the work of lesser artists in the Group, but the KX Painter offers some on shapes other than cups, especially skyphoi. He has also a few myth scenes [20], and the animals, which are seen on the majority of his vases, are neat, stout versions of the Gorgon Painter's beasts, the lions being particularly distinctive with their big ear locks [19]. His florals resemble the earlier type, slimming slightly. The cups with komasts are our first Athenian class which are at all comparable with the repetitive production of many Corinthian workshops, and they are well distributed in the Greek world.

SOPHILOS (c. 580 to 570), the last of this generation, is also the first 'real' name. He signs four vases, three as painter, one as potter, and is generally freer with inscriptions than his spelling would seem to justify. There are more large vases from his bench, notably dinoi and amphorae. His style is ambitious, lively but rarely precise [24-28]. Most of his vases carry animal friezes of degenerate type, and in his florals too we detect still the idiom of the Gorgon Painter, much debased. He is more occupied by myth than his predecessors, and he shows some spirit of invention, as in his treatment of a chariot race with a lively crowd and a fumbling attempt to label the whole picture 'the Games for Patroklos' [26]. But the scenes are accompanied by the normal, poor animal friezes, and the scheme of decoration is virtually the same as that

of the Gorgon Painter. We have seen outline faces in Athenian black figure before, but Corinth may be responsible for Sophilos' common use of outline drawing for flesh parts of women and for some drapery, unusually in red filled with white [25]. He was, however, aware of better things in the potters' quarter and on two dinoi (one recently acquired by the British Museum [24] and another known from fragments found on the Acropolis [25]) he gives his version of the Wedding of Peleus and Thetis, which is to appear at its best and in the new manner on the near contemporary François Vase [46.5]. For the first time we see a long multifigure frieze on a large vase devoted to a single major theme, and not an episodic mixture of myth, man and animal, as on the Gorgon Painter's name vase. From Sophilos' hand there is also a chalice [28], which is a rare shape; and the first of our funerary plaque series, with studies of mourning women. A follower of his (Beazley believed, Sophilos himself) decorated our first lebes gamikos (a marriage vase) with its usual decoration of a wedding procession, in this case, and uniquely, with chariots bearing Helen and Menelaos and the bride's brothers.

Other groups

The Vari cemetery was a rich source for the work of the Nessos Painter, but not of those artists just discussed. There are a few others, however, whose work is known only in the Attic countryside, and who may not have been working in Athens itself. Those supplying Vari mainly decorate lekanai with animal friezes. I mention only the PANTHER PAINTER [29] who liked cable friezes (as did the Nessos Painter on occasion) and the ANAGYRUS (= Vari) PAINTER [30] who decorates other shapes. Eleusis was being supplied by a wilder and old-fashioned artist (the PAINTER OF ELEUSIS 767) for whom 'provincial' is quite the right word. Among his works are tall necked amphorae [31], which seem a ritual shape. The animals and sirens of the PAINTER OF THE DRESDEN LEKANIS [32] look like comic versions of the KX Painter's figures. Several of his vases are in a paler clay than the usual Attic but most of his work is from Athens itself. However, he emigrated to Boeotia where his painting style coarsens a little and is practised on different shapes (the 'Horse Head Group').

Another artist of some individuality but no merit is the POLOS PAINTER (c. 575 to 565) a mass producer of animal frieze vases in a degenerate style, named for the cross hatched 'polos' crowns, worn by his women, sirens and sphinxes [33]. Well over two hundred of his works are known and they were well distributed to less discriminating buyers in the Greek world, although little to the West. He is fond of lekanai and plates, but decorated all current shapes and favours miniatures.

Apart from works of apparently non-metropolitan artists, which we have noticed at Vari and Eleusis, the vases of the Gorgon Painter and his followers

soon win a share of the pottery trade in the Greek world, mainly in competition with Corinthian wares. Naucratis in Egypt, Rhodes and central Italy are the earliest important markets, but the Komast Group is represented even in Corinth and in the Spartan colony at Tarentum, while Sophilos' vases reached the Black Sea and Syria, and the Polos Painter is richly represented in colonial Cyrenaica (Libya). Athenian styles begin to influence other schools too, and there are imitations of the Gorgon and KX Painters in Boeotia, as well as the émigré painter we have just noticed. The Athenian potters' quarter is beginning to export successfully, and, once the animal frieze idiom is shaken off, it will both crowd markets and influence styles far and wide in Greece and her colonies.

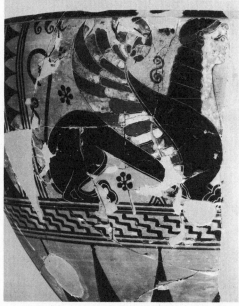

3 Crater stand by the Painter of Berlin A34 (name vase)

4 Skyphos crater by the Painter of Berlin A34. Sphinx

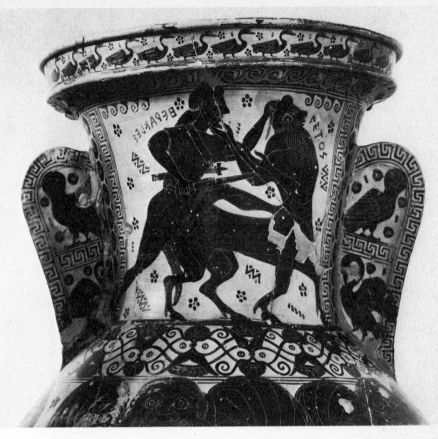

5 Neck amphora by the Nessos Painter (name vase). 5.1: Neck. Herakles fights Nessos.
5.2: Body. The Gorgons

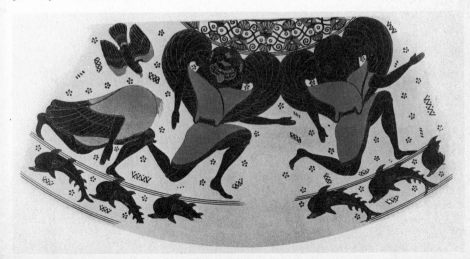

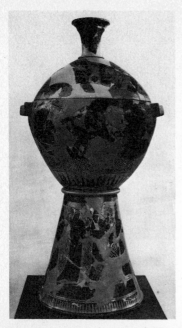

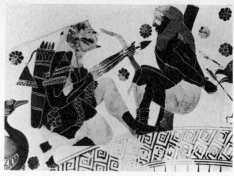

6 Skyphos crater by the Nessos Painter.
H. 110. 6. 1: Whole vase. 6. 2: Body.
Herakles frees Prometheus

7 Skyphos crater by the Nessos Painter.
Bellerophon and the Chimaera

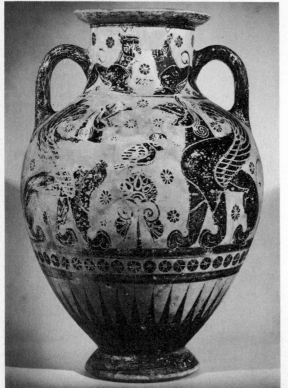

8 Belly amphora by the Nessos Painter.
Lions and griffins. H. 79

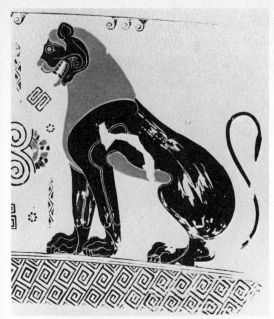

9 Neck amphora (body) by the Piraeus
Painter (name vase)

10 Fragment by the Lion Painter

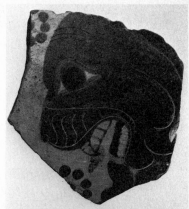

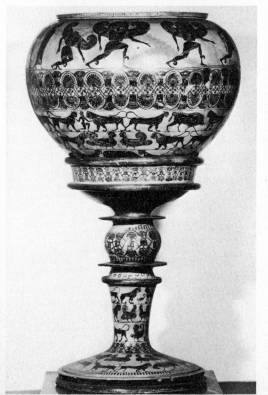

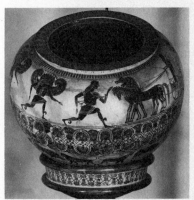

11 Dinos and stand by the Gorgon Painter
(name vase). H. 93. 11. 1 : Whole vase.
11.2: Shoulder. The Gorgons and Perseus

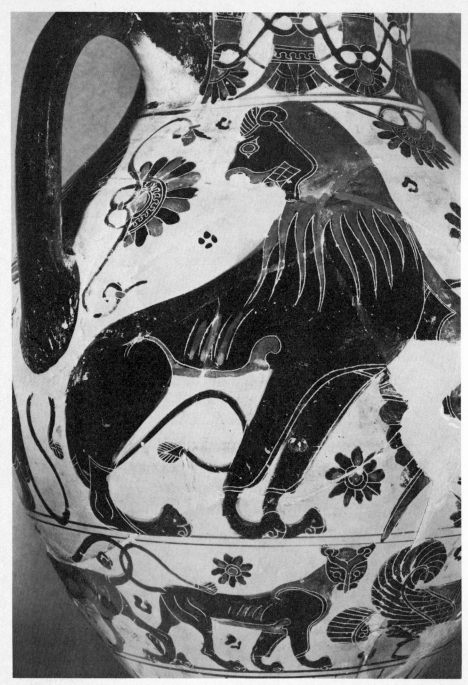

12 Belly amphora by the Gorgon Painter

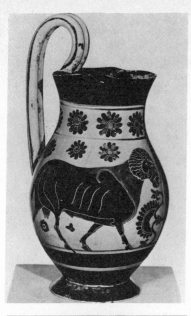

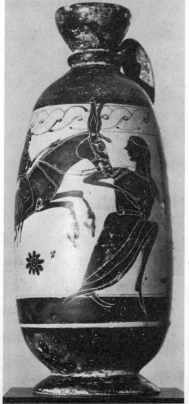

13 *Olpe by the Gorgon Painter. H. 26·3*

14 *Spherical lekythos by the Gorgon Painter. H. 17*

15 *Deianira lekythos in the manner of the Gorgon Painter. A satyr on a mule with a woman*

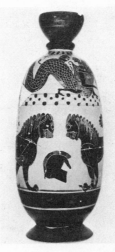

16 *Deianira lekythos in the manner of the Gorgon Painter.*
16. 1: *Whole vase.*
16. 2: *Shoulder. Herakles fights Nereus*

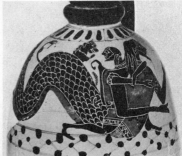

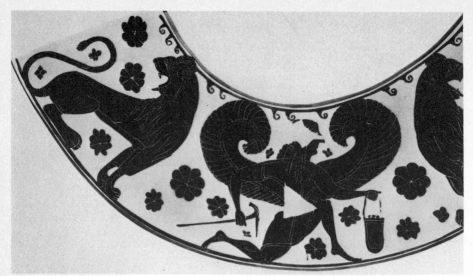

17 Olpe by the Cerameicus Painter. Aristaios

18 Horse-head amphora. H. 31

19 Lekane by the KX Painter

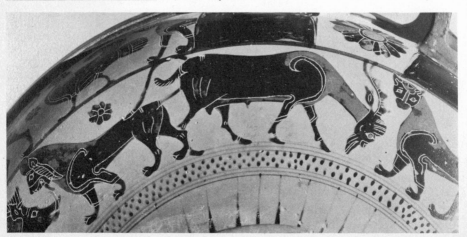

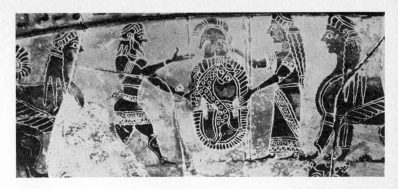

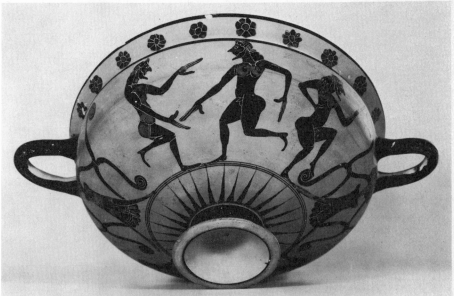

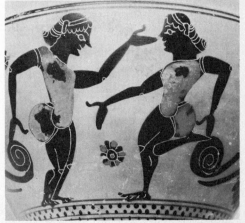

20 *Lekane by the KX Painter. Achilles receives arms from Thetis*

21 *Cup in the manner of the KX Painter. Komasts. H. 11·5*

22 *Komast Group cup. Komast and woman*

23 *Skyphos by the KY Painter. Komasts*

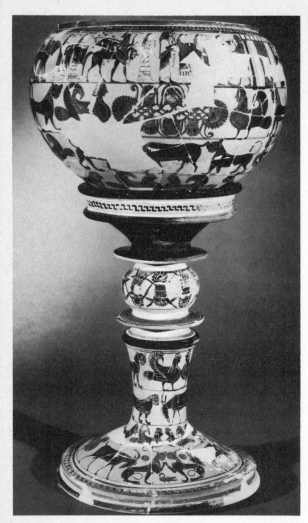

24 *Dinos and stand signed by Sophilos. Marriage of Peleus and Thetis. H. 71*

25.1,2 *Fragments of dinos signed by Sophilos. Marriage of Peleus and Thetis*

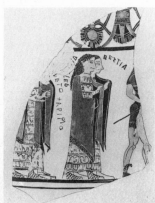

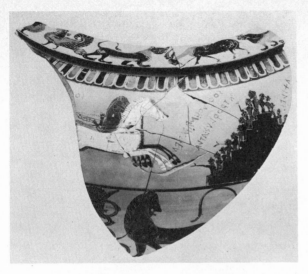

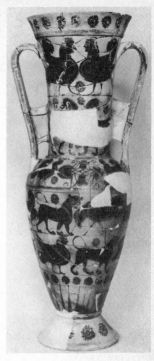

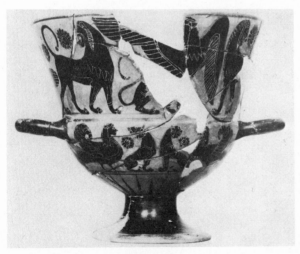

26 *Fragment of dinos signed by Sophilos. Games of Patroklos*

27 *Neck amphora by Sophilos. H. 59*

28 *Chalice by Sophilos. H. 15*

29 *Lekane by the Panther Painter. W. 39·5*

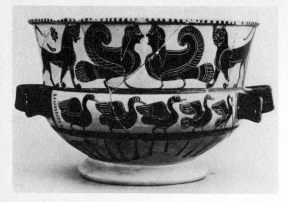

30 Chalice by the Anagyrus Painter

31 Neck amphora by the Painter of
Eleusis 767 (name vase)

32 Neck amphora by the Painter of
the Dresden Lekanis

33 Tripod kothon by the Polos
Painter. H. 10·6

Chapter Three

KLEITIAS, SIANA CUP PAINTERS AND OTHERS

It is from this point on in the narrative that the major preoccupation of the better painters in Athens is seen to be the portrayal of mythological or other figure scenes. Animal friezes are dismissed to subordinate positions, and very few of the painters to be met in later chapters (Lydos and some cup painters), are prepared still to devote thought and care to animal decorated vases. The rejection of the animal frieze style is declared for us by Kleitias' masterpiece, the François Vase [46], and since it has survived nearly intact, it has come to be regarded as a significant monument of Athenian vase painting, as influential in its day as it is instructive now. We exaggerate the importance of what survives now because we have to. The François Vase in fact demonstrates the new idiom, fully accepted, and its debt is twofold – to the dinos painters, from the Gorgon Painter to Sophilos, who developed the tradition of a major figure frieze encircling a vase; but perhaps no less to the cup painters who carried through the revolution started by the painters of Komast cups, since it was they who regularly replaced animals with figures, and sometimes added myth. The friezes of the François Vase resemble more closely in scale and composition the friezes on cups than they do the bigger tableaux on the craters of Corinth or Athens, and the other works of its artists are mainly miniaturist. So the cup painters deserve some pride of place, less for their ability than for the fact that in this period continuity and change in Athenian vase painting can best be studied in their work.

Siana cup painters (c. 575 to 555)

The sequence of decorated Athenian black figure cups cannot be understood without reference to the plain versions, which are black in and out but for a plain lip and handle zone, with a black stripe just below the lip and a reserved stripe lower on the body. They are fine vases, they were freely exported, and the series began with plain versions of the Corinthianising Komast cups [21, 22]. But the plain 'black glazed' cups (as they are often still miscalled) are common to many other Greek wares including Corinth and East Greece. The Athenian can be seen first to depend upon Corinth, then upon East Greece for

plain cups with higher lips and feet than the Komast cups and with groups of fine concentric hoops within. The figure-decorated versions of these are what we call 'Siana' cups (after a cemetery in Rhodes). One or two of the new shape were decorated by the latest of the artists in the Komast Group, and there is one artist who combines the developed Komast cup shape with elements of the East Greek cups (fine lines painted within the hollow foot). His figure style, however, looks to the Siana cup series and, in the new manner, he decorates the interiors of his cups, sometimes leaving the outside plain. This is the PAINTER OF ATHENS 533, and on his name vase [34] we see the refinement of the old Komast cup shape with the figure decorated tondo within which has been met hitherto in Athens only in lekanai. The border of fine hoops is probably borrowed from the plain cups. Of his animals, the lions look like a cross between Corinthian and the KX Painter, while the handle palmettes look forward to some Sianas and the Little Master cups. (Cups of this class are sometimes called ST cups.)

Siana cups are decorated in one of two ways: 'double decker' [34, 40, 42] often with a floral on the lip – an ivy or laurel wreath as on many East Greek cups, or rarely animals, and with figures in the handle zone, sometimes between handle palmettes; or 'overlap' [36, 39, 44-5] with the figures overlapping lip and handle zone, although still split by the inevitable black line running just below the lip. The lower bowl may have a reserved stripe filled with thin lines – another East Greek trait – or decorative bands of tongues, rays or florals, which may sometimes be plump buds and flowers rather than lotus and palmette. Up to three quarters of the interior is occupied by a tondo carrying animal or figure decoration, usually bordered by tongues [41-2, 45]. This is the way that Corinthian cups had been decorated but the C Painter adds dots and other patterned hoops to fill more of the interior. The under-foot is finely tooled and sometimes striped. These are handsome vessels which only slowly move away from their Corinthian models by heightening foot and lip, and deepening the figure-decorated frieze.

The senior Siana cup artist is the C PAINTER [35-38] (C for 'Corinthianising'). He still decorates some old Komast Group shapes – lekanai, tripod kothons [38], skyphoi, but his lekythoi are shouldered – not the old oval 'Deianira' shape although this is still being painted, and he also decorates examples of the first Athenian cup without an offset lip – the 'Merry-thought', nearly hemispherical, with knobbed wishbone handles and generally a tall foot [37]. This shape may carry pairs of thin red lines on the foot and within such as we see on East Greek cups and on other Athenian black vases, and it seems a refined imitation of a rustic wooden goblet. There are very few examples surviving, but the Painter of Athens 533 decorated a footless version and he (or Ergotimos, see below) might have invented it. The C Painter takes most of his subject-matter from Corinth – duelling warriors, horsemen, symposia, and he has not forgotten the Komasts; he uses colour like a

Corinthian but lays his white over black in the Attic manner where the Corinthian draws his ladies' flesh in outline. His myth scenes, however, owe little or nothing to Corinth and he develops them well both in long friezes, which call to mind the Gorgon Painter or the far subtler Kleitias, and in panels, as on the broad foot of a tripod kothon where he offers a Judgement of Paris [*38*]. His figures are neat, big headed, and with a certain compact vigour. The animal head shield blazons are particularly distinctive [*37*]. Near what is probably the end of his career his studio is providing cups very like the Little Master lip cups in shape but decorated in the Siana manner. On one example our artist lets satyrs join the Gorgon chase after a Perseus who carries what must be a miniaturised Medusa head in his hand bag. There is a new spirit here which artists like the Amasis Painter will express more effectively in the mid-century.

The HEIDELBERG PAINTER [*39-41*] is a far more sophisticated artist, more ambitious than the C Painter, with his more detailed figures occupying a deeper frieze on the cup. But his range is slighter and he is more completely dedicated to cup painting and often less careful. He too derives his style from the latest of the Komast Group, but he works later in a manner not readily distinguishable from that of the Amasis Painter in his duller early days (see p. 55): note the bold features, big eyes, elaborate drapery patterns and fringes.

Of the other painters dedicated to Siana cups the only one of merit is the PAINTER OF BOSTON CA (for the Circe and Acheloos on his name vase) whose work bears some resemblance to that of the C Painter [*42*]. Several of his Siana cups have black lips, like later band cups, and the floral on one has still the form and proportion of work in the Komast Group. The SANDAL PAINTER and CIVICO PAINTER [*44*] are careless followers, their figures with tiny eyes in small heads and with no finesse in the drawing; the former paints shoulder lekythoi too [*43*], a shape which the C Painter also came to notice. The GRIFFIN BIRD PAINTER is mainly satisfied with rather careless animals and florals, and his tondos lack fancy borders. But he was prolific, and the monster from which he takes his name [*45*] was also the hallmark of a large group of cheap contemporary Corinthian cups.

The Siana cups were well distributed in the Greek world, and it is interesting to note what a good market for them was found even in Corinth and especially the West, notably at Tarentum. This is true even of the Siana cups decorated by pot painters like Lydos (next chapter), whose other work seems not to have been marketed in the same way. It suggests some specialisation in production and trade.

Kleitias

The François Vase [*46*] was found at Chiusi in Etruria in 1845 by Alessandro François who spent several subsequent seasons looking for missing fragments.

It was shattered into 638 fragments by a discontented museum attendant in Florence in 1900 but was skilfully restored. It survived the recent floods, which otherwise dealt so severely with other museum exhibits, but is again being rebuilt. It is a volute crater – a new shape in clay and proudly signed twice by the potter Ergotimos, just as it was signed twice by its painter Kleitias. Some vital statistics are worth recording: it stands 66 cm. high, carries 270 human and animal figures, and 121 inscriptions, some of them proudly and unnecessarily devoted to inanimate objects like the altar or fountain. Only one frieze is devoted to animals and florals, above the foot where there are heraldic sphinxes and griffins [46.6], and groups of lions attacking other animals which in this form are new to Athenian vases and which long outlive the animal friezes. All the other friezes are devoted to myth. On one side of the neck [46.3] the Calydonian boar hunt, above the funeral games for Patroklos; on the other, Theseus' victory dance (the geranos) with the Athenian men and girls he had rescued from the Mino-taur [46.4], over the fight between Lapiths and Centaurs. The main shoulder frieze around the whole vase [46.5] and passing behind the handles shows the procession of deities honouring the newly wed Peleus who stands before his home, in the open door of which we see his bride, Thetis. Below this comes Achilles' pursuit of Troilos [46.5], watched by Priam outside Troy's walls, and on the back a vigorous Return of Hephaistos [46.7] to the company of the Olympian gods; on the edges of each handle a Gorgon, and Artemis with animals, and Ajax carrying dead Achilles [46.2]; and for comic relief, on the foot, pygmies fight cranes [46.8].

Kleitias has something in common with the best of the C Painter, but is far more fastidious and a master of colour and detail, not for its own sake but for variety of texture (as in the animals), to lend richness to a scene of pomp, or to express lively emotion – the rejoicing Athenians in the boat [46.4], the intent satyrs [46.7]. From his florals, however, and his use of outline drawing, filled with white for women's flesh and some drapery, we can see that he stems from the Gorgon Painter – Sophilos tradition, and it is Sophilos who painted two similar versions of the great wedding procession, probably a little earlier. Where Sophilos completed the vases with animal friezes, Kleitias filled his with myth, in a tour de force which must have taken days to execute from carefully prepared sketches. No other surviving vase from this period is comparably rich and literate, and Kleitias' other work is, as we have observed, mainly miniaturist and often in collaboration with the potter Ergotimos. A new shape they introduce is the earliest class of the Little Master cups – Gordion cups [108] (see page 58), indicating a measure of independence of the Siana cup workshops, and hinting perhaps that c. 570 could be a trifle early for their masterpiece.

34

Other pot painters

We turn to other painters for work on a large scale and on large vases. Some are not lesser artists than Kleitias but they express the new mood in vase decoration, not so readily related to those older traditions to which we can see that both Kleitias and the Siana cup painters were indebted. They paint some familiar shapes – dinoi and column craters – but the ovoid neck amphora is coming into its own now among painters, just occasionally carrying panel decoration like a belly amphora, and with it the hydria in its early form with a globular body.

The name vase of the PAINTER OF ACROPOLIS 606 (c. 570 to 560) is a fine dinos [47] with a vigorous battle scene of warriors and chariots in the main frieze, and others carrying grouped animals, a cavalry fight, and florals, with an animal whirligig on the base. He can match Kleitias' eye for detail and colour, and excel him in skilful composition of overlapping, jostling figures. He loves the detail of harness, weapons, helmet crests, and studies the posture of his figures, if not always with total success (notice the fallen warrior). More sober and more obviously monumental in character are his horsemen-amphorae [48] of the standard belly shape but with the pictures in panels, like the Horse-head amphorae. This is a decorative scheme which allows the artist to present a single figure or group in its own right, not as part of any more developed action scene. Yet even here we are probably to take the coursing hare beneath the horses as an indication of swiftness, and the eagle carrying a snake as an omen.

NEARCHOS (c. 570 to 555), who signs as potter and painter, shares the finesse of the last artist and can add something of the dignity of an Exekias in his study of Achilles harnessing his horses [49]. This is on a big kantharos, a shape he favours, and as potter-painter he makes this a showpiece of innovation, not all of it happy – the white ground beneath the tongues at the lip and the white on the horses inset from the contours to give a black outline. He copies the shape of a Corinthian aryballos too, to carry a tiny frieze of pygmies and cranes, satyrs at play and other figures [50] (the whole vase is less than 8 cm. high). Like Ergotimos he made Little Master cups and so probably worked later than 560.

The other painters to find a place here favoured ovoid neck amphorae and the round-bodied hydriae. The PTOON PAINTER decorates Siana cups too and is very fond of friezes of opposed palmettes and bold red-black patterns on wings. He is still a painter of animal friezes, in these hardly better than Sophilos, and he still uses blob rosettes in the backgrounds to his scenes, but his florals with hoop links instead of interlaces, and his draped figures which are so close to Lydos show that he may be later than he looks (c. 565 to 555). His key vase, the Hearst Hydria [51], is now in New York. The CAMTAR PAINTER [52–3] (named after vases in Cambridge and Tarquinia) is a poorer

and also deceptively old-fashioned artist with his animal friezes, florals linked still with tendrils, and treatment of a belly amphora in the old manner with continuous friezes instead of panels, and even a row of rosettes at the rim [52]. His stocky wooden figures are robustly decorative. Idiosyncrasies include the use of red instead of black for inscriptions (as often Sophilos) and turning the wavy lines which had hitherto crossed lotuses into rows of circles. Most of his contemporaries had omitted these bands. The BURGON GROUP belongs here, with our first complete Panathenaic vase [296], to which we shall return, and closely related, the PAINTER OF LONDON B 76 [54, 55]. He is another red-letter man, has the familiar animals and florals, but adds a little more colour to his figure work which is closer to that of the Lydan Vases. His interest in a narrow range of Trojan myth scenes reminds us that by now some conventions had set hard in the vase painters' repertory, and that innovation and invention will distinguish the true masters of this craft as much as technical ability. Thus, in his name vase, a conventional frontal chariot scene with warriors is only rendered heroic by the addition of Trojan names [54]. This is a period which favours colourful flower and bud friezes, later to become black and ema-ciated, and which may evoke the older filling ornaments by exotic blossoms rising from the ground line of figure scenes.

Tyrrhenian amphorae (c. 565 to 550)

The ovoid neck amphora has been the characteristic vase shape for several pot painters of the second quarter of the sixth century. The largest single group produced in these years, numbering nearly two hundred surviving pieces, seems to have been destined for western markets – whence its name [56–63]. One or two only are known from Aegean sites. We have already noted the importance of the western markets, notably in South Italy, to the Siana cup painters. The Etruscan cities, especially Caere and Vulci, had been good customers too, but generally readier for Corinthian wares. Now Athens entered the competition seriously with a line aimed at a market conditioned already to Corinth's colour and animal friezes, and becoming accustomed to Athens' interesting range of myth and genre scenes. The shape chosen was a useful one, not well supplied from Corinth, and perhaps travelling filled with prime Attic oil. The scheme of decoration resembles that of Corinth's vases, although by the mid-century these had generally abandoned subsidiary animal friezes on amphorae and better contemporary Athenian work is closer to them in style (including the Lydan vases yet to be considered). Colour is used freely, especially on the figure scenes. Some are intelligibly inscribed; several carry nonsense inscriptions for their snob value. There is a good range of stock myth scenes, with emphasis on Herakles and Amazonomachy, some komasts still and their successors, satyrs, as well as our earliest batch of Athenian love-making displays – an early and specialised interest in everyday

life. The vase necks usually carry a lotus and palmette cross or interlace, and below the main scene on the shoulder come two or three friezes of animals, one of which may be replaced by a floral. Rarely they are all black beneath a deeper shoulder frieze [59]. The latest amphorae are slimmer in shape and their lotuses lose the central spiky leaf. Several artists have been distinguished and a few may be picked out here: the Castellani Painter, the most characteristic of the whole group, for his jolly, big-headed figures and his fondness for one floral frieze above his two of animals [59, 60]; the Goltyr Painter for his bulbous-headed animals [58]; the poorer sexy Guglielmi Painter [61] and the Timiades Painter [56–7] who invents some interesting cock monsters; the Kyllenios Painter [62] who has some pretensions to real skill and wit, since in his scene of Zeus giving birth to Athena from his head it is Hermes who steals the show with his declaration 'I am Hermes of Kyllene' (his Arcadian home); and the OLL Group (Oxford–Leipzig–Louvre) of earlier, finer vases, not purely export models.

We have not seen the last of animals and animal friezes on Athenian vases, but by now a figure style of some versatility and vigour has been established to express a growing repertory of stock myth scenes and to serve the more imaginative artist to tell new stories or depict everyday life. What changes have there been in the idiom of figure drawing? In effect, very few. The black for men – white for women convention is almost fully established but there are still some male red faces and chests. When some Tyrrhenian painters give komasts, and even some heroes, red torsos but black faces we may suspect that the point of the convention is being lost. On women's drapery grid patterns take no notice of fold or contour but there may be closer observation of the detail of peplos sleeves and cloaks (himatia). We come to see the bandage pattern of oblique lines suggesting folds for men's himatia, and occasionally an angular fold where an edge hangs free. On the figures the patterns of knees, elbows or ears may be carefully observed and even approximate to life, but this represents little advance on the seventh century. Frontal chest and profile hips offer no problem since no attempt is made as yet to show the stomach muscles but there are some effective side views of the torso, sometimes rather oddly combined with half a frontal chest. The male eye stares round and frontal in the profile face, the female eye is half closed, often with a black or red dot for the pupil. Within these conventions which allowed no rendering of depth, foreshortening of limbs or facial expression – beyond an open mouth or the panting anxiety of a satyr – the artists achieved a good range of studies of action and repose. It was for the next generation to attempt to add feeling.

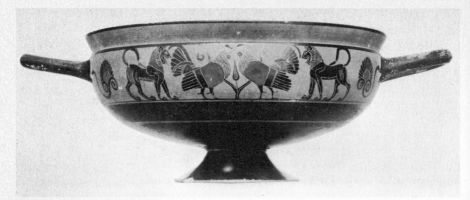

34.1,2 *Cup by the Painter of Athens 533 (name vase). H. 10*

36 *Cup by the C Painter. Symposion*

35 *Cup by the C Painter. H. 14*

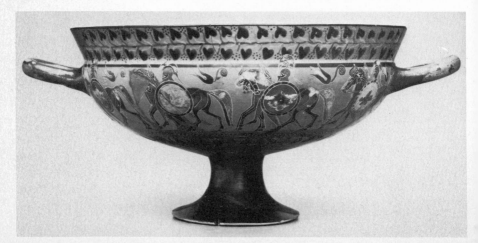

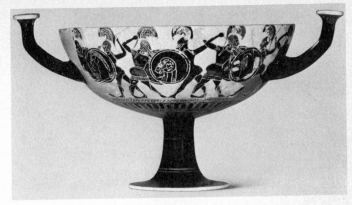

37 Merrythought cup by the C Painter. H. 14·9

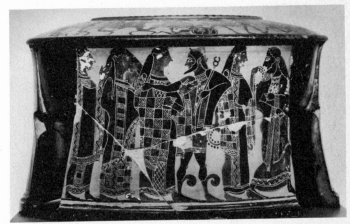

38 Tripod kothon (leg) by the C Painter. Judgement of Paris

39 Cup by the Heidelberg Painter. Bellerophon and the Chimaera. H. 14

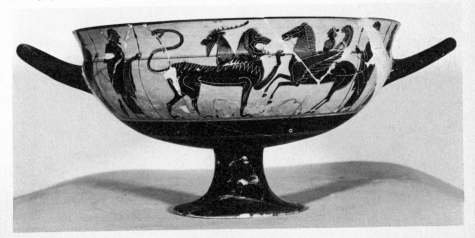

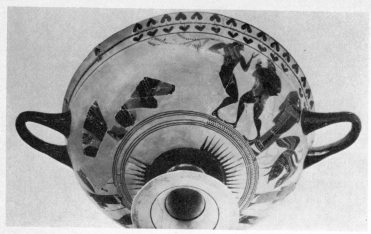

40 Cup by the Heidelberg Painter. The infant Achilles brought to Chiron. H. 14

41 Cup by the Heidelberg Painter

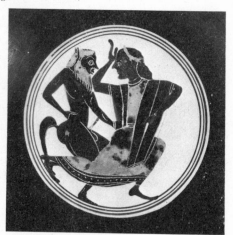

42.2 Interior – satyr and maenad

42.1 Cup by the Painter of Boston CA. H.14

44 *Cup by the Civico Painter.*
H. 12·3

45.1,2 *Cup by the Griffin-bird Painter. H. 11·3*

43 *Lekythos by the Sandal Painter (name*
vase). A boy beaten with a sandal. H. 17·5

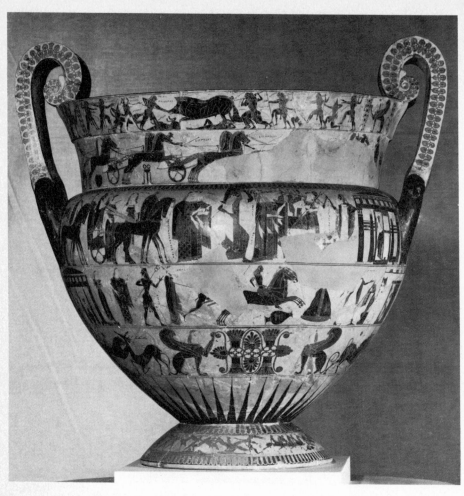

46 *The François Vase. Volute crater signed by Kleitias and Ergotimos. H. 66*

46.1 *Whole vase*

46.3 *Neck – The Calydonian Boar Hunt ; Funeral Games of Patroklos*

46.4 *Neck – The Athenians' boat retrieves Theseus*

46.5 *Body – The Wedding of Peleus and Thetis ; Achilles chases Troilos*

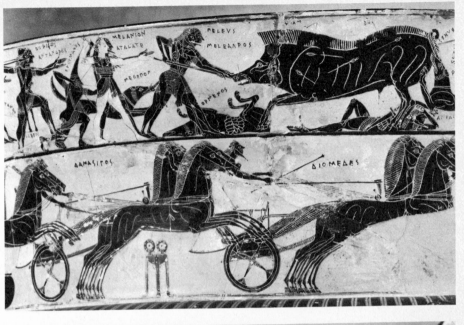

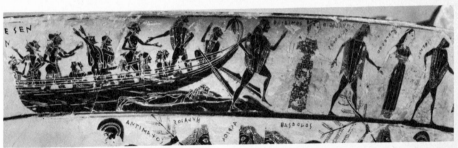

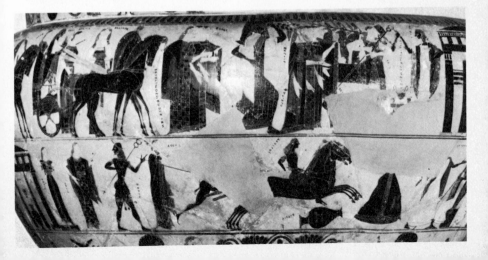

46.6 *Body – Griffin*

46.2 *Handle – Artemis; Ajax carries the dead Achilles*

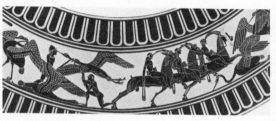

46.8 *Foot – Pygmies fight cranes*

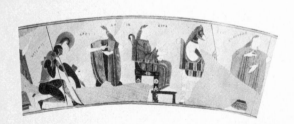

46.7 *Body – The Return of Hephaistos*

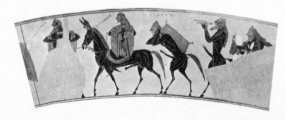

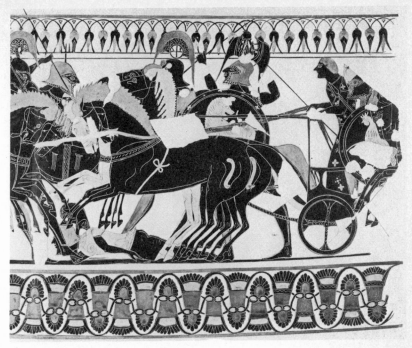

47 Dinos by the Painter of Acropolis 606 (name vase)

48 Belly amphora by the Painter of Acropolis 606

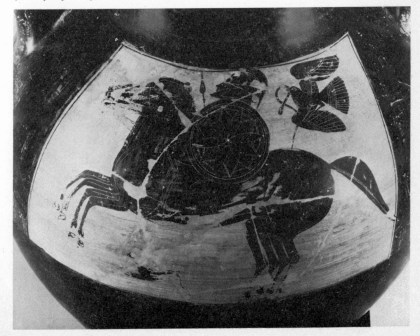

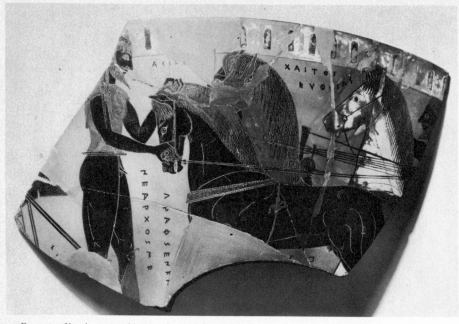

49 *Fragment of kantharos signed by Nearchos. Achilles with his horses*

50 *Spherical aryballos signed by Nearchos. H. 8. 50. 1 : Pygmies fight cranes; Hermes. 50. 2 : Satyrs*

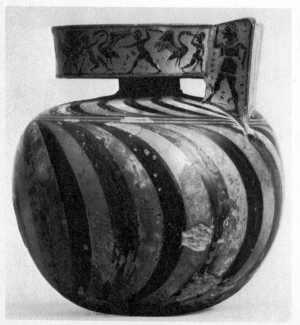

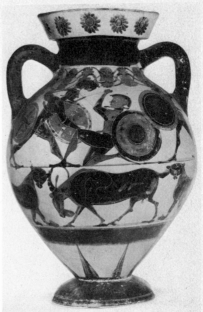

52 *Belly amphora by the Camtar Painter*

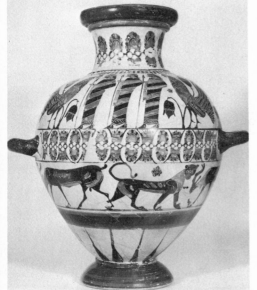

51.1,2 *Hydria by the Ptoon Painter (The Hearst Hydria). H. 40·8*

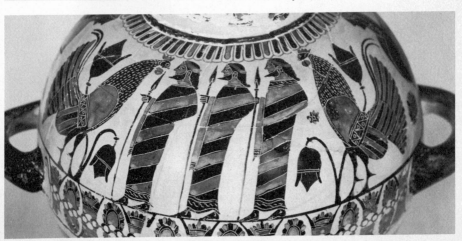

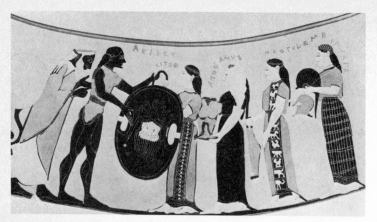

53 *Neck amphora by the Camtar Painter. Achilles arming*

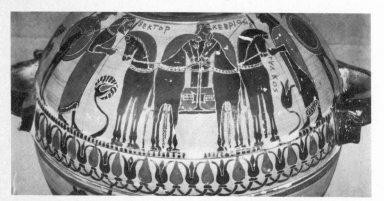

54 *Hydria by the Painter of London B 76 (name vase). Hector's chariot*

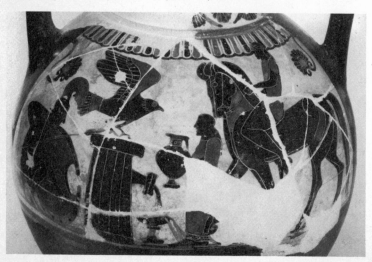

55 *Neck amphora by the Painter of London B 76. Achilles ambushes Troilos and Polyxena*

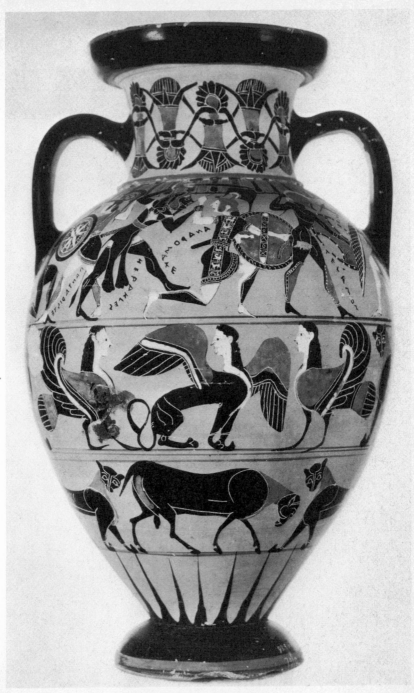

56 *Tyrrhenian amphora by the Timiades Painter. Herakles fights Amazons. H. 39·4*

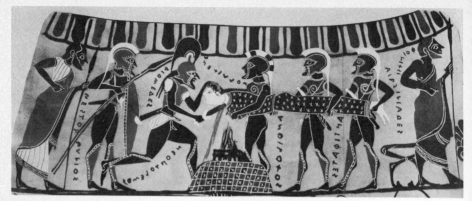

57 Tyrrhenian amphora by the Timiades Painter. The sacrifice of Polyxena

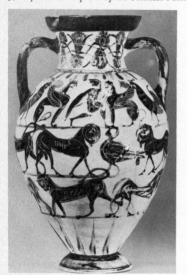

58 Tyrrhenian amphora by the Goltyr Painter. Amazon and sphinxes. H. 39

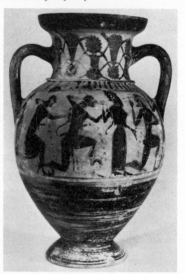

59 Tyrrhenian amphora by the Castellani Painter. Apollo and Artemis shoot down Tityos. H. 28·5

60 Tyrrhenian amphora by the Castellani Painter. Apollo and Artemis shoot down the Niobids

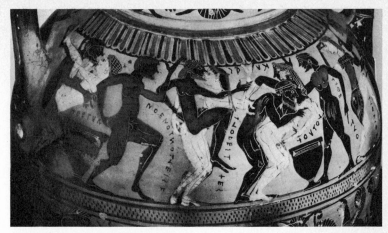

61 *Tyrrhenian amphora of the Guglielmi Group*

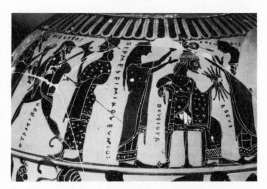

62 *Tyrrhenian amphora by the Kyllenios Painter (name vase).*
The Birth of Athena

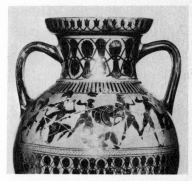

63.1 *Tyrrhenian amphora. H. 45*

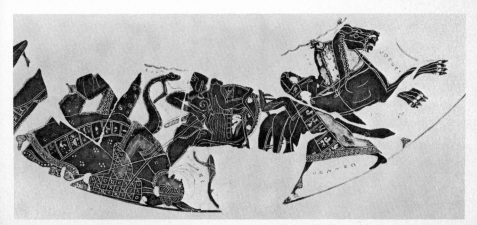

63.2 *The Death of Eriphyle*

Chapter Four

THE MID CENTURY AND AFTER

Lydos, Amasis and Exekias

Three artists, whose works span the years from about 560 to 525 and so to the threshold of red figure, if not beyond it, represent Athenian black figure in its prime and exploit all that the technique can offer.

Lydos [64–71], at his best, rises to the quality of his seniors, Nearchos or the Painter of Acropolis 606. He is rooted in the tradition of Athenian black figure, even its animal style to which he gives a brief new life, but he had a long career and, albeit in a rather selfconscious and mannered fashion, his later work records the new styles of his more accomplished contemporaries. His is especially, though, the mood of the years before the mid-century, and 'Lydan' describes a style which is distinctive, if not always of distinction.

The Amasis Painter [77–91] also worked long: an individualist in the history of Athenian painting whose brush was as expressive as his graver, and whose most trivial work can please with its fluency or humour.

And Exekias [97–106], a truly great artist who, in his few surviving vases, demonstrates how it was possible to rise above the exigencies of a technique so poorly suited to vase decoration, and to express a mood and dignity such as was achieved, ancient writers assure us, in the paintings of the great classical muralists of the fifth century B C.

LYDOS (c. 560 to 540)

Two surviving vases are signed [64], as painter, by 'ho Lydos' – 'the Lydian' – a sufficient indication that the artist or his family was immigrant from Croesus' Empire, although he may have been born in Athens and he certainly learned his trade there. It has not proved easy to isolate Lydos as an individual artist when his signed works and their obvious kin fall within the range of a very large group of vases, fairly homogeneous in style but widely differing in quality. We seem to be dealing with a prolific workshop in which the standards were set by the Lydian. Moreover, the working life of Lydos and his studio seems to have been long. His style is firmly rooted in the tradition of the painters described in the last chapter; he decorates many Siana cups (overlap) and he is the last of the painters in Athens to devote large vases wholly to large animals, drawn with considerable care and no little colour. In these respects his style remains close to that of the Corinthians, while in his

figure work he carries us from the swaddled gentry of the immediately post-Kleitian vases, through the dapper dressing of Amasis, to near the dignity of Exekias. Within his group we find good miniaturist work too on Little Master cups and eye cups, while Lydos himself painted a band cup [70] for a potter, Nikosthenes, whose floruit belongs to the years of red figure. Lydos paints the full repertory of large and small vases available in the potters' quarter, including a trick vase [68], a cooler [66], loutrophoroi and a funeral plaque series [71].

One signed piece is a superb, now fragmentary dinos from the Acropolis [64], a shape and source which have rendered the best work of some of Lydos' predecessors. In the florals, detailing of dress and features, and the bold grouping of the battle of gods and giants, we are not far from Acropolis 606 and Nearchos. The main frieze has the gigantomachy and below it there is a procession and a hunt, then animals alone. There is detail and colour here to the point of fussiness, relieved by the verve of the fighting groups and the extremely sympathetic treatment of the animals, from the wasp shield device to the sacrificial beasts accompanied by the man with a case of wicked looking knives. A column crater in New York [65] is nearly as big as the François Vase but, with a single frieze, its figures are nearly 25 cm. high. The Return of Hephaistos is rendered with the minimum requisite attention to the story – Dionysos on one side, Hephaistos mounted on the other – and maximum interest in the gestures and behaviour of the accompanying satyrs and maenads, but without the circumstantial detail which Kleitias offered. Notice the satyr snake-handler; there is some stealing of drink from a wine skin, and tail-pulling. Lydos' satyrs are gentlemen – hairy sometimes or wrinkled – but almost never as sexually exhibitionist as the Amasean, who are rougher beasts, nor as some of Lydos' men when faced by handsome youths. Perhaps this teaches us something about Lydos and Amasis.

The myth scenes establish and elaborate stock themes, not all of them rendered with the finesse seen on the vases already considered. The onlookers are more common now – 'penguin' women holding their cloaks in front of them (presumably wrapped across their chests) trailing off into 'tails' and men with the folds of their himatia shown in slanting stripes like bandaging. A trick jug (an air hole in the hollow handle will, when uncovered, release liquid from a separate inner cavity through the foot of the vase!) made by the potter Kolchos [68] has more mannered figures and the Athena supporting Herakles against Kyknos has her flesh drawn in outline as Amasis might have done, while the folds of Ares' dress and of Zeus (who intervenes) show an attempt to handle the new three-dimensional conventions of the 540s. The neck and handle palmettes too are late, and well on the way to patterns of the red figure period. (On this vase see also p. 61.) Some of Lydos' other best work is seen in the running or flying figures on plates. A gorgoneion is promoted to fill a plate once [69].

The animals, especially on the earlier vases where the friezes may still burgeon with blob rosettes, carry much colour and some interesting detail, like the whiskery hind quarters of some felines which go back to the François Vase. They are stiff-legged, slim-bodied, rather wooden but decorative beasts, and the closest of all in Athens to the very latest of those painted on vases by Corinthian artists (compare [72]). Beazley distinguishes two principal companions of Lydos, but only from their human figure work since the animals remain 'Lydan'. Of these the PAINTER OF VATICAN 309's perky-featured figures rarely approach Lydos even in his most pedestrian mood [73-4], while the PAINTER OF LOUVRE F6 only occasionally rises above hack work [75-6]. The former is more old-fashioned and shorter-lived, decorating mainly neck amphorae: the latter goes on to decorate the new shouldered hydria, craters and many belly amphorae, most like the latest Corinthian in shape, and setting above the panels the long tongues, which are so common in Corinth, or rows of blobby ivy leaves. The column craters too are laid out much like the latest Corinthian. What links the work of these artists to Lydos is the style of the animals on their vases and their use of them on big vases still so late in Athens. The Lydan figure style lingers on deceptively into the 520's or later (with the Ready Painter) perhaps for elderly customers with slender means.

THE AMASIS PAINTER (c. 560 to 525)

The delicate touch and wit of the Amasis Painter are an excellent foil to the workmanlike Lydos or the more statuesque dignity of Exekias. Although some features of his style seem almost foreign to the main stream of black figure in Athens, his apprenticeship was Athenian, in the shops of the Siana cup painters, and especially of the Heidelberg Painter [39–41].

Amasis signs eight black figure vases, all decorated by one artist. His other potter work is slight, including two vases for Lydos and, near the other end of his career, a cup (which he also signs) for a red figure artist. The black figure painter and potter are surely the same man. 'Amasis' is a Hellenised form of the Egyptian Ahmosis, which is a common Egyptian name. There was a Pharaoh Ahmosis ruling Egypt from 570 B C, probably too late for the Greek to be named after him at birth. The earliest vases by the painter-potter are not signed so the name could have been adopted later in life, but there are other factors which might indicate a part-Egyptian origin and early years spent, say, in Naucratis: his introduction of the Egyptian alabastron shape in clay to Athens [79], and Exekias' naming of negroes on two of his vases 'Amasis' [99] and 'Amasos', which suggests that the familiar Amasis was swart. But the idiosyncrasies of his style are not specifically Ionian.

Amasis pots and decorates a wide range of shapes (but not hydriae or craters). Of the large vases he prefers the belly amphorae, with one or two of the new Type A [87–8], with the elaborated handles and feet, but a small number of neck amphorae span his career, from the early ovoid to fine late

examples of stout 'special shape' [85–6]. His signatures are on three neck amphorae, a cup and four oinochoai, another favoured shape. His earliest work is on shoulder lekythoi [77–8], and he paints also a few of the older 'Deianira' type. His cups include ordinary band cups [81] and some experiments with the lipless Type A cups [83] including what looks like a parody of the Exekian eye cup, with its eye-siren and exercises in manipulation [82], and some with plain stems and one-piece profiles to foot [84], which anticipate cups of Type B. His potting is uniformly excellent and, like the painting, out of the ordinary run of production in Athens potters' quarter.

The broad development of the painter's career can be observed both in the style of his figures and ornament, and in the shapes of the vases he decorates, for instance in the series of neck amphorae. The early shoulder lekythoi [77–8] are close to the work of the Siana cup painters. The relationship with the Heidelberg Painter has been noted, and this indicates that Amasis was painting by about 560 BC. On the amphorae we can see changes in the ornament – the lotuses losing their centre leaf [85:89, 91]. The early draped figures have foldless drapery [77], then flat angular folds ('Lydan' [87]) and finally sinuous ones [86], so Amasis' career spans this important stylistic change. This last phase must be contemporary with the early years of red figure but he is in no respect seduced by the new interest in anatomical detail or the looser drawing of drapery which beset his poorer contemporaries. On a number of his later vases he draws women's flesh in outline [85, 87, 89], not white on black [86, 90]. Earlier Athenian painters had done the same but in this respect alone Amasis may be acknowledging or anticipating the new technique. Another feature of his late work, on the stout amphorae and cups, is the occasional omission of a ground line for his figures [84, 86]. He favours finely patterned drapery, making great play with delicate wavy lines [85–6], while fringed hemlines are a speciality. He uses stippling a great deal – for the hairy bodies of satyrs [88–9], even for head hair and beards, and many of his young men sport long love locks before the ears. A red face may be given to an occasional siren [82] or Athena (then with black flesh), and in general his use of colour and area patterning is bold and original. He was fascinated by armour and especially by shield blazons [87] which he makes much of (especially animal foreparts), incising rather than merely painting them white. He also enjoys details of jewellery and dress. His figures have an elastic delicacy of limb and contour, best appreciated on his smaller vases, but not lost on the large ones. Unusually, for a black figure artist, his brush work is as impressive as his incising.

His groups and friezes are composed with a careful symmetry, rather staid at first, but later never dulling the impression of movement. Dionysos is his favourite, usually standing complacently with satyrs, maenads or mortals, supervising the vintage [89], once skipping forward to have his cup recharged [88]. The satyrs are particularly aimiable beasts, with low, heavy

buttocks, skinny pricks and alert features. His mythological scenes are well composed but rarely show the originality of his divine stables with the animated architectural sculpture [83], and he is often satisfied with a divine conversazione. There is originality, however, born of observation, in many of his dancing figures, and he is one of the first to introduce everyday scenes of some complexity – the wedding procession [77], a weaving shop [78], the hunter's return, plausible dogs, a magnificent cavalcade [91].

Through temperament or training he was able to add something of delicacy and wit to a style which seemed always to work against these qualities. His skill as a painter as well as draughtsman indicates his sympathy with the idiom of red figure, and we catch his spirit more clearly in the work of various red figure cup painters than in other black figure artists. His son Kleophrades made pots for two of the finest red figure artists of the early fifth century.

EXEKIAS AND GROUP E

'Group E . . . is a large and compact group which is very closely related to the work of the painter Exekias, though earlier . . . than nearly all the vases assigned to him . . . Group E is the soil from which the art of Exekias springs, the tradition which on his way from fine craftsman to true artist he absorbs and transcends'. Thus Beazley and in his first account of the group he added 'Most of these vases will be by one hand'. The artist or artists deserve our attention and some respect, more than we may naturally accord an anonymous group, since their work leads not only to Exekias but also represents a conscious break with what we may regard as the 'Lydan' tradition of the 550's. It is expressed in shapes – the dominance of the belly amphora and emergence of Type A (most Lydan belly amphorae are poor and late), the total abandonment of ovoid neck amphorae and (almost total) of column craters, some new 'special' neck amphorae, an apparent lack of interest in small vases. Exekias potted a Group E vase [96] (the only potter signature in the group) before he is recognised as a painter, so he may have contributed to the potting tradition of the group in its earlier years, but some regard this as his earliest surviving painted work also. The figure style of Group E [92–96], with no animal vases, lacks the monumentality of Exekias or even Lydos, and the mythology can be very repetitive (many of Herakles with Geryon or the Lion, or Theseus with the Minotaur) but more painters of the second half of the century follow the lead of this group and Exekias than of Lydos or the Amasis Painter. It is possible that Exekias' importance in the history of Athenian black figure is due as much to his potting as his painting. We have noted his early potting already [96] and he also signs some fine lip cups as potter, for a Little Master to paint. We can see from his potter signatures that he may have been responsible for the early development of the Type A cup [104] and Type A belly amphora – big vases, [100] is over 60 cm. high; he

may have invented the calyx crater since the earliest yet known was decorated by him [*103*]; and he potted Little Master cups for others to paint. The range and quality of this work is remarkable. From the short list of his signed and attributed vases we can see that he worked both on plump neck amphorae and Type A belly amphorae (rather than the standard belly amphora of Group E), and on one example of each he signs as both potter and painter, metrically – 'Exekias egraphse ka'poiese me'. His other painting we know from one ordinary belly amphora only, a Panathenaic [*106*], a dinos [*102*], a pyxis and parts of two funerary plaque series [*105*].

His debt to the tradition of Group E is demonstrated by shapes, ornament and style. The neck amphorae in particular are provided with a variety of flower, bud and even animal friezes on their lower walls and shoulders [*94, 97-8*]. The underhandle scrolls are unparalleled for their finesse. Where Group E usually has interlaces of lotus and palmette in the older manner, Exekias has chains (with hoop links not tendrils), and although on one side of an early amphora the palmettes have close set leaves [*97*], on the rest of his work the leaves separate and are always finely drawn, sometimes alternately coloured. In many of these respects Amasis was conservative, where Exekias skimped nothing and planned every detail. His work as a painter (he probably potted far longer) falls in the third quarter of the sixth century, starting later than Amasis, out of touch with Lydos, and at the end making no concession to red figure although the first of the red figure artists works in his manner. From his rendering of drapery we see that the splaying, three dimensional folds are new to the vase painter [*98*]. His treatment of them is confident, not yet mannered. The development of the style of a perfectionist is less easy to observe than might be imagined and it may well be that his active painting occupied far fewer years than many have thought – say 545 to 530. And did such an artist work only in the potters quarter? We might look to the kouros, Munich 169, or even the marker for Kroisos' grave.

It is easy to dwell on details of his work, the care he lavished on manes, armour, ornament [*100*], and indeed there are few who could match his precision and draughtsmanship. But the hallmark of his style is a near statuesque dignity which brings vase painting for the first time close to claiming a place as a major art. This is not a matter of size or proportion, although both play their part, for his scenes of action are composed with originality and verve.

His originality appears in many forms. He breaks Athenian convention to let his Dionysos sail across the whole empty interior of a cup [*104*], prepared with a warm 'coral red' background and decorated outside with the classic eyes – both perhaps his own invention. He is the first to set painted ships sailing around the inner rim of a dinos [*102*]. Heroes and horses [*Frontispiece*] (who equally deserve, and often are given, names) walk like thoroughbreds through a craft devoted too long to workmanlike decoration and often naive

story telling. For the first time the graphic artist can challenge his poet contemporaries, and on similar grounds of observation and feeling. The men of earlier artists are, at best, elegant puppets. Amasis could see men as men, Exekias could see his men as gods and in this he gives us a foretaste of classical arts. Few of his mythological scenes follow established patterns while some set new fashions. For Ajax's suicide [*101*] we have the brooding preparation in a convention which will not yet admit facial expression beyond a furrowed brow, and not the bloody impalement, the moment of maximum action beloved of Archaic art. His Athenians mourn [*105*] with the dignity of Olympians. His warriors and young men with their parents [*Frontispiece*], even when identified as divine (as the Dioskouroi with Leda and Tyndareos), act a human, everyday scene, with that awareness of the divine in human thought and action which the classical artist was to codify for the tradition of western art. All this was new in the art of any land.

Little Masters and other cup painters

Successful miniaturist work in the black figure technique had been the hallmark of the best Corinthian painting of the seventh century B C. In Athens the Siana cup painters were at their best when their figures occupied the highest available field, on the overlap cups, but their rivals and successors, the Little Masters, renounced the overlap and concentrated their figure work in the narrow friezes of lip or handle zone, on shapes of a new elegance and delicacy. Very few Siana Cup Painters were also Little Masters and it was for artists like Kleitias to introduce the new style in, it seems, new potter's studios. The tendency to increase the height of the foot on cups was apparent in the black cups of other parts of Greece, and in the decorated black figure cups of East Greece and Laconia, but their lips are set off still in the manner of older skyphoi. In Athens some early merrythought cups had high feet [*37*], and for the lips the potters sought other solutions, while the painters successfully mastered the miniaturist style which suited these new shapes. Few were recognisably the painters of larger vases also, although most of the best pot painters also decorated a few cups. Stylistic comparison between the big and the small is not always easy. We have many signatures of Little Masters because the inscription sometimes formed an important element in the overall design, especially of lip cups. Most are of the 'epoiesen' type. The potting is often even better than the painting, so this is not surprising, but they do not help us to identify bigger works painted by the same artist. If there are not more signed larger vases it may be that the signatures did not (or did not yet) have the advertising value that some had later. We shall look first at shapes and decoration, then at artists of the main series, finally derived types.

GORDION CUPS [*108*] are the earliest and among the smallest. The straight lip is black, clearly marked off from the body. The handle zone has a line near

its top (lower than on most Sianas) and often near its base. The foot is like the Sianas, but growing, and with decorative hoops beneath, while inside there is a figure tondo edged with tongues, also like the Sianas, and often a reserved band at the bottom of the lip. In fact the main difference from the Sianas is in the size and the profile of the lip, and even some Sianas had black lips. Kleitias and Ergotimos collaborated on the name piece of the Group, found at Gordion [108]. Their signatures run straight between the neat handle palmettes, and this is the normal scheme of decoration for this class and for the lip cup. The same artists produced other examples, but no other Little Master shapes, and this suggests a floruit for the class about or just before 560. SONDROS signs several others and also seems an early specialist in the class, but other Gordion cup signatures (Phrynos, Sokles, perhaps Archikles) are met on other Little Master shapes.

LIP CUPS, as [113], resemble the Gordion cups in shape, with a straight lip tooled off from the body, but not at an abrupt angle. The high feet have a broad flat base plate: the feet of most earlier cups are hollow cones of even thickness. But the underfoot treatment appeared on some Sianas which have quite broad resting areas, while the C Painter made at least one with a high, purely Little Master foot. The figure decoration is on the plain lip, usually only one to three figures at the centre on each side, which means that it is rare to find a whole myth scene in this position, but the lip is often left empty. The handle zone has a line near its top and almost always an inscription between handle palmettes. The inscription may be a signature, a motto – 'chaire kai piei tedi' ('hail and drink this') or the like, or nonsense letters to make the desired pattern. There is a reserved band lower on the wall and the tall foot rarely has hoops beneath. Inside there is often a figure tondo edged with tongues which have white dots between their tips [110-1]. Outline drawn female heads are not uncommon as the lip decoration ('head cups') on work by Sakonides [115], Hermogenes, Phrynos and others; Epitimos has finer busts of divinities in this position, also outline drawn [121]. Rarities replace the handle palmettes by animals or figures [121]; have florals on the lips like Sianas (these by Hermogenes); put figures in the handle zone, like our next class.

BAND CUPS, as [109], have black, slightly concave lips which run into the line of the body, and often a red painted fillet at the junction of body and stem. The figure decoration is in the handle zone, often between palmettes, and it normally fills this field but may be 'brief'. Few have inscriptions here; few, decorated tondos within; few are all black with a patch window for figures between the handles; and a very few big ones (Andokidean) have figures on the flat underfoot. We might wonder why two cup types such as these were developed and so long remained equally popular with painters and customers. The black lip is more comfortable to the drinker, but the heavy ridge below the lip within the lip cup probably meant that less wine was lost

by splashing. The answer must be that both pleased in their way, but the lip cup was probably the more difficult to throw and decorate fully.

Little Master signatures are generally of potters but hands sometimes seem to correspond. There is a strong family interest too – Nearchos' sons Tleson and Ergoteles; Ergotimos' son Eucheiros, and his grandson were in the business. We have noticed some Little Master cups by the three great mid century painters in the last section and there will be others noticed later. We turn now to a few of the more distinguished specialists.

Tleson is the classic Little Master, no doubt painter and potter, and always naming his father, the painter Nearchos in his signatures – Tleson ho Nearcho epoiesen. His figures are usually animals (cock and hens [109], sirens, rams, stags [111]) both inside and outside lip cups (many of which he leaves plain). They are executed delicately with much colour, rather like the best Lydan, with many replicas of stock groups. His band cups have the same schemes.

The painter of cups signed by Xenokles was a poorer artist [112], cramming on figures and treating his lip cups rather like Sianas: Beazley notes the influence of the C Painter on his work. He also makes several plain, including band cups carrying the signature only. Hermogenes marketed lip cups [113], including some bearing outline female heads (head cups), a few with ivy on the lip, and band cups with chariot and warrior [114]: neat work, but we cannot be sure that one artist painted both groups.

Other head cup artists of distinction are Sakonides [115] (resembling Lydos) and Phrynos. Sakonides may come late in the series since he also paints a Type A cup. Archikles, on the other hand, signs a lip cup with a black lip resembling the Gordion cups, and collaborates (how?) on a cup also signed with 'epoiesen' by Glaukytes [116]. This is an elaborate large band cup, with detailed myth scenes. The Centaur Painter is late, liking equids – horses, centaurs, satyrs, rendered in a lively, nervous style [117]. He regularly does without handle palmettes. The Oakeshott Painter might claim to be one of the finest of the specialist Little Masters with two multifigure band cups, one with animals, the other with Dionysiac scenes [118], and a lip cup decorated only within [119]. Other prominent artists worked for Neandros, whose painter is garrulously proud of his animals [120], and Sokles, represented here by a kantharos [122], a shape which rarely found its way onto the Little Master's work table.

There is a high proportion of surviving Little Master cups which remain unattributed and are often of good quality. Just as some major artists like the Amasis Painter also decorated a few Little Master cups, so some Little Master hands can be detected on larger vases. The Phrynos Painter is an early example, painting an excellent and famous lip cup in London [123], and neat small amphorae [124], including some plump examples, with rays on their lips (Botkin Class) looking rather eastern. The Taleides Painter [125], a

lesser and later artist but with a wider range, offers amphorae (including a horseman amphora), hydriae and lekythoi, one of which announces the new cylindrical shape. And the EPITIMOS PAINTER's head cups so recall the oinochoe made by Kolchos [*68*] that Beazley wondered whether the latter should not be removed from Lydos' list.

The main period of this series of Little Master cups must run from just after the floruit of the Gordion cups, about 560, down to about 530. Many are contemporaries of the later Siana cups but in a different tradition and generally by other artists. A later start for the band cups is often assumed, but the type is as well rooted in the past as the lip cup, and there are some painters of lip cups and band cups who also painted Gordion cups. The band cup does continue after about 530, but no longer Little Master in character as we shall see. Development within the series is not easily determined, but handle palmettes change from the semicircular with tight leaves [*109*], through the near triangular with growing centre leaf [*115*], to the latest type with separating leaves [*112, 114*]: nearly the range we see on the Amasis Painter's vases. Only the most carefully drawn figures or the tondo groups offer details of drawing susceptible to stylistic analysis. The band cups tend to become flatter with time.

There are some related or derivative classes and shapes to consider before we leave the Little Masters. DROOP CUPS [*126-8*] (pronounced 'drope', after the scholar who first studied them) have concave black lips marked off more clearly from the body than Little Masters, a tall stemmed foot with a plain fillet and band, sometimes grooved, at the top and a black toe. There is a broad black band within the hollow foot, and in the bowl a reserved band low down in the lip and sometimes a reserved centre disc. The construction is sometimes heavier than that of the Little Masters. The earliest, from about 550 to judge from their grave contexts with other vases, have all black bodies (a type which lingers), but some admit a row of buds in the reserved handle zone like band cups. From about 540 the whole body below the lip is usually covered with decorative bands – leaves, palmettes, dots, buds, reserved leaf zigzags, rays [*128*], a row of silhouette animals (usually upside down). A few have better black figure friezes in the handle zone (chariots are popular), the commonest being the GROUP OF RHODES 12264 [*126*], and some of the best by the Wraith Painter (cf. [*174*]). ANTIDOROS (some have called them Antidoran cups) and Nikosthenes sign examples, the former using the under-foot for the inscription [*127*]. Details of the shape and scheme of decoration after about 540 are so close to those of black figure Laconian cups (which are also decorated within) that there must be some connection. The Laconian type with these details is established by about 550 or soon after. The Droop cups probably owe nothing to the Laconian in shape, though both may owe something to the common East Greek black cups whose influence in Athens we have observed already. The later and most common scheme of decoration for the

Droop cup may derive from Laconia, however. Athenian painters and potters were never above learning from potential rivals. Grave contexts for the latest Droop cups bring them down to about 510, but some with black bodies appear even later, and there is even an example with Haimonian decoration of the second quarter of the fifth century.

CASSEL CUPS, have a rather flat, band cup shape and are generally small [130]. Both lip and body are usually covered with simple patterned bands. Tongues at the lip and rays above the usual Little Master foot is a common scheme, and a few add silhouette figures in the handle zone. All were probably made in a short period within the last thirty years of the sixth century, but the scheme of the decoration derives from Siana cups, rather than Little Masters, and there is a late Siana cup in Würzburg [129] with a Little Master foot, Cassel tongues on the lip and good animal friezes to demonstrate the ancestry.

Deeper drinking vessels, corresponding to the skyphoi of Corinthian shape in the Komast Group, were also made by some Little Master potters. The finest are the HERMOGENEAN SKYPHOI, with delicate walls, a lightly flaring lip and low flaring foot, owing nothing to Corinth. They are decorated like band cups [131]. BAND SKYPHOI are similarly decorated but are squatter, with separate concave lips (like band cups) and feet like some eye cups [132]. They are less distinguished and probably even later than the main series of Little Masters: none are signed. Amasis made and decorated a skyphos related to these shapes, but with a tall figure frieze, and KLITOMENES made one with the band cup scheme of decoration but resplendent with spaced red lines in and out, and admitting a tondo within [133]. Indeed, in spite of the facile categorisation of cup shapes accepted by scholars, there is a wealth of individual invention and variation on the stock schemes: hybrids too to confuse the family trees – just as the C Painter had to decorate a Siana cup with a Little Master foot, so Hermogenes and Amasis made lip cups with a Siana foot.

Other pot painters and Nikosthenes

We have already looked at the work of some painters who may have sat in the same studios as the great artists of this period – Lydos, Amasis, Exekias. There are others, not only committed to decorating the larger vases (usually belly amphorae), who achieved some distinction and may claim some originality, although overshadowed by their contemporaries; and we can study for the first time the operation of a major workshop, that of Nikosthenes, who saw to it that a majority of the vases he marketed bore his name.

First, some painters who are contemporaries of Group E but with other interests and some individuality. The name vase of the PAINTER OF THE VATICAN MOURNER [134] shows a woman standing over the body of a dead man, laid out carefully on branches in a woodland setting, where the trees are

allowed more of the scene than we are used to seeing on Greek vases. She tugs at her hair in grief, raises a corner of her dress to her eyes; he lies as sleeping, his armour stripped from him and laid aside. The din of battle is already distant, and if this is Eos with Memnon, the artist may be thinking already of Elysium. This is a thoughtful if sometimes imprecise artist. The PAINTER OF BERLIN 1686 is more academic with a subject range and style closer to those of Group E. Two of the vases I show are atypically original with a sacrifice [135] (on his name vase) and a dance of mummers playing cavaliers [137], their mounts, it may be noted, in the old komast dress. The knee tremblers on [136] are conventional enough but the stag is a surprising love gift.

Of the immediate successors the PRINCETON PAINTER [138-140] is representative of several whose work on belly and neck amphorae of the usual later variety occupies the third quarter of the sixth century. They turn out the stock motifs with slight original variations, and show awareness rather than understanding of new developments, as in the representation of drapery, better rendered by an Exekias. Yet there is something of the master on [140] with its careful florals and statuesque figures. In many respects these works herald the exhaustion of black figure as a major style of vase painting and it takes the invention of red figure, about 530, to give a new lease of life to the technique. Meanwhile they enhance our knowledge of Athenian treatment of myth. The PAINTERS OF MUNICH 1410 [141] and VATICAN 365 can sometimes rise to better work, but this is an area for the connoisseur of attribution, personalities are hard to grasp and the future of Athenian vase painting lay with others.

The SWING PAINTER [142-6] stands out in this crowd for the number of vases which can be attributed to him, which may reflect the ease with which his hand can be recognised rather than his industry. He is not a good painter, nor a conscious comedian, although his placid figures with their big heads, fashionably tiny noses, and often clenched fists, bring a smile to our lips. He worked mainly from about 540 to 520, with a good range of myth scenes, a unique Herakles and Busiris [143], and some oddities like men on stilts [144] and domestic occasions including the swinging which gives him his name [142]. He can use colour skilfully for dress patterns. His compositions on the later vases which are of the red figure period, may become involved, but generally they are prosaically simple and his style, never very precise, easily becomes careless. Precision is not an essential quality in art, but it is often in Greek art, and especially in black figure.

Painters of smaller vases, other than cup painters, need not detain us, but the progress of the lekythos shape and its decoration is worth attention. The old 'Deianira' shape persisted, especially the 'sub-Deianira' which has a short neck below its cup-like lip. The PHAROS PAINTER, named for the cloak shared by two women on several of his vases [147], paints in panels in a good style of the 540s; and little later there is the BLACKNECK CLASS (self-explanatory) of

small lekythoi decorated with sprightly if careless figures, again in panels [*148*]. But the shoulder lekythos is the dominant type by now, its shoulder becoming flatter and broader giving more vertical surface for the body picture.

The signature of NIKOSTHENES is the commonest of all in black figure: always with 'epoiesen' and with several different hands supplying the figure work, so he was clearly a potter or pottery owner, primarily the former to judge from the common quality of inventiveness displayed by most of his shapes. The range of his products was enormous, and the originality of his work can be gauged from the number of his works and features which have come to be called 'Nikosthenic'. In cups alone, we have lip cups, band cups (once collaborating with Anakles and one painted for him by Lydos), Droop cups and eye cups – a type we have yet to describe and which brings us well into the red figure period. Some of the eye cups have a large, special, splaying foot plate (Nikosthenic). This suggests that his studio was active from soon after the mid century until near 510, when the potter Pamphaios takes over, employing more red figure artists. The 'Nikosthenic amphora' is the most distinctive product of the studio [*149, 150*]. Its broad flat handles and angular body, which slims as time passes, imitate a shape native to Etruria and executed there in a plain black ware (bucchero) with, at the best, stamped decoration. The black figure version made in Athens was clearly an export model and is a further indication of Nikosthenes' flair for business and advertisement. Almost every single example with a recorded provenience was found in Caere, while a majority of his other vases went to Vulci – an odd distribution reflecting local tastes in Etruria, and some credit to Nikosthenes' agents. The figure decoration may overlap all three body zones untidily [*150*], or be disposed in friezes [*149*], some animal or floral, while the handles could also carry figures and the splaying lip had a decorative band within. Nikosthenes' observation of foreign shapes does not end with the amphora. The kyathos-dipper (see [*171*]) was another Etruscan shape borrowed for Athenian black figure which he probably introduced, and he brings back into the Athenian repertory the purely Corinthian skyphos shape (signed under the foot) and phialai, an eastern bronze shape. The squat splaying feet of cups made in a Chalcidian colony in Italy are copied (see p. 107, [*176*]). The 'Nikosthenic pyxis', with flaring body and domed lid is less certainly one of his inventions ([*153*]; for a complete example see [*267*]). He signs (on the top of the lip) one of the earliest examples of a psykter-cooler [*154*]. He may have introduced the use of the 'Six technique' for major decoration of vases (see [*309*] and p.178), and he was among the first to use a white ground for black figure decoration (jugs by his Painter of Louvre F 117).

Of Nikosthenes' staff painters, later than his potting for Lydos (a band cup [*70*] and belly amphora) the BMN PAINTER is the best, and probably the earliest since a Siana cup and some Little Masters (one, a lip cup signed by

Nikosthenes) have been assigned to his hand. To him were entrusted most of the fine 'BELLEROPHON CLASS' amphorae, with their plump bodies, curly handles and open decoration [152] (Bellerophon attacks the Chimaera from the other side of the vase). PAINTER N seems to have decorated all the Nikosthenic amphorae [149, 150], some kyathoi and cups [151], and the psykter [154], and if Nikosthenes himself ever used a brush these may be his, mainly of the 530's and 520's. The painting of larger figures is competent: of smaller figures dull, sometimes sloppy, coming close to mass production. His florals can be particularly ungainly. Visiting artists were better, including Lydos, but the best of them painted red figure – Oltos, Epiktetos, the Nikosthenes Painter – the team inherited by Pamphaios along with most of the shape innovations.

Finally, two highly individual mannerists. THE AFFECTER (c. 540 to 520) decorates ovoid neck amphorae of rather old fashioned appearance, some belly amphorae including the new Type C with a rolled lip [156], and smaller vases. His figures have tiny heads, well upholstered bodies when dressed, but angular and spiky when undressed: they are easily recognised [155–7]. His pattern work is careful and as odd in its proportions as his figures, with well sprung little palmettes at the end of long thin tendrils, skinny but well formed lotuses and a rash of tiny red and white dots all over clothing. The patterning of florals is close to that of some East Greek black figure studios (Clazomenian, the Northampton Group) and in a period when so much else of Ionian origin seems to have been introduced in Athenian art – in sculpture and architecture – we probably ought to look for influence in the vase painting. Major instances of copying are unlikely and it is more like noticing Americanisms in current English usage. The Affecter is a stylist as no other, and the content of his figure scenes concerns him little. Passive clockwork elders stand and gesticulate pointlessly while men accost youths or a Hermes flutters before a seated Zeus [155]. It is a make-believe world, and if the Athenian tradition had not been to put figures on pots the Affecter might have proved an outstanding and original exponent of Archaic art nouveau. His latest amphorae have florals, not figures on the neck [157] and one of them was painted for him by an artist of the 520s, which helps place his rather elusive style. He was possibly a potter-painter.

The other mannerist was called ELBOWS OUT (c. 550 to 530) by Beazley for the exaggerated gestures and anatomy of his dancing figures. His neck amphorae are of a special shape with heavy ovoid bodies, slim flaring necks, spreading feet and flat handles usually decorated with a laurel band [158]. The shape may owe something to bronze amphorae. He offers several friezes on these vases, but is also a Little Master, and decorated several band cups where the animals are more canonical, recalling Tleson or Lydos. They appear also on the lydion [159], one of the rare Athenian imitations of the Lydian perfume vase shape. He is as little interested in myth as the Affecter, more

interested in love-making. The style is more vigorously appealing too, more 'normal', with sedation removed. Both artists can recall Amasean figures, but not the typically Amasean ones, and connections between the three are easily exaggerated, even though there is slight evidence that they may have sat together for potters early in their career when painting shoulder lekythoi.

64 Fragments of dinos signed by Lydos. Gigantomachy

64.1 Artemis

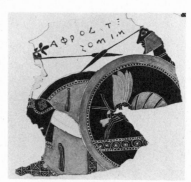

64.2 Aphrodite and Giant

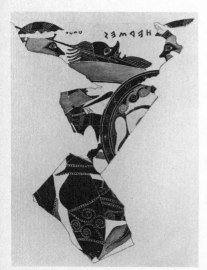

64.3

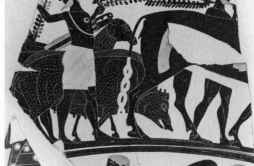

64.4 Procession to sacrifice

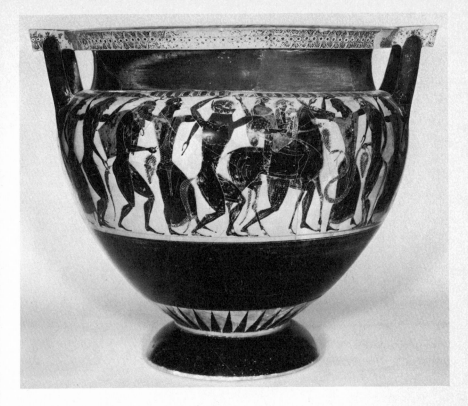

65.1,2 *Column crater by Lydos. The Return of Hephaistos. H. 56·5*

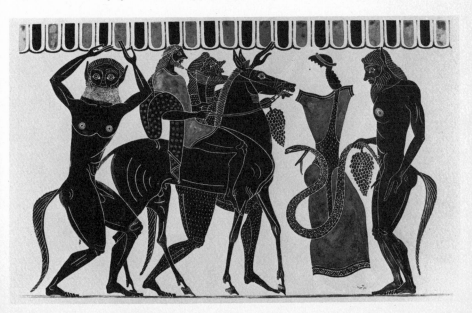

66 *Psykter amphora by Lydos. 66. 1: Dionysos with maenads and satyrs. 66. 2: Theseus fights the Minotaur.* H.32

67 *Belly amphora by Lydos. Menelaus recovers Helen; The Death of Priam*

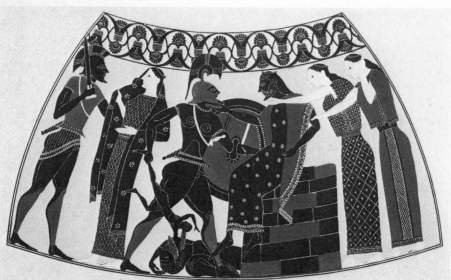

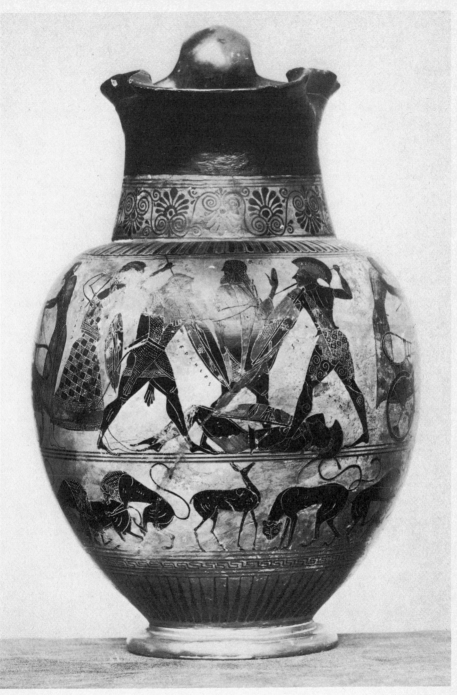

68 Oinochoe by Lydos, potted by Kolchos. Herakles fights Ares over Kyknos. H. 25·5

69 Plate by Lydos. Gorgoneion. W. 24

70 Fragment of band cup by Lydos, potted by Nikosthenes

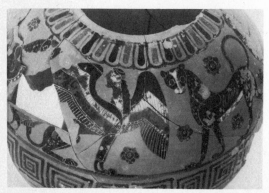

72 Hydria in the manner of Lydos

71 Funerary plaque by Lydos. H. 37

73 *Neck amphora by the Painter of Vatican 309 (name vase)*

74 *Hydria by the Painter of Vatican 309. Herakles rescues Deianira from Nessos*

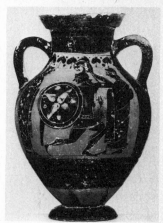

76 *Belly amphora by the Painter of Louvre F 6. H. 26*

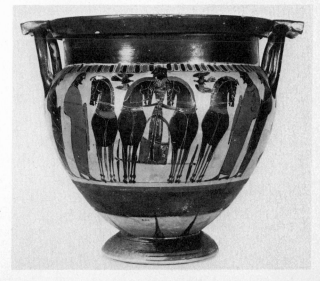

75 *Column crater by the Painter of Louvre F 6. H. 41·8*

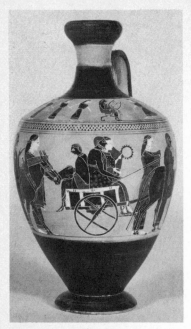
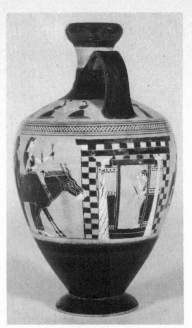

77.1,2 *Lekythos by the Amasis Painter. Wedding procession. H.* 17·1

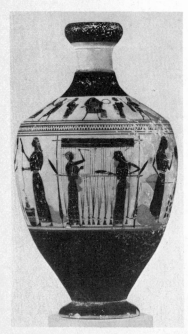
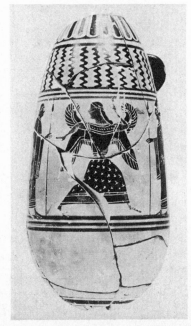

78 *Lekythos by the Amasis Painter. Weaving.*
H. 17·2

79 *Alabastron by the Amasis Painter. H.* 9·2

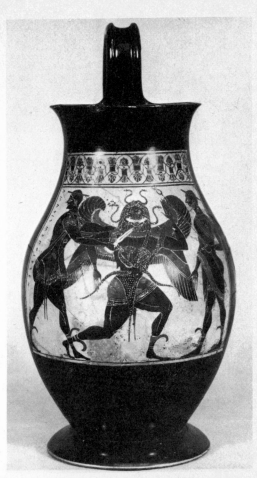

80 Olpe by the Amasis Painter. Perseus
decapitates Medusa. H. 26

81 Cup by the Amasis Painter. Dionysos and Ariadne

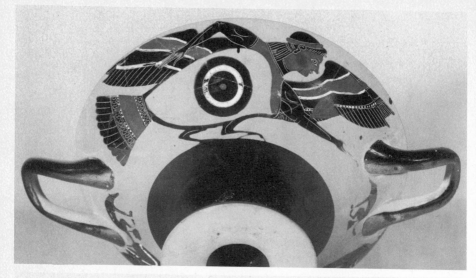

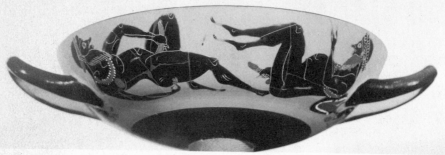

82.1,2 Cup by the Amasis Painter

83 Cup by the Amasis Painter. Divine stables

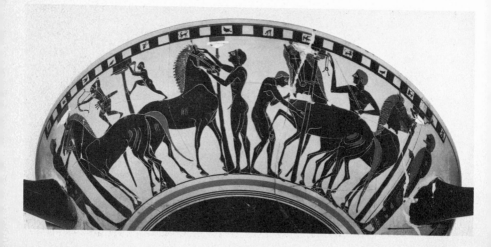

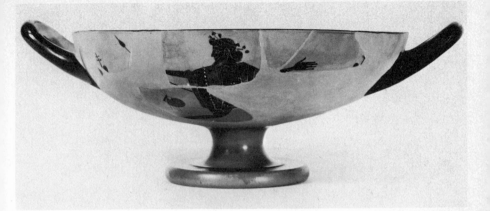

84 Cup by the Amasis Painter. H. 7·5

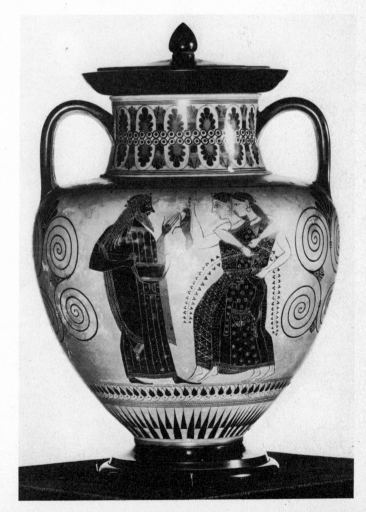

85 Neck amphora by the Amasis Painter. Dionysos and women. H. 33

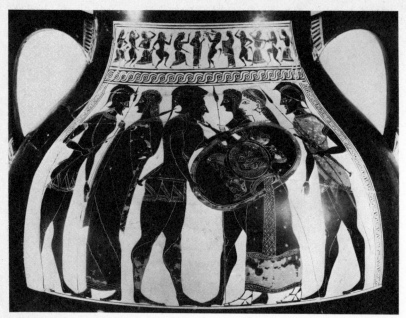

87 *Belly amphora (Type A) by the Amasis Painter*

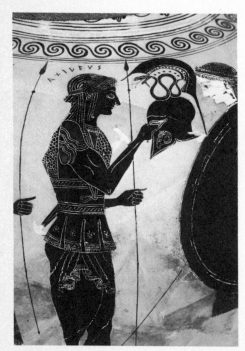

86 *Neck amphora by the Amasis Painter. Achilles arming*

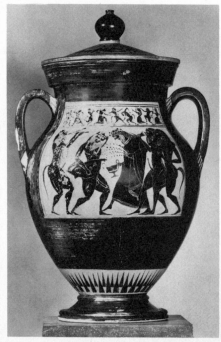

88 *Belly amphora (Type A) by the Amasis Painter. Dionysos and satyrs. H 34·7*

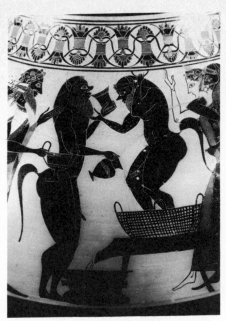
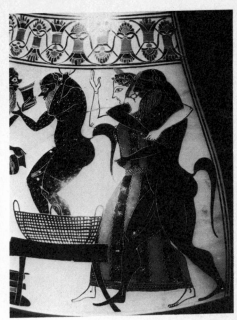

89 Belly amphora by the Amasis Painter. Dionysos and satyrs at vintage

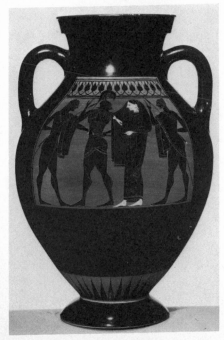
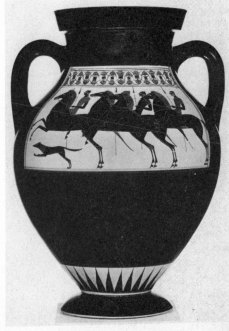

90 Belly amphora by the Amasis Painter. Menelaos recovers Helen

91 Belly amphora by the Amasis Painter. H. 42

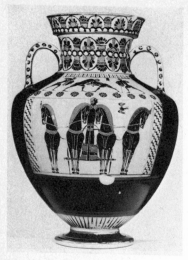

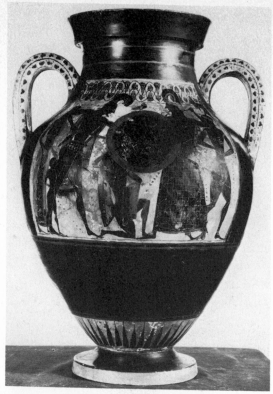

92 Neck amphora related to Group E.
H. 36

93 Belly amphora of Group E. The Rape
of Kassandra. H. 50·5

94 Neck amphora of Group E. Herakles
fights the Lion; men and centaurs

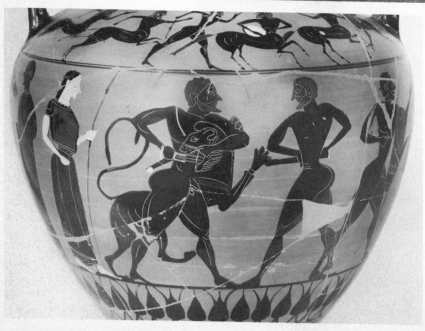

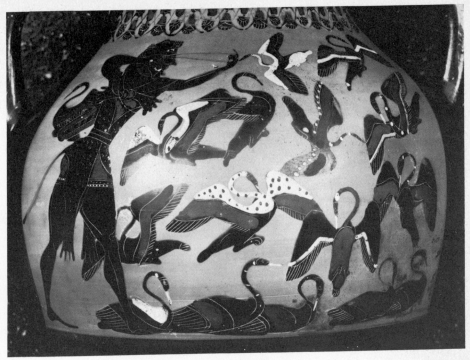

95 Belly amphora of Group E. Herakles and the Stymphalian Birds

96 Belly amphora of Group E, potted by Exekias. Herakles fights Geryon

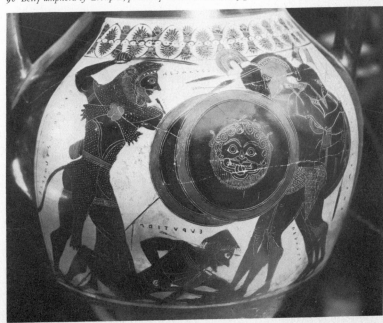

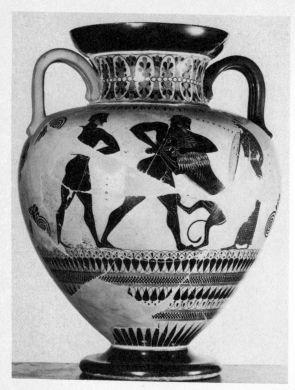

97 *Neck amphora signed by Exekias.*
Herakles fights the Lion. H. 40·5

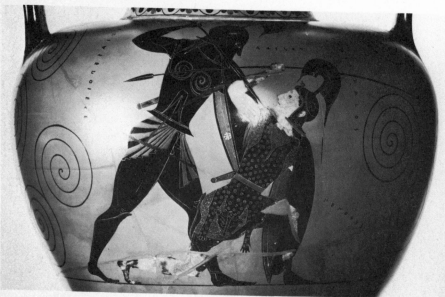

98 *Neck amphora signed by Exekias. Achilles fights Penthesilea*

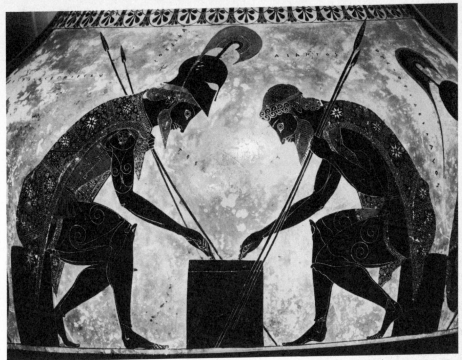

100 Belly amphora (Type A) signed by Exekias. Achilles and Ajax at play. (See also Frontispiece)

99 Neck amphora by Exekias (detail). Memnon's squire, 'Amasis'

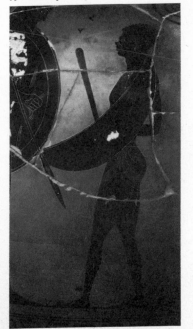

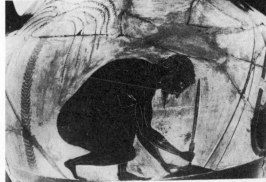

101 Belly amphora by Exekias. The suicide of Ajax

102 Detail within a dinos rim, by Exekias

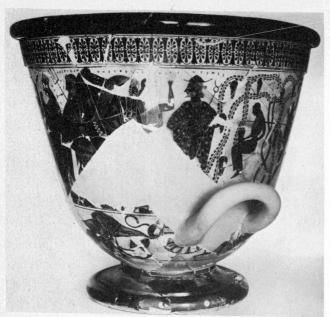

103 Calyx crater by Exekias.
The chariot of Athena and
gods. H. 44·5

104.1,2 Cup signed by
Exekias. W. 11·5

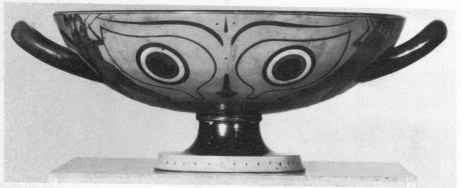

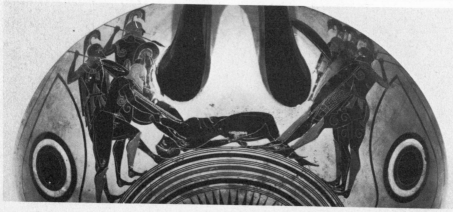

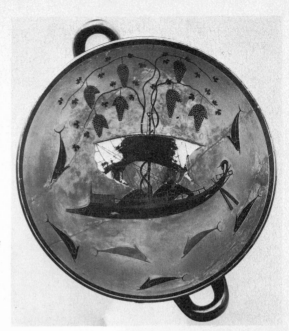

104.3 *Cup signed by Exekias*

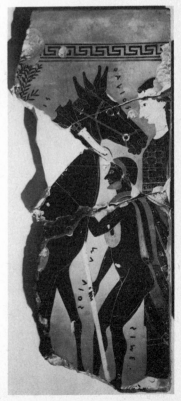

105.1,2 *Funerary plaques by Exekias. Mourners and the cart for the procession. H. 37*

106 *Panathenaic amphora by Exekias*

107 *Belly amphora near Exekias. Hermes kills Argos, with Io*

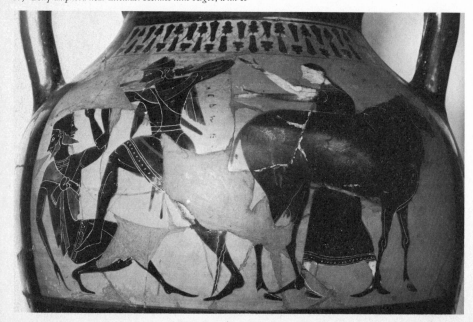

108.1 *Gordion cup signed by Kleitias and Ergotimos.* W. 17·7

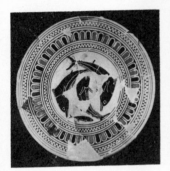

108.2 *Interior of 108.1*

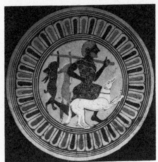

110 *Lip cup signed by Tleson*

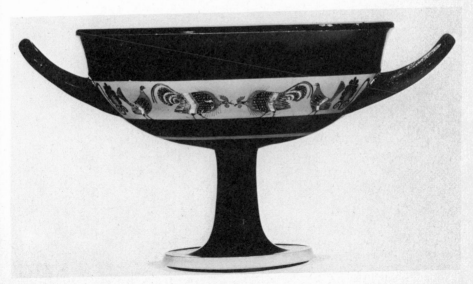

109 *Band cup by the Tleson Painter*

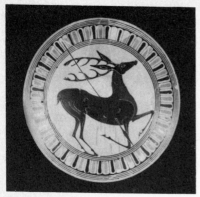

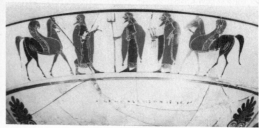

111 Lip cup by the Tleson Painter

112 Lip cup signed by Xenokles. Gods

113 Lip cup signed by Hermogenes. H. 14·2
114 Band cup signed by Hermogenes

115 Lip cup (head cup) signed by
Sakonides

117 Band cup by the Centaur Painter.
H. 12·5

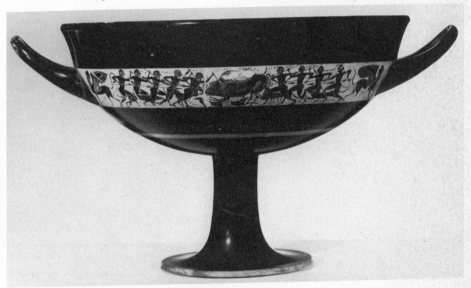

116 Band cup signed by Archikles and Glaukytes. H. 18·3. 116.1: The Calydonian Boar Hunt.
116.2: Theseus fights the Minotaur

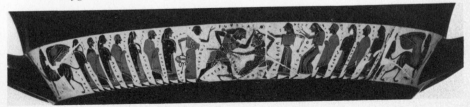

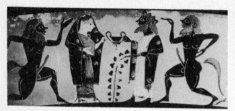 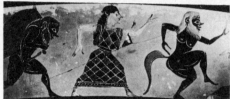

118.1,2 Band cup by the Oakeshott Painter. Dionysos and Ariadne; satyrs and maenads

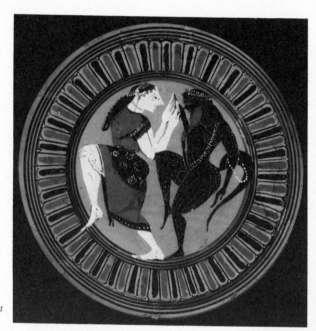

119 Lip cup by the Oakeshott
Painter. Satyr and maenad

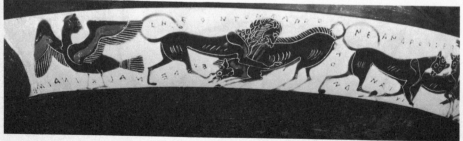

120 Band cup signed by Neandros

121.1,2 *Lip cup by the Epitimos Painter. The Giant Enkelados; Athena*

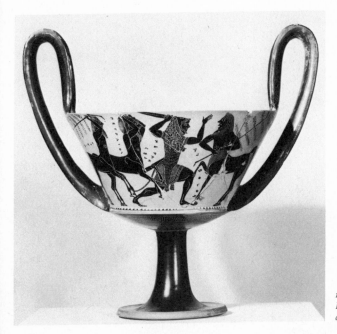

122 *Kantharos by the Sokles Painter. Herakles fights centaurs. H. 25·5*

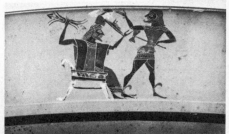
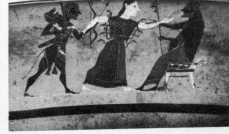

123 *Lip cup by the Phrynos Painter. 123. 1: The Birth of Athena. 123. 2: The Introduction of Herakles to Olympus*

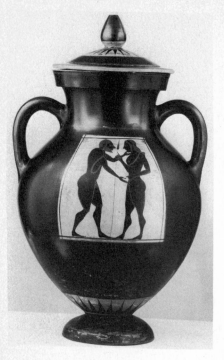

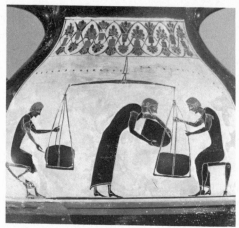

124 *Belly amphora by the Phrynos Painter. Courting. H. 36*

125 *Belly amphora by the Taleides Painter. Weighing goods*

126 *Droop cup of the Group of Rhodes 12264. Amazonomachy. H. 13*

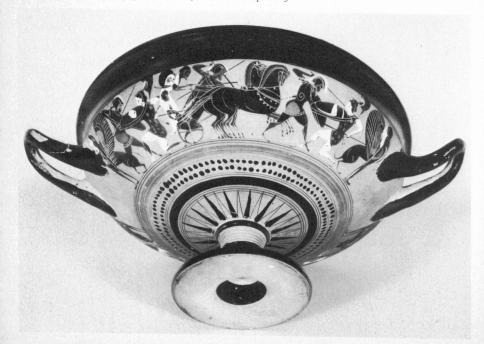

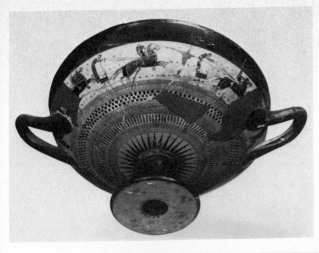

127 *Droop cup signed by Antidoros. H. 30·9*

128 *Droop cup. H. 11·5*

129 *Proto-Cassel cup. H. 14·5*

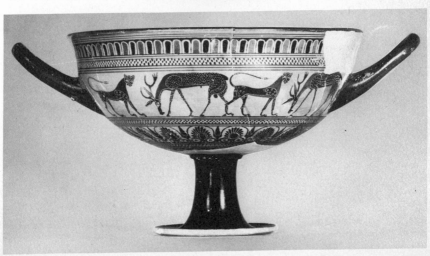

130 Cassel cup. H. 8·5

131 Hermogenean skyphos.
H. 9·6

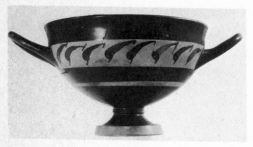

132 Band skyphos

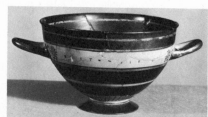

133.1,2 Skyphos signed by
Klitomenes. H. 10·7

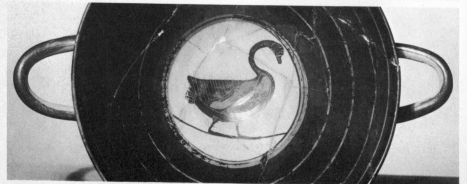

134 *Belly amphora by the Painter of the Vatican Mourner (name vase). Eos mourns Memnon (?)*

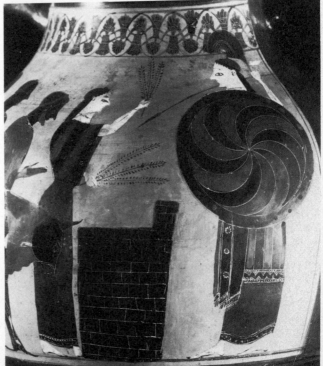

135 *Belly amphora by the Painter of Berlin 1686 (name vase). Sacrifice to Athena*

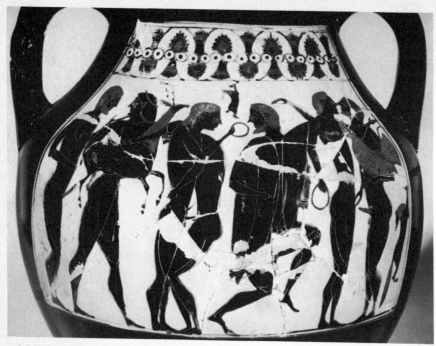

136 *Belly amphora by the Painter of Berlin 1686. Courting*

137 *Belly amphora by the Painter of Berlin 1686. Chorus of 'Knights'*

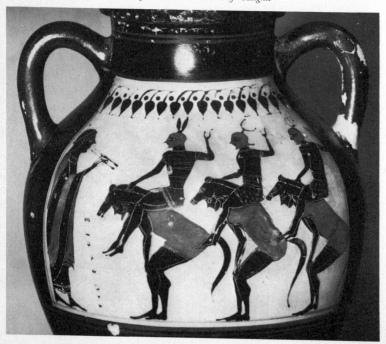

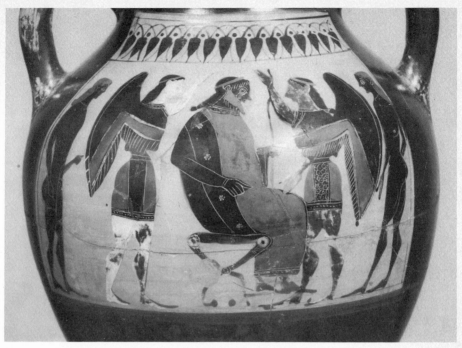

138 Belly amphora by the Princeton Painter. Zeus before the Birth of Athena (?)

139 Belly amphora by the Princeton Painter. Herakles victor

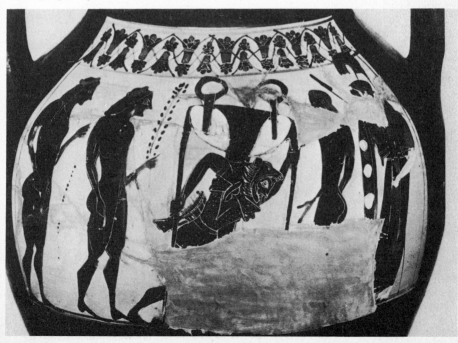

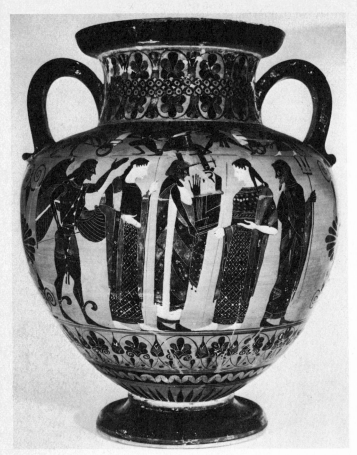

140 Neck amphora by the Princeton Painter. Gods – winged Hermes, Apollo, Poseidon. H. 45·5

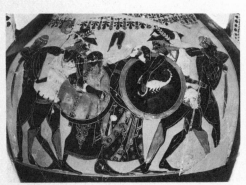

141 Belly amphora (Type A) by the Painter of Munich 1410. Quarrelling heroes parted

142 Belly amphora by the Swing Painter

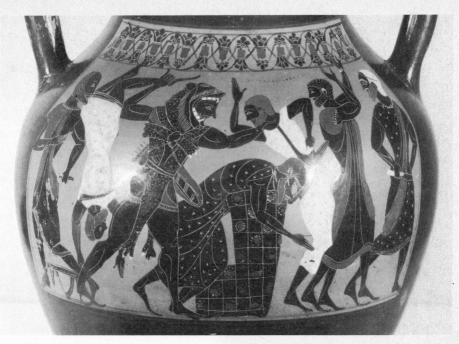

143 Belly amphora by the Swing Painter.
Herakles kills Busiris

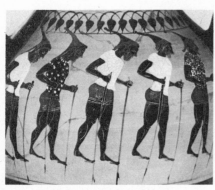

144 Belly amphora by the Swing Painter

145.1 Panathenaic amphora by the Swing
Painter. Hermes and Athena. H. 45

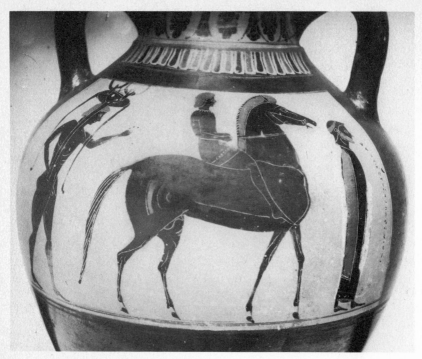

145.2 Panathenaic amphora by the Swing Painter. Victor

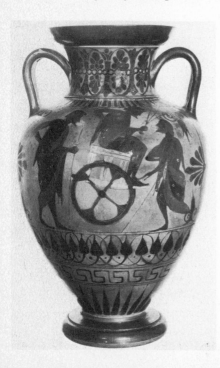

146 Neck amphora by the Swing Painter. Triptolemos. H. 39·5

147 Deianira lekythos by the Pharos Painter. H. 21

148 Deianira lekythos of the Black-neck Class. H. 14·3

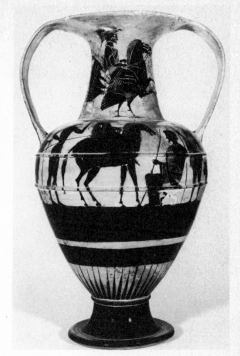

149 *Nikosthenic amphora by Painter N (Thiasos Group). Satyrs and maenads. H. 32·8*

150 *Nikosthenic amphora by Painter N (Overlap Group). Warrior on cock-horse. H. 30·5*

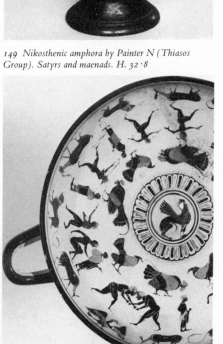

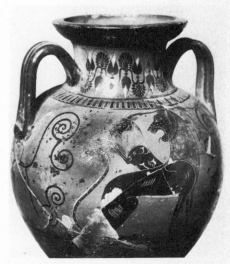

152 *Neck amphora of the Bellerophon Class by the BMN Painter (name vase of Class). The Chimaera*

151 *Cup signed by Nikosthenes, by Painter N. W. 20*

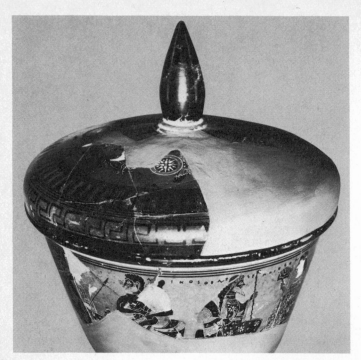

153 *Nikosthenic pyxis signed by Nikosthenes. Gods in Olympus with Herakles*

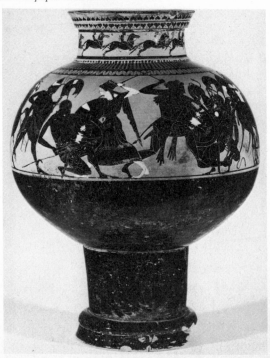

154.1 *Psykter signed by Nikosthenes, by Painter N. Battle of Gods and Giants.* H. 39·4

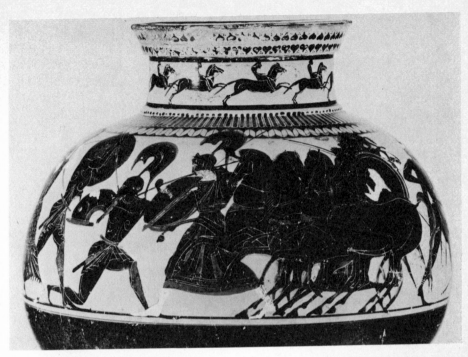

154.2 *Another view of 154. 1*

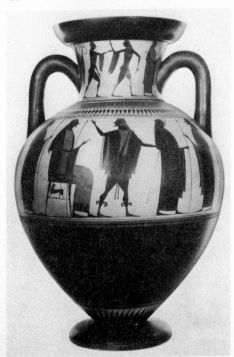

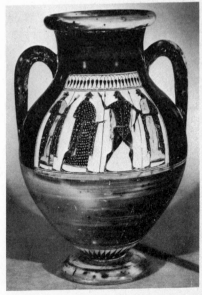

156 *Belly amphora (Type C) by the Affecter.* H.36.5

155 *Neck amphora by the Affecter. Zeus and Hermes. H. 41·8*

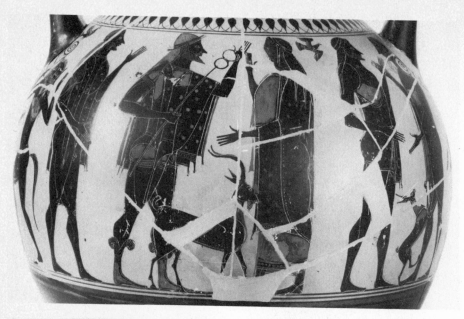

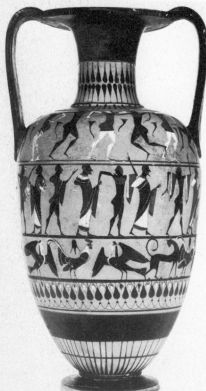

157 Neck amphora by the *Affecter*. Hermes and others

158 Neck amphora by Elbows-Out. H. 30·7

159 Lydion in the manner of Elbows-Out. H. 9·8

Chapter Five

THE AGE OF RED FIGURE

In about 530 BC, more probably earlier than later, the red figure technique of painting was invented in Athens and the first artist to practise it regularly was the Andokides Painter. He also worked in black figure, sometimes on the same vase with the new technique, and other early red figure painters also produced these 'bilinguals'. Not all the best painters were now attracted to red figure. The technique introduced new methods of drawing which were observed by artists committed to the old style and which influenced their work. Until about 500 there were accomplished artists still working in black figure only, so far as we can judge, with a few using both techniques, and it is their work we consider in this chapter. But we have first to look at the new technique to judge what it could offer to the old. The effect [161-2] is the reverse or negative of black figure. The figures are drawn in outline and left in the pale colour of the clay while the background was painted all black. This threw them into more vivid relief than black figure. It did not make them any more easy to distinguish in overlapping compositions, and the black figure artist's increasing interest in these may be read as a reaction against the more statuesque style. It was, however, largely vitiated by a decreasing use of colour, which had helped differentiate dressed figures before, and this may owe something to red figure. Within the outline figures details were drawn with the brush, and not incised with the graver. The early red figure artists still use some colour on their figures but it is soon abandoned for a more simple linear, 'black and white', effect which suited the new technique better than the old. Gone, for instance, is the old colour differentiation of sex, although there is some experimental use of white ground by the Andokides Painter and Paseas. The use of a brush also gave the opportunity for different emphasis in the line drawing, from the crisp black 'relief line' to dilute honey-coloured strokes which the eye barely catches. In this way different textures of drapery or strength of body modelling could be rendered. In black figure the temptation was to use the graver like a brush with lighter, scratchy strokes on anatomy and drapery where all before was explicit and precise. The brush also encouraged more detailed and realistic treatment of anatomy and attention to depiction of posture. Copy this new realism on black figures and the result is bound to suffer by comparison with the more life-like red.

These are the factors which played on the work of the black figure artists we have yet to discuss, and it must be remembered that from now on the prime achievements of Athenian vase painting lie elsewhere.

The shapes which occupy the artists now are generally different and we can observe more specialisation and clearer distinction between the cup painters and the pot painters. The belly amphora is falling from favour, except for some of Type A. The neck amphora is the commonest amphora shape and the scheme of decoration is soon stereotyped, with floral on the neck and a fairly simple palmette cross beneath the handles, as [186]. The hydria is far more popular: shouldered now, so that there is a separate shoulder scene and for a while a predella below the main scene, as [190], figuring animals, horsemen or a hunt, rarely myth. Later (after the Antimenes Painter) there is only a floral here. Red figure panels, with black backgrounds, required decorative borders to set them off from the black body of the vase and the scheme is copied on black figure vases. The Little Masters give place to cups of Type A – the eye cups, as [173], while the deeper skyphoi come into fashion, as [181-2]. The lekythoi now acquire their familiar cylindrical shape but the full range of late black figure lekythoi, together with the new series of oinochoai and some new shapes like the mastoid cups are not characteristic of the best black figure of the late sixth century, and will be considered in a later chapter.

The drawing conventions are unaltered but, following the lead of red figure artists, the anatomical detail of naked bodies is better rendered, and the twist from frontal chest to profile hip is achieved with near plausibility by shifting the stomach pattern to one side. For three-quarter views of objects the combination of front and profile can lead to some odd effects, as with shields, but elementary foreshortening is managed and this is all better observed in red figure. Drapery patterns are simpler and there is generally less colour added, but the arrangement of folds with zigzag edges is now normal. The neck florals now have thin lotuses, palmettes with separate leaves, and less and less added colour. The relief line of thick black paint standing up boldly from the vase surface had been used since the mid century in black figure to separate tongues in decorative friezes and for spears or sceptres. It comes into its own now for outlines and emphatic detail in red figure but has a reduced role if anything in black figure. Outline incision for black figure seems almost a counterpart to the contour relief line. It had been used before but it is interesting to notice how it becomes common again especially on the work of bilinguists like the Andokides Painter and Psiax. It helps define the figures where the background is a rich red, an intensity of colour lost through time and cleaning, and deliberately toned down by the photographer.

Bilinguists I

Five of the vases signed by the potter Andokides are by one hand – the ANDOKIDES PAINTER [160-6]. All are red figure but one, a cup in Palermo, is half black figure – a bilingual, and the red figure amphora in New York has a black figure (white ground) lip. Other red figure vases and bilinguals can be attributed to this artist. It would seem reasonable to suppose that only one man was involved, whatever the technique, but Beazley changed his mind twice about this and in the end preferred to attribute the black figure work to a second artist, the Lysippides Painter. There is a clear general congruence of style, and although exact comparisons of detail between the techniques is not always easy, such a fine artist might have gone out of his way to vary detail and composition even when the scenes on a single vase were superficially replicas. If so he was very thorough on some vases. Indeed, it looks as though this could have been the artist's intention, since the problem arises most acutely with some bilinguals [161] and not with many of the attributed all-black-figure and all-red-figure vases where the work of a single hand is more clear [162-3]. So the Andokides Painter did paint black figure and it is difficult to escape the conclusion that he and the Lysippides Painter are one and the same. It is at any rate quite inconceivable that he painted only red figure, since he seems to be one of the first, if not the first practitioner in the new technique, which was obviously invented by a skilful black figure artist, and not, for instance, a distinguished muralist (if there were such specialists) since many details and patterns are borrowed straight from black figure. So some of his black figure vases could be earlier than the red figure or bilinguals. We cannot say readily which, but some of the amphorae with figures which have little or no outline incision may go here [165]. It was almost as though Exekias had taken up his brush again but in another man's workshop, and it is generally agreed that the Andokides Painter was Exekias' pupil. Certainly the tradition is the same, so what are the differences? In details they are too great to allow identification. Ornament is much the same and some favourite scenes are repeated in much the same manner – Ajax and Achilles playing, Herakles and Kerberos: Herakles is a particular favourite as can be judged from the illustrations chosen here. Some scenes still carry an Exekian dignity but generally the compositions are looser and invention, though not lacking, is not so brilliant. The precision is comparable, but becomes slacker in the black figure, and there is in a way more of Exekian composition in the red figure work, but here comparisons become even more difficult. It is interesting to notice that most of the bilinguals are by no means the earliest of his vases.

The black figure work of the Andokides Painter and of artists close to him appears on neck amphorae, belly amphorae of the new Type A, which had possibly been introduced by Exekias, eye cups and hydriae. The MASTOS PAINTER is of this group, named after the breast-shaped cup [167].

PSIAX [*168-171*] painted a bilingual amphora for the potter Andokides, but we get his name from two red figure vases. Beazley thought he might have been a pupil of the Amasis Painter and there is in his work something of the delicate prettiness which that artist sometimes expressed, but it is more brittle, less robust. He seems much affected by red figure and he uses wavy lines for folds not to emphasise but to weaken the stiff effect it was difficult to avoid in black figure. Five fine plates survive, plain but for simple and usually single black figure subjects at their centres [*169*]. He had the instinct of a miniaturist and on his larger vases (neck amphorae, hydriae, calyx craters and amphorae of Type A – the last being bilinguals) his figures lack substance but can be enjoyed in detail. Most of his work probably belongs to the years from about 525 to near 500.

A contemporary – also a plate painter and close to Psiax in style – was PASEAS (formerly known as the Cerberus Painter), a fine red figure artist who used the older technique for some dedicatory plaques found on the Athenian Acropolis. They were prepared with a fine white ground, and all represent Athena [*172*], sometimes alone. The black figure technique was being retained by his contemporaries for another traditional product, the Panathenaic vases, on which similar Athena figures appear. Paseas painted on none of these so far as we know, but before one of the Athenas on a plaque he signs with a phrase which echoes the formula of the Panathenaics – 'one of the paintings of Paseas'. Perhaps he had been disappointed of an order for the prize vases.

New techniques for treating the background to figure decoration on vases appear more frequently now. Paseas used a fine, glossy white or cream for his plaques and one plate, a technique which appeared by about 525 and is often used on later black figure. He sometimes used a second, whiter white for women's flesh, but on a white ground the ladies were bound soon to have black faces. Psiax uses white ground on other shapes – alabastra, a lekythos and a kyathos [*171*]. The Andokides Painter had used white ground experimentally on one 'red figure' vase (as does Paseas once, on a red figure plaque) and for a black figure frieze on the lip of another. Exekias had introduced the coral red background on his Dionysos cup [*104*]. Psiax has it for the whole interior of a cup with a simple centre piece [*170*] giving exactly the decorative effect of his plates. Skythes, a red figure artist of these years, used it for the background to black figures outside red figure cups and it is used for areas on some plain vases of the generations before and after 500.

Cup painters

There is another large class of bilingual vases which need not be studied closely here. They are eye cups by red figure painters who put a black figure picture in the interior tondo. Nikosthenes' [*151, 173*] and Pamphaios'

workshop were responsible for many, and the artists who decorated such cups were among the very finest practitioners of the new technique. The cup shape, however, must occupy us since it was invented for black figure and most commonly so decorated.

The usual variety, Type A, as [173, 178, 183], has a shallow bowl rising to a plain lip, not offset like the Little Masters. The foot is short and splaying with a moulding at the top, usually a plain blunt toe like the Little Masters, but the hollow cone within the foot is painted black. A less common shape in black figure is Type B, with a continuous curve from the lip onto the top of the toe (cf. [84]). The interiors are often decorated with a figure in a tondo, now lacking a decorative border, and a very common device is a gorgoneion, painted in the usual manner with an outline, not black figure face, but there are a few cups with full insides [151, 177]. Outside, the usual decoration (but not invariable especially for the later examples) is a pair of large eyes on either side between the handles. Eyes had appeared on Greek vases in the seventh century, usually under arched handles which suggested eyebrows, and in East Greece on jug necks, either side of the nose spout, as well as in the eye cup position on lipless vases which are earlier than the Attic. On our cups they are sometimes provided with eyebrows, rarely noses, and the full facial effect is got by tilting the vase so that the handles look like ears and the underfoot a mouth: a view enjoyed by a drinker's companion, not the drinker himself. It may be noted that some eyes are 'female' – almond-shaped without tear ducts. The eyes deny the possibility of any frieze composition on the vase and instead we have single figures or small groups between and beside the eyes, or around the handles. The latter is the scheme, with fighting warriors, for the earliest known example of standard shape – Exekias' famous cup in Munich [104]. Often a vine will grow beneath each handle and creep into the field around the eyes [177-8], and on simpler cups there is just a flower, leaf, dolphin or similar simple device in this position [179, 183]. Handle palmettes of Little Master types are not unknown, but there are cups and skyphoi, of the so called FP (Flower-Palmette) Class with distinctive flowers beneath the handles and beside them a large horizontal black palmette, smaller side palmettes and scrolls; no room for eyes on these. Several fill the whole high frieze with figures, without eyes [175, 179, 180]. The lower bowl is usually black, with a reserved band, but the earlier cups often have more elaborate friezes of lines and dots, with alternating black and void rays below [177-8]. The Nikosthenic foot for some larger cups lacks the flat resting surface but splays, with a thin, trumpet-shaped wall and may be decorated beneath. [173] is an unusually elaborate example with nine stripes on the underfoot. Another variant which may have been devised in the Nikosthenes-Pamphaios workshop, to judge from two signed specimens, is the 'CHALCIDISING CUP', which has a shallow, heavy foot with a plain concave edge [176]. It seems to copy a type made by Chalcidian potters in South Italy, and so

represents a further observation by this workshop of fashions in the western market. The decoration too sometimes copies Chalcidian, the eyes being supplied with noses and satyr ears, and all known proveniences are Italian with one possible exception in Athens. They belong to the 520's.

The prehistory of these shapes and some hybrids can usefully be discussed before turning to details of decoration or the works of painters and groups. There had been earlier Attic cups which lacked the offset lip, such as the more nearly hemispherical merrythought cups [37]. The standard eye cup shape had many variants, especially with the one piece profile (Type B) of which there are examples painted by Amasis with the figures between the eyes, painted in free field [84], without lines or paint on the lower body or stem of the cup. There are hybrids too, including Little Masters with Type A feet. The WRAITH PAINTER, named for his rather insubstantial figures, put a Little Master foot on Type A bodies [174], and these he decorated like the Droop cups (which he also painted). His companion, the PAINTER OF THE NICOSIA OLPE [175], shows a similar eclectic taste: and the two painted both 'sub-Deianira' and shoulder lekythoi. There are a few later cups of about 500 (Type B) with a black top band over the handle zone, so that the scheme is as for band cups, but the profile not (compare [184]).

The main run of early eye cups have ornate lower bodies and the whites of the eyes are drawn in outline [173, 177-8], later more often being filled with white or painted white over black. The early cups are represented by Nikosthenes' products [151, 173] and a few of high quality by [160], and in the manner of the Andokides Painter, like the one with the funny foot [177]. Related is the important GROUP OF WALTERS 48.42 which specialises in frontal masks of Dionysos [178], satyrs or maenads between the eyes, and gorgoneia within. Of the same family are skyphoi of the KROKOTOS GROUP, so called for the saffron yellow used by the painters for some animals and dresses. These skyphoi are heavy, deep vessels, with shallow concave lips which may be black or decorated with a ivy wreath, and with red and black or all-black tongues at the base. The scenes are often Dionysiac, their backgrounds filled with vines [181-2]. They are less finely painted than the cups and must bring us to the end of the sixth century, but the group has some important successors.

In a different tradition are other cups and skyphoi many of which have the flower and palmette (FP) decoration at the handles that we have already described. In the GROUP OF COURTING CUPS we see a homosexual courting couple [183] or a horseman between outlined or white eyes (sometimes omitted). Ure's CLASSES OF SKYPHOI A1 AND A2 (a classification devised for the prolific finds at Rhitsona in Boeotia) have black lips which carry a groove below the rolled top, or are merely shallow and convex, with undecorated lower walls. The range of subjects is somewhat greater but the style is still wretched.

Finally, there are some stemless cups of the last quarter of the century. They have broad, shallow, torus feet. The TOP-BAND STEMLESSES have the decorative scheme of band cups [184], but with eyes in the handle zone and sometimes with gorgoneia within. The SEGMENT CLASS have black exteriors, but the picture inside, with or without a segmental ground line, fills the cup. The subjects are usually Dionysiac, the style fair to poor, but they offer some of the last black figures of any size, apart from the Panathenaic amphorae. [185] is a particularly elaborate example, with red figure eyes below the ground line. We shall see that from the later sixth century on the skyphoi will attract still some worthwhile black figure decoration, but by that date all the shallow cups of quality were being painted in red figure.

The Antimenes Painter and Leagros Group

The most prolific of the black figure painters working in the first generation of red figure is the ANTIMENES PAINTER [186–190], so called from a kalos name on one vase. Beazley regarded him as perhaps a pupil of Lydos and a 'brother' of Psiax, but he seems to have painted no red figure and to have been little influenced by the new technique. Most of his work (some 150 vases are attributed to him) must belong to about 530 to 510, and appears on hydriae and neck amphorae, his scheme of decoration on these shapes being standard for this period. He continues the tradition of straightforward narrative exemplified earlier by artists of Group E, but with a remarkable range of scenes. Few of them may be his own invention, but his presentation of them is telling and explicit, though very few are inscribed, and the compositions are neatly observed and simple, rarely with overlapping figures except of men and horses or dancing couples. Herakles is his especial favourite and we may also pick out some fountain scenes, possibly inspired by Peisistratid works in Athens; a rustic scene of olive picking [186] in which, unusually for Greek art, the trees get something near their full value; and some borrowing from eye cups, such as compositions with eyes (usually white now, not outlined), often Dionysiac and including the frontal mask which characterised the contemporary Group of Walters 48.42. Psiax does this once too, also on a neck amphora.

His drawing is not over-precise, but it is never incompetent, and he offers some quite detailed studies. The mass and proportion of his figures show him to be a master with the brush. He likes to fill the field comfortably, with no emphatic masses of colour, and in the Dionysiac scenes we see now, as on many eye cups and skyphoi, the ivy or vine tendrils, which, whether held or not, sweep gracefully around the figures. He succeeds in demonstrating that, despite new developments, black figure can still effectively serve the needs of simple narrative; a reliable conservative; the typical black figure painter.

He has many followers who worked in a comparable style on the same

shapes, some of them at least as good artists but none, to judge from attributions, as prolific [191–4]. The EYE-SIREN GROUP is worth mentioning at least for its name vase with eye-sirens [195] recalling Amasis' conceit [82], and the GROUP OF TORONTO 305 [196–7]. The BUCCI PAINTER [198] is an older man, closer to the Andokides Painter, who sometimes borrows Panathenaic columns to frame his scenes. The painters on occasion add a small animal frieze to their neck amphorae, like the predellas on hydriae. They also introduce a new shape – the stamnos [193].

The last important and numerous group of large black figure vases takes its title, the LEAGROS GROUP (c. 520 to 500) from the kalos name on five of its hydriae. Around four hundred vases have been attributed to it of which nearly half are hydriae, nearly half neck amphorae, the rest amphorae of other shapes, craters and lekythoi, to name the commonest. The hydriae resemble those of the Antimenes Painter, tending to more flaring lips and flatter, broader shoulders [201–6]. The animal predella [190] and sometimes the ivy borders give place now to neat palmettes with broad but separate leaves, arranged in rounded scrolls or loops [202–4, 206], a pattern rare hitherto in black figure [68] but which soon becomes very popular in red figure. A very few Leagran hydriae follow rare examples by the Antimenes Painter in having white-ground necks. The neck amphorae are Antimenean but the neck floral is becoming less articulated and the lotuses more like black sticks of celery than flowers, as on [199, 200].

The compositions of the figure scenes have a new vigour and complexity. Involved groups of overlapping figures are skilfully managed and are only occasionally confusing to the eye because the incision is clear and bold and the display of anatomical detail is moderate. There is restrained use too of added colour while drapery folds and patterns are, if anything, less elaborate than the Antimenean although contemporary red figure – the Pioneer Group – rejoices in folds, texture and anatomy. These artists realise what is possible still in the old technique and are able to reduce to reasonable terms several features of the new, rendering complicated folds or muscles with less explicit strokes (and notice the tiny eyes), but profiting from newly learnt skills in showing more eloquent poses, like the rare twisting figures with one leg frontal, one profile. The figures are all heroic in their proportions and features – burly squires beside the Antimenes Painter's clerks. The panels are always full with no figures or spaces wasted. Thus, the foreparts of chariots may emerge from the borders of the picture if their presence is required [205] and not only Dionysiac scenes are found with their complement of filling vines or tendrils. [201] is a good example of the 'intensity' of narrative with the action and figures overlapping the borders, where a Trojan team sallies to try to rescue Troilos but is foiled by Athena, and running up onto the shoulder of the vase, where on the battlements of Troy men fight and drink, a grey-beard watches, and women weep. The two fields are linked by the trees spreading up from

the plain and the women's arms outstretched to the carnage below. The inscriptions, though nonsense, seem to heighten the sense of bustle.

Several painters and minor groups have been distinguished within this series but the generic similarity is strong and this is the idiom of the best black figure of the end of the sixth century. The ACHELOOS PAINTER [208–211] can be singled out for his robustly original myth scenes and the wit of his antithesis of love, sacred and profane [211]; and the CHIUSI PAINTER for rather tedious finesse [213]. The stand supporting the painted amphora [209] is not by the Acheloos Painter but by another artist who appears to have specialised in decorating these accessories. The men on it seem to be feeding and fanning a fire. Another pelike, Leagran in period, shows the vase shape itself in use for the retail of oil [212], and both sides carry legends – 'Oh father Zeus, may I get rich', and on the other side with a similar scene, an argument over the filling. The upper part of the vase is restored but the other side shows that palmettes appear over the scenes, as on [210].

Herakles and Trojan scenes are the favourites of the Group, with some subjects being introduced for the first time, others being rendered in a novel manner, sometimes offering views of hitherto ignored moments in familiar stories. Although this is rather in the spirit of the new red figure the scenes are by no means simply borrowed from the red figure repertory and this is basically a different, though parallel tradition for all that Beazley observed the Leagran character of black figure work by some bilinguists (the Nikoxenos and Eucharides Painters).

Other pot painters

The Antimenes Painter and the Leagran series account for a very small proportion of the larger pots, mainly neck amphorae and hydriae, which survive from the last thirty years of the sixth century. Connoisseurship of painters is more difficult in this period of black figure than in any other and I mention here only a few of the artists and groups, distinguished by Beazley. They are chosen for their quality or for their special interest in some forms of decoration or shapes.

First, some involving distinctive or less common shapes. The CLASS OF C.M. 218 comprises variants of the Nikosthenic amphora [214] in which the profile is smoother, omitting the angularity of the canonic form and generally looking more Greek. Pamphaios, Nikosthenes' successor, made two to be painted in red figure by Oltos, and, like the real Nikosthenics, the only proveniences for vases in this class record Caere, so they seem to be firmly in the Nikosthenic tradition and an export ware with a limited market.

The HYPOBIBAZON CLASS (named from the picture of a mounting warrior on an example in Athens) is of belly amphorae which up-date the old form with rounded handles and feet – a type by no means forgotten (it appears in

the Leagros Group) although by now less popular than the Type A amphorae. A line meander over the panels is a distinctive feature, and the figure compositions are equally frugal, but delicately painted, with a penchant for genre scenes other than myth, including oddities like fishermen or men carrying pots [215–6]. Notice the rejected sketch of the dog's hindquarter on the latter. These are of the 510's.

Earlier are some neck amphorae of standard type, but small, with triple lines between the body patterns – the THREE LINE GROUP [217]. Small black figure neck amphorae become very common in later years and their decoration is usually of the poorest, but this group could recall to Beazley the Andokides Painter, and one or two other groups, hardly later than the 510's, are well painted and offer some original neck patterns (as in the Medea Group [218]).

A new shape which is introduced about 520 is the stamnos, well represented in the PERIZOMA GROUP [219], so named for the white loin cloths worn by the flabby athletes and even by the warrior dancers and among the symposiasts with whom the painters of this small but distinctive group are preoccupied. In the same group are some one-handled kantharoi [220], copying an Etruscan shape and destined for the western market, but post-Nikosthenic. And we may notice here a rather later stamnos of different shape [221], a rare example of a variety otherwise confined to red figure.

Of the other painters I mention four of quality. The EUPHILETOS PAINTER [222] is best known for his Panathenaic vases [297–8] where we see his finest work and his capacity for detail – notice the shield devices. It is in the athlete studies on these vases that the transition from the anatomically impossible runners of most earlier painting to the more plausible views of runners with their arms close to their sides can be observed. His other work (it is all mainly of the 520's) is poorer and obsessed with the chariot scenes which seem fashionable in these years.

Hardly much later is the MADRID PAINTER, who is far more conscious of the anatomical detail being offered by his red figure contemporaries, but he executes it in an old fashioned and unconvincing way although he has learnt the new poses (frontal and profile legs for collapsing Kyknos on [223]) and attempts foreshortening (his shield). On the same vase the figures overlap the border pattern and we see still the old style animal predella.

The PRIAM PAINTER is an important and prolific artist, in some ways linking the Antimenes Painter and the Leagros Group. His work is imaginative, for although his interest lies in few themes he treats them in each instance with originality of detail and composition. He is especially fond of the Athenian fountain house scenes [224] and of chariot scenes with Athena and Herakles [225]. These interests seem to reflect some measure of sympathy for the Peisistratids and their use of myth and most may be painted before their ejection from Athens in 510.

The RYCROFT PAINTER [226–7] has more of the red figure artist about him, which may explain his readiness to outline-incise much of his figure work. He likes Dionysiac scenes but his best work, on belly amphorae of Type A, has dignity and presence [226]. Beazley relates him to the Priam Painter and to Psiax, but the 'body' of some of his work bears comparison with Pioneer red figure and he understands how anatomical detail can be translated effectively into black figure: compare [228] by a companion of his (the name vase of the Painter of Tarquinia RC6847) and contrast the Madrid Painter's effort [223].

Bilinguists II

By the last years of the sixth century almost every vase painter of quality in Athens was committed to red figure. There were, however, reasons why some still had occasion to practise the older technique. Among the earliest of the bilinguals there had appeared eye cups, black figure within, red figure outside, decorated by the best of the cup painters – Oltos, Epiktetos, Pheidippos, Skythes and their followers. The scheme remained an extremely popular one throughout the first generation of red figure but barely survives into the fifth century. There was also a demand for Panathenaic vases (see Chapter Seven) which was met by studios which specialised in larger pots. Since the work either was well paid or conveyed prestige, several of the better painters decorated the vases, and among them we recognise the Kleophrades Painter, the Berlin Painter (or his workshop) and, nearer the middle of the fifth century, the Achilles Painter. Of these the first named seems to have been interested in painting some standard black figure neck amphorae and in introducing some black figure onto his red figure vases – for lids or subsidiary friezes, and the Achilles Painter may have decorated in black figure another traditional shape, the loutrophoros.

Apart from these artists, whose interest in the old technique can be at least partly explained by special demand, there are few red figure painters with any notable black figure output. The NIKOXENOS PAINTER has a thoroughly Leagran black figure style on amphorae and pelikai, but his hydriae are the new shape (kalpides, with one-piece profiles). He painted red figure too, without distinction, as did his presumed pupil, the Eucharides Painter. The latter, however, has been credited with several Panathenaic prize vases as well as pelikai [229] and kalpides, and it has been suggested that these might all be taken for the Nikoxenos Painter's work, which would make him another of those with reason for keeping up black figure. The ATHENA PAINTER, a distinguished artist who worked in black figure mainly on lekythoi and oinochoai (see the next chapter), has been identified with the Bowdoin Painter, who was painting red figure and white ground lekythoi in the second quarter of the fifth century, but the connection may be a matter of workshop

only. The use of white ground and of outline techniques on black figure lekythoi of the early fifth century bring these vases very close to the spirit and technique of red figure, and the fine fifth-century tradition of white ground funerary lekythoi, although the work of red figure artists, was born in the studios of painters of black figure lekythoi. Of these, and of the Athena Painter, there will be more to say in the next chapter. I show only one white ground oinochoe [230] which illustrates well the rather metallic details of the shapes often reserved for this technique (the moulded head at the handle and the collar) and the way in which full value is given to large areas of plain, glossy white.

Lekythoi

Active, if often illicit excavation in Attica and Boeotia, and the common ancient practice in these areas of offering lekythoi in graves, have meant that we have a fuller record of Athenian black figure lekythoi of the late sixth and early fifth century than of most other classes of Athenian black figure vase. It has also meant that the average quality of these vases is low and, since the finest vase painting was done in red figure by now, the contrast with the earlier vases, best known from the fine pieces exported to Italy, is the greater.

The coming of red figure sees the introduction of a new variety of the shoulder lekythos, as [233], with a taller cylindrical body, giving a deeper field for the artist's work, and often with a stepped profile to the foot, but the old shoulder lekythos with tapering body dies hard, and a compromise shape with gently swelling body and echinus foot has a vogue. Normally now there is a band of pattern above the body scene. On the shoulder the row of buds is now usually pendant or we see a chain of seven full palmettes of the new type [231], not growing vertically from chains as in black figure.

Important innovations are introduced by the Edinburgh Painter about 500, but these are best considered in the next chapter and there are few artists or classes still sixth-century in date or manner which deserve mention. Several of the Leagros Group artists decorate lekythoi. Among them is the DAYBREAK PAINTER who has a good eye for detail and a sense of colour [231]. Like other lekythos painters he also decorates oinochoai and especially the new variety of olpe with a slim body and high decorated lip [232]. The CACTUS PAINTER is also capable of a delicacy we miss in much Leagran work. He is named for the prickly pears on his palmette tendrils [233]. The GELA PAINTER [234–6] starts a long career here too, but most of his vases are fifth-century and are influenced by the new fashions. Although his style may often be slipshod he shows an original approach to myth and genre scenes, and can compose as for the larger field of more expensive vases. On the shoulders of his lekythoi the outer buds are normally replaced by flowers. A very high proportion of his vases seem to have been sold in the Western Greek colonies.

Stock vases of the end of the century are represented by the PHANYLLIS GROUP which retains the old tapering shape, sometimes with a patterned neck and the old vertical palmettes (and lotuses reduced to lines like rays or leaves) on the shoulder [237]. The style of painting varies enormously but is seldom more than adequate. Some originality of theme is attempted but there is a lot of near mass production of stock scenes like arming, a warrior leaving home, Dionysos between eyes. This is true too of the COCK GROUP, named for the usual cock and ivy leaves on the shoulder, but these last well into the fifth century. The Medea head (her name is lightly inscribed before her) [238], looks as old fashioned as the Athenas on contemporary coins, and the rosettes above her are an archaising feature.

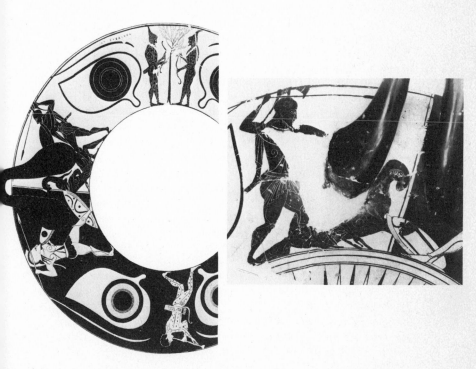

160.1,2 *Eye cup by the Andokides Painter, signed by Andokides*

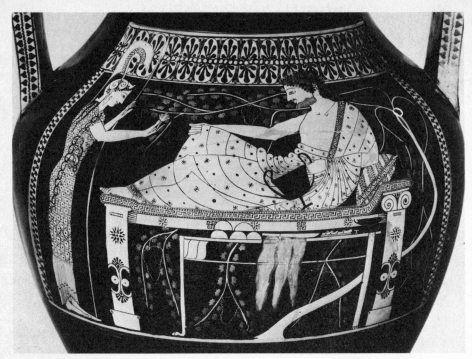

161 Belly amphora (Type A) by the Andokides Painter. 161.1: Red figure – Athena and Herakles.
161.2: Athena and Herakles

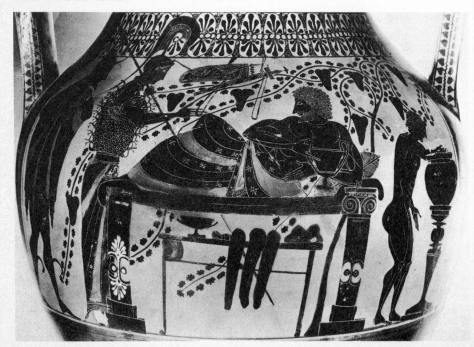

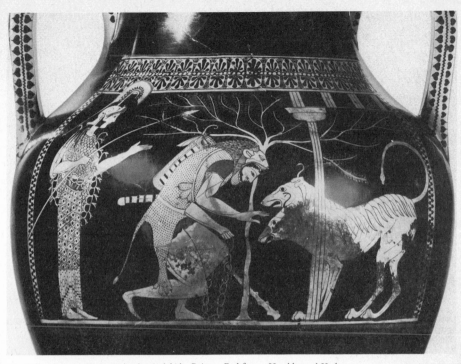

162 Belly amphora (Type A) by the Andokides Painter. Red figure. Herakles and Kerberos

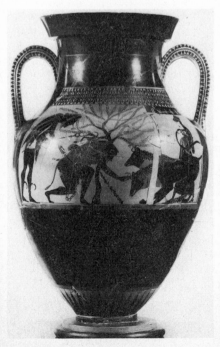

163.1,2 Belly amphora (Type A) by the Andokides Painter. Herakles and Kerberos. H. 56

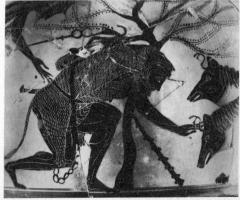

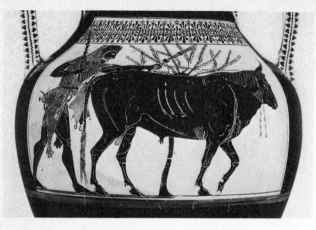

164 *Belly amphora (Type A)
by the Andokides Painter.
Herakles leads a bull to
sacrifice*

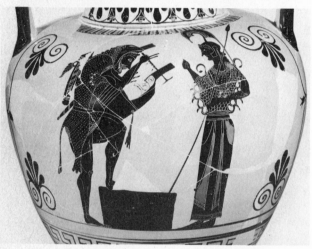

165 *Neck amphora by the
Andokides Painter. Herakles
with a kithara, and Athena*

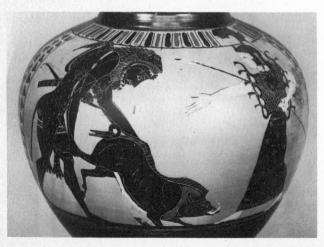

166 *Oinochoe by the Andokides
Painter. Herakles with the
Erymanthian Boar*

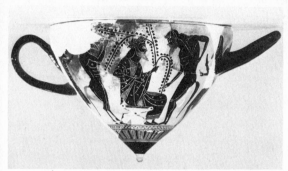

167 Mastos by the Mastos Painter (name vase). Dionysos and
satyrs. H. 10

169 Plate by Psiax

168 Belly amphora (Type A) by Psiax. Herakles' chariot

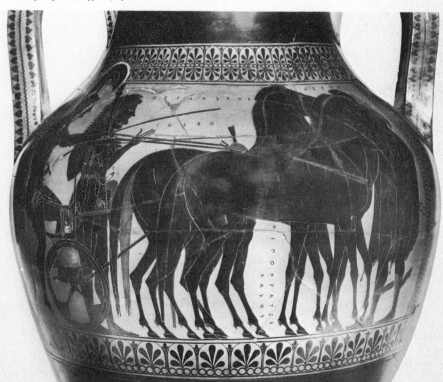

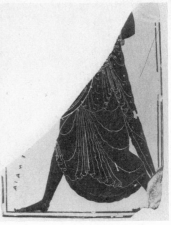

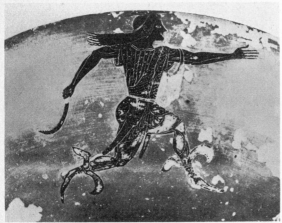

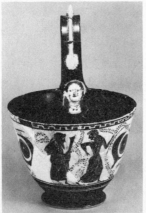

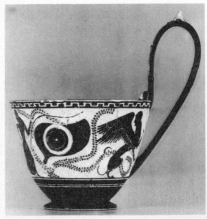

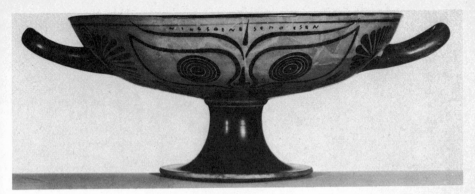

173 *Eye cup signed by Nikosthenes. H.* 10·5

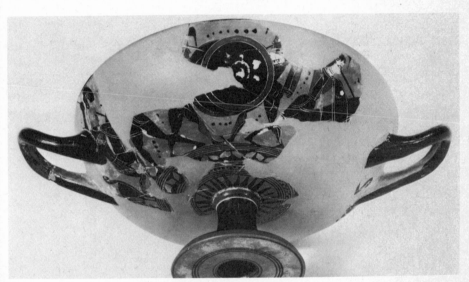

174 *Cup by the Wraith Painter. Amazonomachy. H.* 8·3

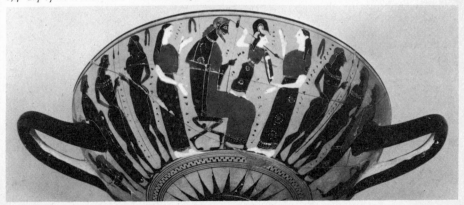

175 *Cup by the Painter of the Nicosia Olpe. The Birth of Athena*

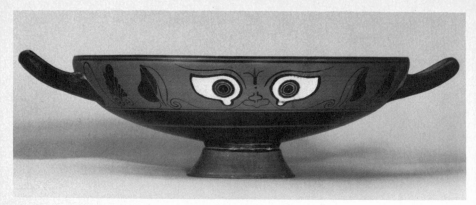

176 *Chalcidising eye cup. H. 9·5*

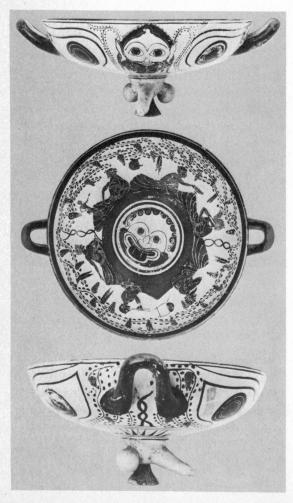

177.1,2,3 *Eye cup in the manner of the Andokides Painter. Satyr mask*

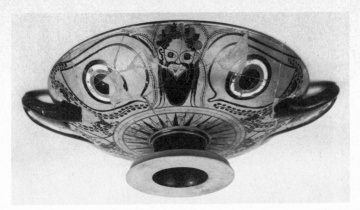

178 Eye cup of the Group of Walters 48.42 (name vase). Dionysos mask

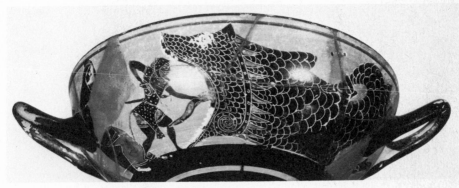

179 Cup. Herakles rescues Hesione from the sea monster

180 Cup. Warship and merchantman

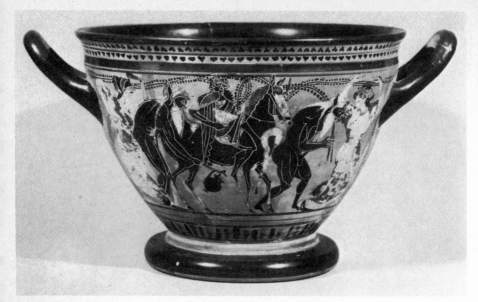

181 *Skyphos by the Krokotos Painter. Dionysos with satyrs and maenads.* H. 16·2

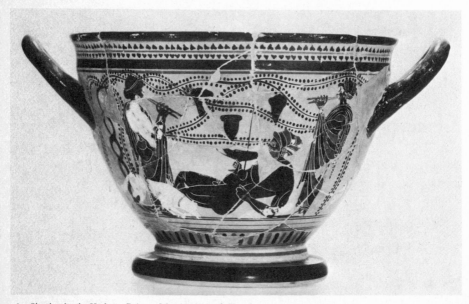

182 *Skyphos by the Krokotos Painter. Man in vineyard.* H. 25·9

183.1,2 *Cup of the Group of Courting Cups. H. 8·4*

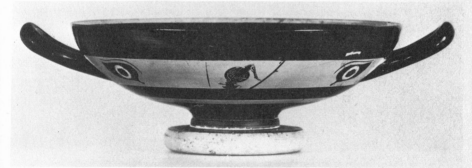

184 *Cup (Type C) of the Class of Topband Stemlesses. Warrior acrobat. H. 5·5*

185.1,2 *Cup of the Segment Class. W. 17*

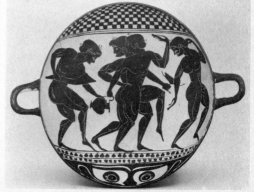

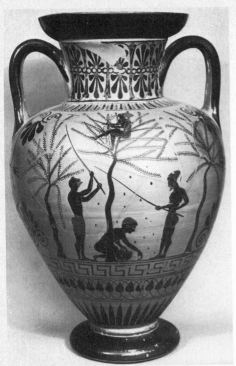

186 *Neck amphora by the Antimenes Painter. Olive harvest. H. 40·3*

187 *Neck amphora by the Antimenes Painter. Warrior's departure with extispicy (omen-taking from entrails)*

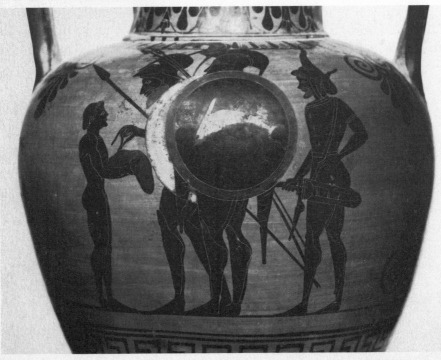

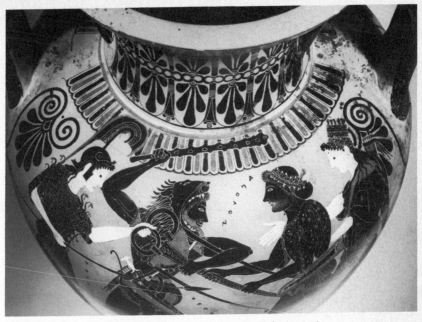

188 *Neck amphora by the Antimenes Painter. Herakles fights Apollo for the tripod*

189 *Neck amphora by the Antimenes Painter. Herakles fights the lion*

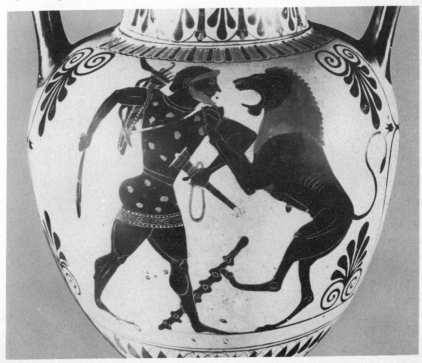

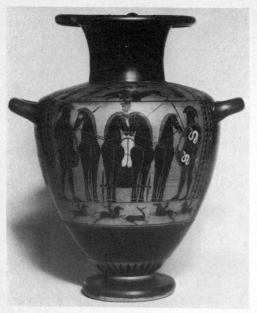

190 Hydria by the Antimenes Painter

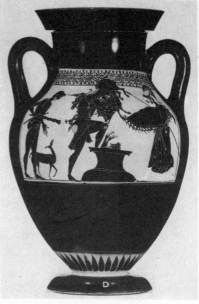

192 Belly amphora in the manner of the Antimenes Painter. Herakles delivers the Erymanthian Boar to Eurystheus. H. 52·8

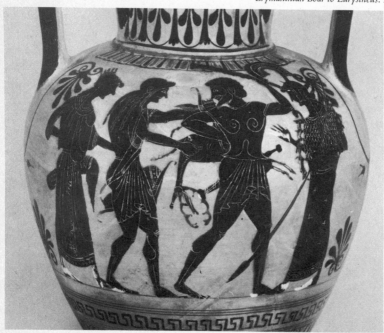

191 Neck amphora of the Group of Würzburg 199 (name vase). Herakles fights Apollo for the deer

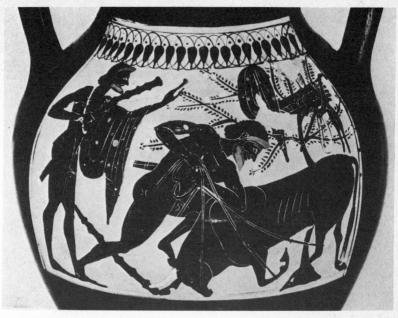

194 *Belly amphora of the circle of the Antimenes Painter. Herakles fights the Cretan Bull*

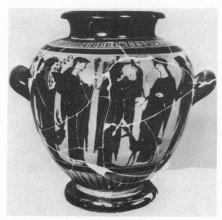

193 *Stamnos related to the Antimenes Painter. Gods. H. 32*

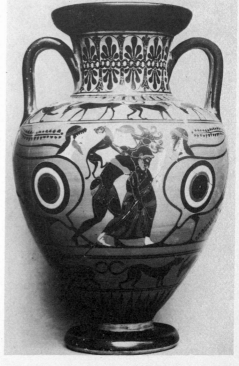

195 *Neck amphora of the Eye-siren Group (name vase). Peleus wrestles with Thetis. H. 39*

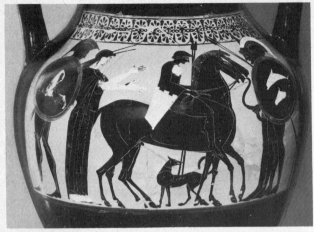

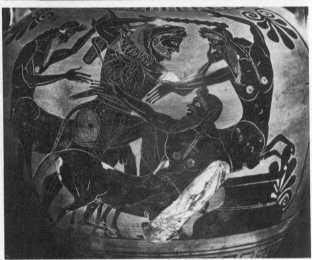

196 Belly amphora of the
Group of Toronto 305.
A warrior leaves home

197 Neck amphora of the
Group of Toronto 305.
Herakles with Pholos and other
centaurs

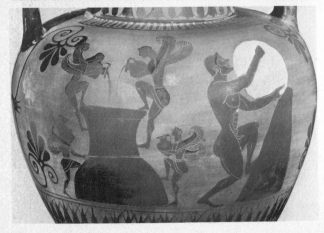

198 Neck amphora by the Bucci
Painter. Souls pour water;
Sisyphos rolls his stone in
Hades

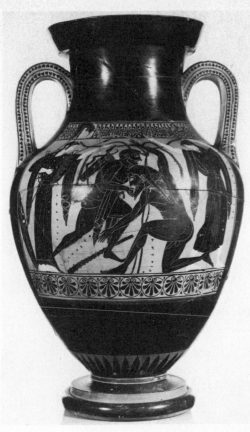

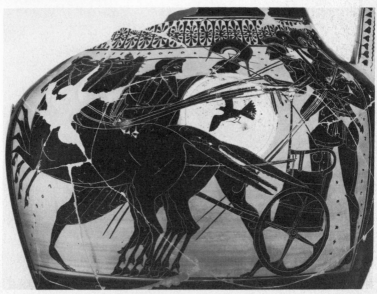

199 Belly amphora (Type A) of the Leagros
Group. Herakles fights Antaios. H. 63

200 Belly amphora (Type A) of the Leagros
Group. Theseus carries off the Amazon
Antiope

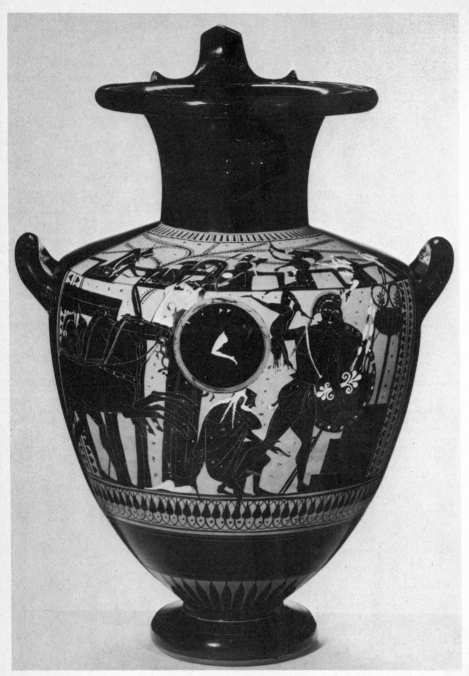

201 *Hydria of the Leagros Group. Achilles slays Troilos before Troy. H. 47·5*

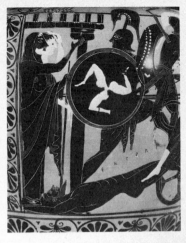

202 (left) *Hydria of the Leagros Group.*
Herakles fights Nereus. H. 47·5

203 (above) *Hydria of the Leagros Group.*
Achilles prepares to drag Hector's body round
Troy

204 *Hydria of the Leagros Group. Achilles*
carries the dead Penthesilea (?)

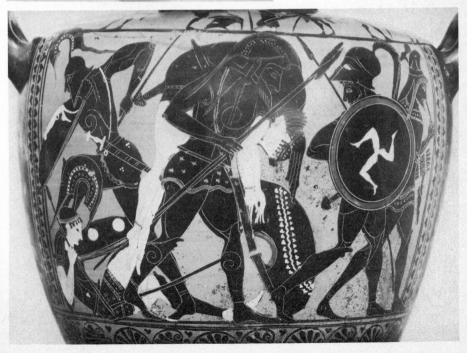

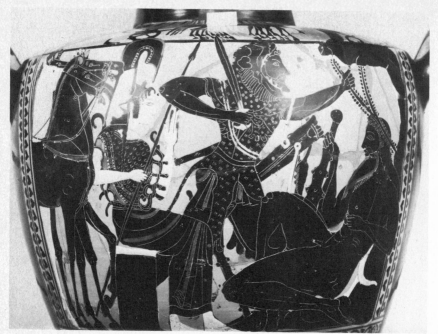

205 Hydria of the Leagros Group. Herakles kills the sleeping Alkyoneus

206 Hydria of the Leagros Group. Gods fight Giants

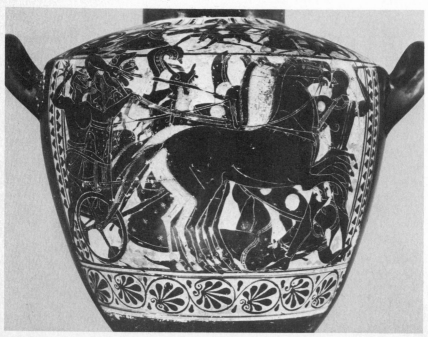

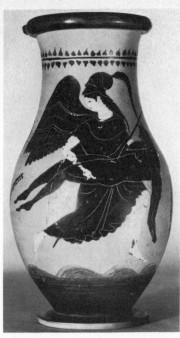

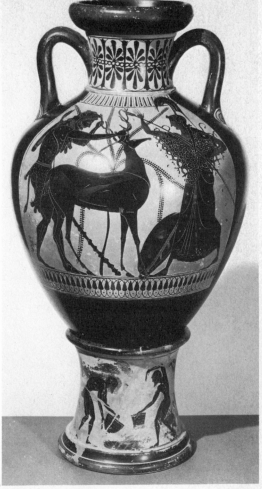

207 *Olpe of the Leagros Group. A winged Athena carries a body over sea (or Eos and Memnon?). H. 22·5*

209 *Pointed amphora by the Acheloos Painter on a stand by another artist. Herakles captures the Kerynitian Deer. H. 65*

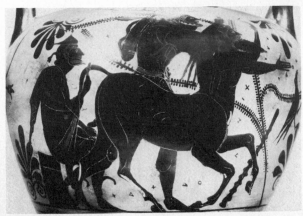

208 *Neck amphora by the Acheloos Painter (name vase). Herakles fights Acheloos*

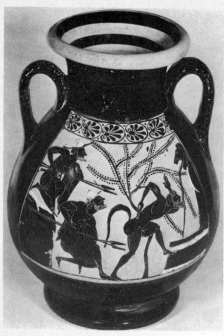

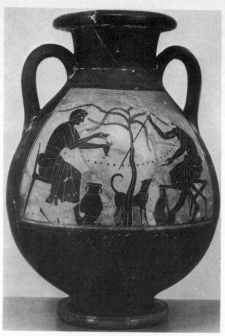

210 Pelike by the Acheloos Painter. The capture of Silenos. H. 31

212 Pelike. Sale of oil. H. 37·8

211.1,2 Pelike by the Acheloos Painter. H. 32·5

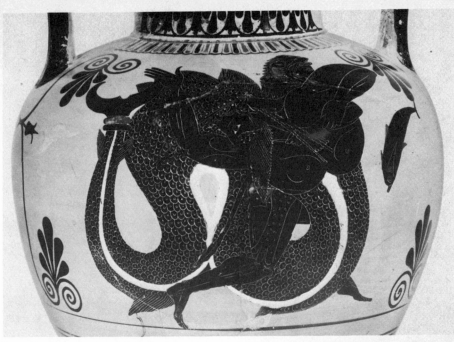

213 Neck amphora by the Chiusi Painter.
Herakles fights Triton

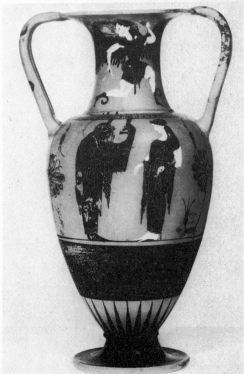

214 Neck amphora of the Class of Cab. Méd. 218.
Apollo and a goddess. H. 30·5

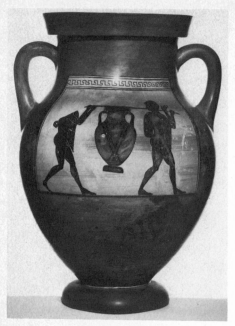

215 *Belly amphora of the Hypobibazon Class. H. 56*

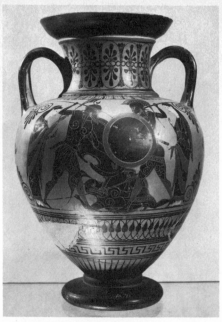

217 *Neck amphora of the Three-line Group. Achilles fights Memnon (?). H. 23*

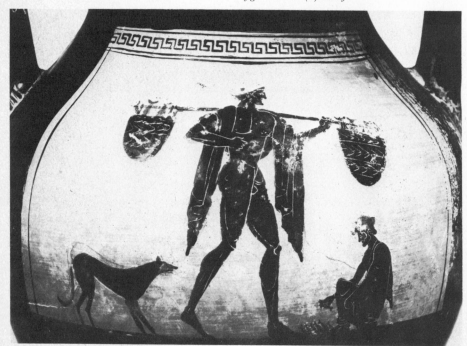

216 *Belly amphora of the Hypobibazon Class. Fishermen*

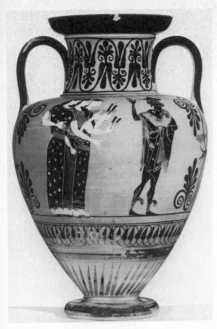

218 Neck amphora related to the Medea Group.
Hermes and goddesses. H. 31

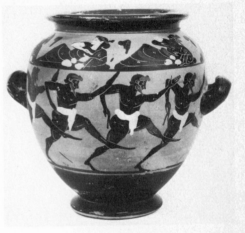

219 Stamnos of the Perizoma Group. H. 17·3

220 One-handled kantharos.
Funeral procession. H. 19·3

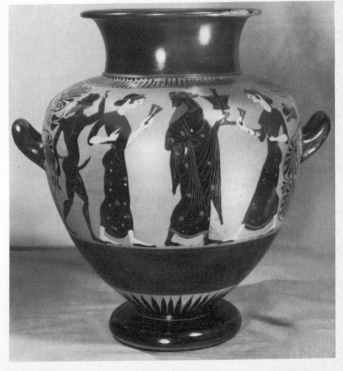

221 Stamnos. Dionysos and
satyrs. H. 34

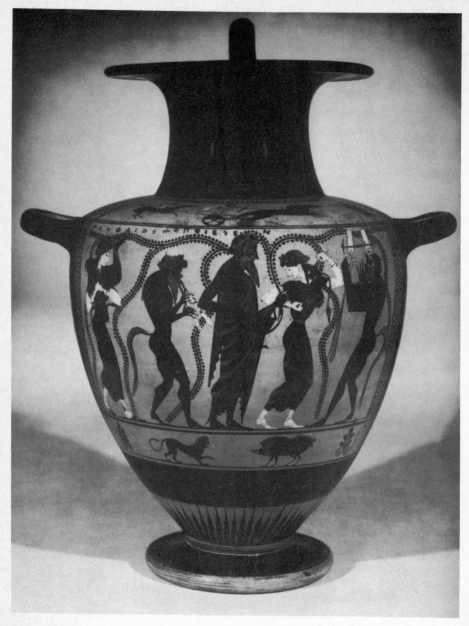

222 *Hydria by the Euphiletos Painter, signed by Pamphaios as potter. Dionysos with satyrs and maenads. H. 40·6*

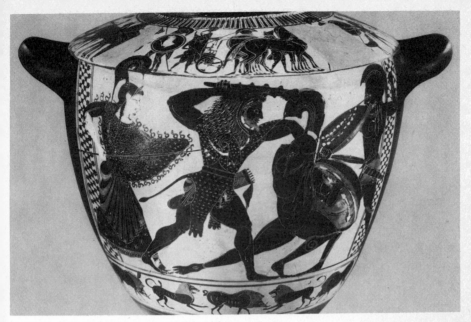

223 Hydria by the Madrid Painter. Herakles fights Kyknos

224 Hydria by the Priam Painter.
Fountain house in Athens. H. 57·5

225 Belly amphora (Type A) by the Priam Painter. Athena and
Herakles, harnessing a chariot

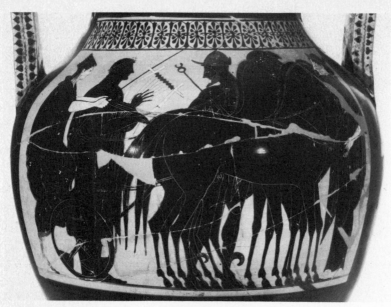

226 *Belly amphora (Type A) by the Rycroft Painter (name vase). Leto's chariot*

227 *Calyx crater by the Rycroft Painter. Achilles and Ajax play. H. 40*

228 Belly amphora (Type A) by the Painter of Tarquinia RC 6847 (name vase). Herakles fights Apollo for the tripod

229 Pelike by the Eucharides Painter. Cobblers. H. 40

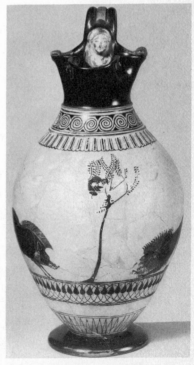

230 Oinochoe by the Painter of London B 620.
White ground. Peleus up a tree. H. 25

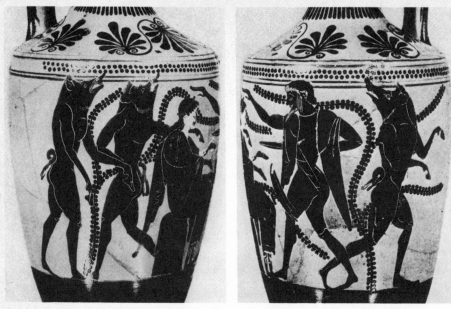

231.1,2 Lekythos by the Daybreak Painter. Circe, Odysseus and his transformed companions

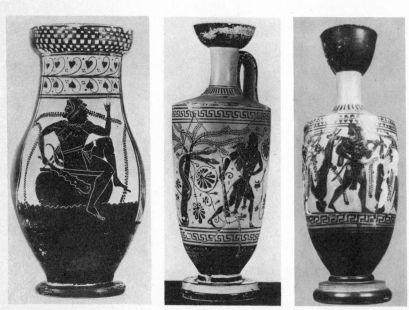

232 Olpe by the Daybreak Painter. Herakles in the bowl of the sun. H. 21·9

233 Lekythos by the Cactus Painter. Herakles at the Tree of the Hesperides. H. 27

234 Lekythos by the Gela Painter. Herakles with the Kerkopes

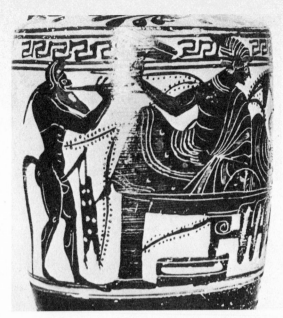
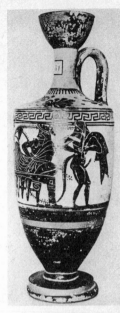

235.1,2 *Lekythos by the Gela Painter. White ground. Dionysos and Ariadne at feast. H. 29·4*

236 *Lekythos by the Gela Painter. White ground. Head of Athena crowned by Nike. H. 30·3*

237 *Lekythos of the Phanyllis Group. Arming. H. 32*

238 *Lekythos of the Cock Group. Head of Medea*

Chapter Six

THE LATEST BLACK FIGURE

From about 500 to at least the middle of the fifth century a considerable number of black figure vases were still being made in Athens, despite the fact that red figure was by then well established as the prime technique, and virtually no other figure decorated pottery was being produced in the Greek world. With rare exceptions in the first quarter century the quality of the black figure is low, and we can see that it satisfied a demand for cheap cups, jugs and oil flasks at a time when the pottery industry in Athens was booming but the finer red figure was probably beyond the purse of poorer citizens. There was, therefore, no demand for the larger craters, amphorae and hydriae in the old technique, to furnish the symposia of the well-to-do, yet black figure persisted far longer than can be explained in terms of the conservative taste of the elderly. The export market for these poor wares in Greece and beyond Greece remained strong. Here conservatism may well have played a part since the export of Attic pottery to other Greek towns, to Cyprus and to colonies in the north and west, did not abate, yet for the first fifty years after the invention of red figure this trade is very largely taken up by black figure vases, while only the major markets of Etruria and Campania (and to a lesser extent Naucratis) showed a marked preference for the new style. During the years surveyed in this chapter Athens' new democracy was tested by invasion, her city and temples sacked and burned by the Persians in 480. These dire events had no perceptible effect on the production of black figure vases or on the scenes painted on them, but the disaster left some valuable archaeological dating points in the debris of the city, while the tomb mound at Marathon, fought in 490, makes its contribution to chronology too.

It is the lekythos painters that we have to follow, since the lekythoi left the most prolific series for classification, but these painters decorated other shapes too, and some even preferred other shapes. Swift production for a brisk market led to specialisation, and there is little of either art or craft in most of the black figure of these years. The poorer work will not be ignored here, because it is plentiful, but its subject matter is repetitive. Some of the better artists could show flair still, and originality in the treatment of old or the invention of new themes, and so to them most of the following pages and pictures are devoted.

The lekythos painters

The EDINBURGH PAINTER is the first important painter of the large cylinder lekythoi [239–242]. His style derives directly from that of the Leagros Group, but when he decorates vases other than lekythoi they are small neck amphorae [243–4] or lekane lids, rather than the larger vases favoured by the Group, of which we have only one or two from his hand. Soon after the start of his painting career he introduced two innovations. First is the trivial but easily detectable one of reducing the number of palmettes on the lekythos shoulder from seven (characteristic of the Leagros Group) to five [241]. The other is more important – the use of a thick white ground for the body picture [241–2] instead of the customary red clay ground [239, 240]. The white ground becomes regular now for all the finer lekythoi as well as many of the simpler, patterned vases, and it is introduced for some other shapes like the oinochoai and small neck amphorae decorated by the lekythos painters. It makes a nonsense of painting women's flesh white, so these parts are normally now left black on white ground vases. The Edinburgh Painter's style is clear, simple and uncluttered, the expression of his actors rather vacant with big round eyes. He is capable of delicacy of detail but real finesse is no longer to be looked for in black figure. His range of myth and genre scenes is notable and on late black figure is only rivalled by his immediate companions and successors whose work we next consider.

The GELA PAINTER, whose earlier vases have already been noticed, is influenced by the new styles, but clings to his preference for flowers, beside the reduced number of palmettes on lekythos shoulders, and may introduce palmettes beside the figure scenes. I show two of his later vases, both white ground [235-6].

The Theseus and Athena Painters were colleagues, working in a related style on related shapes, and taking their lead from the Edinburgh Painter in the matter of the use of white ground and the new scheme for decoration of the lekythos shoulders. But each had wider interests and a more varied career than their Leagran mentor. The THESEUS PAINTER started his career as the best painter of the White Heron skyphoi whose immediate predecessors we have seen in the Krokotos Group [181–2]. A white heron is painted by the handles of many of these skyphoi (but not all white herons are his) and there is the same distinctive use of yellow, at least for hair, which gave the Krokotos Group its name. His skyphoi [245–7] are from his early years, perhaps mainly before 500, and more of them are preserved than of his lekythoi. The latter lacked something in the elegance of the figures on his skyphoi, but show the same firm hand with stocky bodies, round heads. He has a good eye for animals, some imagination when it comes to monsters, and was one of the first of the black figure artists to take much notice of the new vogue for Theseus scenes [245, 249], whence his name.

The ATHENA PAINTER [250–5] was more wholly dedicated to the decoration of lekythoi and oinochoai, and must have started his career later. If he in fact also painted red figure (hitherto known as the work of the Bowdoin Painter) specialising in lekythoi either in the usual technique or with outline figures on a white ground, he was working still through or beyond the second quarter of the century. He had learned the use of white ground from the Edinburgh Painter and had some minor innovations of his own to contribute to the standard decoration of black figure lekythoi, adding tendrils with thin closed buds to the five shoulder palmettes, blacking some necks [251], outlining the upright bars (debased tongues) above the shoulder, dispensing with a ground line. His best work has the dignity of the best Leagran; the rest have a simple, lively quality, sometimes mannered in detail, the figures tending to the egg head. He puts some fine large heads on his jugs [254] and lekythoi, and his devotion to scenes with Athena gives him his name. His choice of subject was varied and sometimes original. From his workshop come a number of black bodied lekythoi, and a great many oinochoai of varying merit, mainly white ground, as well as the later red figure lekythoi (Bowdoin Painter).

There was room for several different workshops producing black figure lekythoi in Athens of the early fifth century. Beside the painters of the larger cylinder lekythoi there were many others, generally more prolific and making smaller more repetitive vases, but keeping alive, although in terminal condition, a tradition in black figure which was to last to the mid century.

A large group of the early fifth century, the CLASS OF ATHENS 581, stands on its own, and centres on the work of the Marathon Painter [256–7] who supplied many of the lekythoi deposited in the tumulus raised over those who fell in the battle of 490. The shapes are generally old fashioned, tapering steadily to the foot. The MARATHON PAINTER has a sense of colour and pattern, introducing pattern bands on some vase necks and lower walls, and varying the areas of the vase to be covered by white ground, but the earlier vases, as those from Marathon, were mainly clay ground. The shoulders of lekythoi in this Class [258–9] carry palmettes, buds or rays, the figures are generally flimsy and carelessly executed, the backgrounds often full of leafy branches, a style continued on the Haimonian lekythoi (see below). There are also many examples of 'palmette lekythoi' decorated only with the old black figure lotus and palmette frieze.

There were other and better painters of small lekythoi in these years, and at their head stand the Sappho and Diosphos Painters, humbler cousins of the Edinburgh Painter and influenced by his work. They too preferred the smaller lekythoi, often rather old fashioned in shape and keeping the old bud frieze on the shoulders, but admitting white ground. The SAPPHO PAINTER [260–6] is the more interesting and inventive artist. For his name vase see [311]. He decorated some larger vases, even a column crater, and other

shapes including epinetra for wool workers [263]. He had a particular inter-
est, it seems, in funeral scenes, and gives us a good conspectus of contempo-
rary practice on funerary plaques for attachment to tombs [265], a 'bail-
vase' [266] and loutrophoroi [264] – a ritual shape for which the old tech-
nique was long retained (the Theseus Painter also decorated some). His figures
have a sprightly quality which compensates for the often hurried incision.
Although not illiterate he sprinkles the field freely with distinctive nonsense
inscriptions. A variety of small lekythos which he may have invented (or
which may have been invented for him) has a tapering body incurving
sharply above the foot [261–2] and sometimes decorated with lions on the
shoulder; however, most of this numerous LITTLE LION CLASS are not by
his hand but by colleagues, and there are many others of the Little Lion
shape with other shoulder patterns (e.g. hound and hare).

The DIOSPHOS PAINTER [268–272] was a slighter artist with a poorer
repertory, his figures big headed, slim but lively, although he had a bolder
style for a few lekythoi. Some of his best work is on alabastra [268], and he
specialised also in small neck amphorae. His later lekythoi become slimmer.
On some he introduces figures between large palmettes and parts of the
figures are drawn in outline [269]. This 'semi-outline' technique was no
doubt influenced by the white ground lekythoi of the Athena Painter or other
red figure artists. He was probably working still in the mid fifth century.

The HAIMON PAINTER was an industrious younger contemporary of the
Sappho and Diosphos Painters. He painted small, slim lekythoi, with the
double reserved line in the lower black area [273] which the Diosphos Painter
may have popularised. His slim figures stand or posture aimlessly in a field of
branches. The cup-like lips of lekythoi had been beginning to flare slightly,
and a rather sudden innovation is to make them tall and mainly concave sided.
The Haimon Painter decorates some of these 'chimney-lekythoi'. He has a
prolific 'Haimonian' following. Some of the other shapes he and his compan-
ions decorate show a different interest from that of the lekythos painters so
far discussed. There are mastoid cups [274], with or without handles; a
variety of footed cups, usually with a single figure tondo, and cup sky-
phoi [275]. On these the large handle palmettes have long, knobbly leaves.
The figures range from poor to execrable, the subject matter is repetitive and
the painter's companions regularly dispense with white ground, while in
other closely related groups even incision is abandoned.

The workshop of the BELDAM PAINTER, also active into the second quarter
of the fifth century, offers the last important group of black-figure vases to be
produced in quantity in Athens. It is closely linked with the Haimonian series,
continuing the tradition of small thin lekythoi, the poorest bearing the
chimney mouth [278–9], sharp shoulders and a high blunt foot. The painter
himself was capable of better work than the Haimon Painter on large lekythoi
with incurving necks and early in his career. An example is his name vase

where a nameless harridan is being tortured by satyrs [277]. He put ivy on the neck of some other lekythoi too, and these include some with purely outline figures and funeral scenes – among the first of the great series of Athenian white ground funeral lekythoi. His smaller lekythoi are also superior to the Haimonian, with much use of white, and added use of white ground, sometimes only beneath the pattern friezes. A speciality was pattern lekythoi [280], white ground with floral or chequer patterns (also made in other workshops and throughout the century), and palmette lekythoi which continued the tradition of the Class of Athens 581.

Other late work

A very few standard neck amphorae were still being decorated in black figure after the Persian wars. Most fifth-century examples of this shape, painted in the old technique, are small vases. A few (doubleens) have only double reeded handles, not treble, and many carry white ground on all or part of the vase as did the lekythoi. Of the lekythos painters the Edinburgh and Diosphos Painters also decorated small neck amphorae [243–4; 271–2], usually with three palmettes on the necks and some with panels for the body pictures. Several painters and classes have been distinguished, most of which require no mention. I name only one of the earliest, the RED LINE PAINTER, who sometimes outlines the pattern band below his pictures in red [282]; and the DOT BAND CLASS, named for the pattern beneath the pictures. Both of these have Leagran connections and the Edinburgh Painter decorated examples of the latter [244].

Oinochoai and olpai were other favoured shapes of the Athena Painter. The many other examples of the first quarter of the fifth century are seldom white ground. I mention the KEYSIDE CLASS [285–6] (most of which do not have this border pattern), the ALTENBURG CLASS [284], and the CLASS OF VATICAN G47 [287] which include some good genre scenes. The tall olpai acquired a patterned lip before 500 [232]. Some oinochoai have flat mouths [288] instead of trefoil, and a few are red bodied with no painting below the figures.

The successors to the black figure eye cups are numerous but undistinguished. Some early in the century carry a black lip, following the scheme of band cups (TOP BAND CLASS) and several simply carry lotus and palmette friezes in the old manner. The latter type continues to be made right through the fifth century to judge from finds in Athens and in Corinth, some still with slightly out-turned band cup lips. The eye cup scheme was continued in the LEAFLESS GROUP, named for the stripped branches which appear in the fields of many examples. They have gorgoneion or single figure tondos, and below their handles lurk dolphins, birds or leaves [290]. Most, however, dispense with eyes and present a weary repetition of Dionysiac scenes, generally of the

slightest merit [*291*], but on the whole better than the similar but mainly later Haimonian cups. The Leafless style is traced on kyathoi and mastoid cups, which also had a more distinguished record in the late sixth century, and on skyphoi. The Theseus Painter had worked on skyphoi and in the Heron Class to which he contributed there was a succession of far poorer quality. Better are the mastoid cups with feet and ordinary cup handles, of the PISTIAS CLASS [*294*]. Among the skyphoi have been distinguished the CHC GROUP, the figures being set in narrow bands and commonly showing a chariot wheeling round [*292*] or a courting scene (the initials of these subjects name the group). Of larger works the Sappho Painter's funerary vases have been remarked already and we may add (not by him) a late lebes gamikos [*293*], another shape with ritual connections for which the old technique was retained, as it was for some loutrophoroi to the mid century.

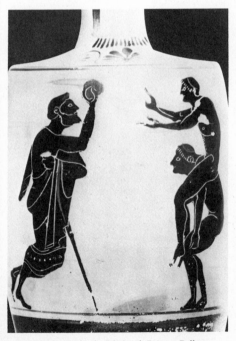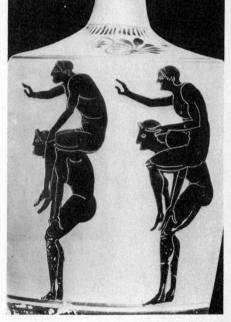

239.1,2 *Lekythos by the Edinburgh Painter. Ball game*

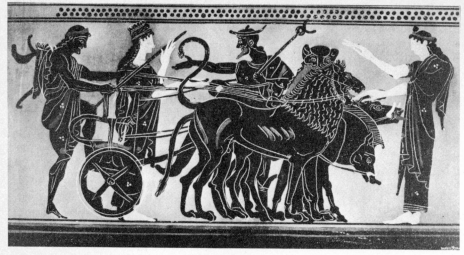

240 *Lekythos by the Edinburgh Painter. Apollo harnesses Admetos' chariot*

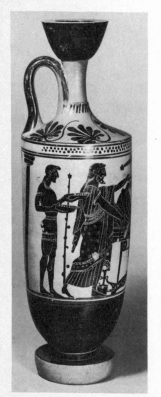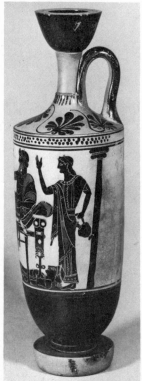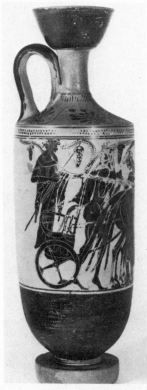

241.1,2 *Lekythos by the Edinburgh Painter (name vase). White ground. Priam ransoms the body of Hector from Achilles*

242 *Lekythos by the Edinburgh Painter. White ground. Dionysos' chariot. H. 34*

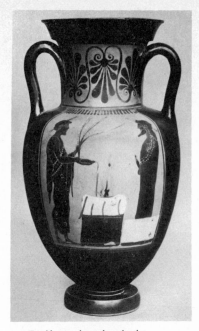

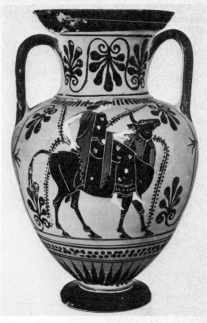

243 Doubleen neck amphora by the
Edinburgh Painter. A man before an altar
and a herm. H. 27·6

244 Dot-band Class neck amphora by the
Edinburgh Painter. Europa on the Bull

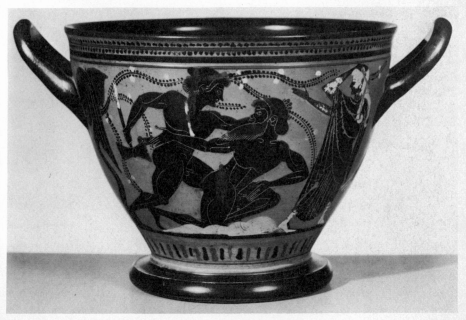

245 Skyphos by the Theseus Painter. H. 17. 245.1: Theseus fights Procrustes.

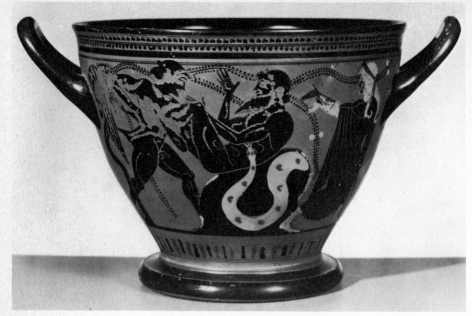

245.2: *Theseus fights Sinis*

246 *Skyphos by the Theseus Painter. A satyr, Herakles and Athena. H. 17·5*

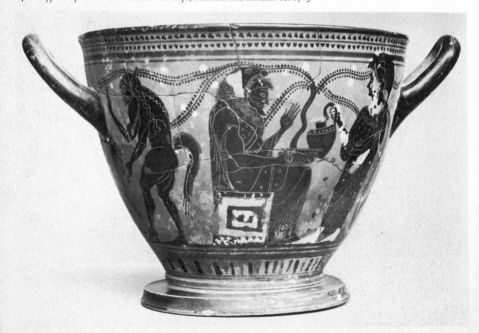

247 *Skyphos by the Theseus Painter. The ship car of Dionysos*

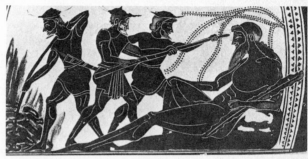

248 *Oinochoe by the Theseus Painter. The blinding of Polyphemos*

249 *Oinochoe by the Theseus Painter. White ground. Theseus with the Bull of Marathon. H. 18·5*

250 *Lekythos by the Athena Painter. White ground. Poseidon on a sea horse. H. 30·3*

251 *Lekythos by the Athena Painter. Sleep and Death carry the body of Sarpedon. H. 41*

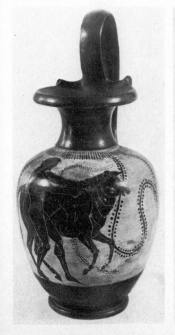

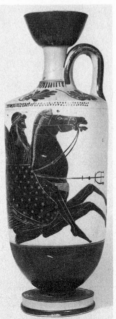

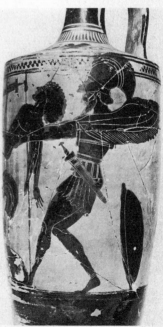

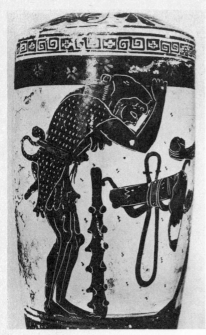
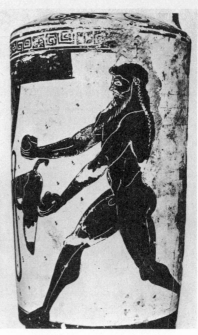

252.1,2 Lekythos by the Athena Painter. White ground. Herakles and Atlas

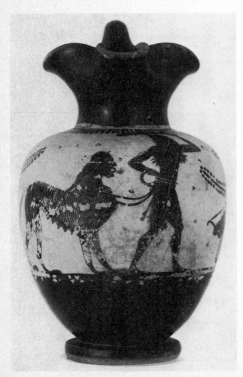

254 Oinochoe by the Athena Painter. H. 11

*253 Oinochoe by the Athena Painter. White ground,
Herakles leads a monster. H. 22*

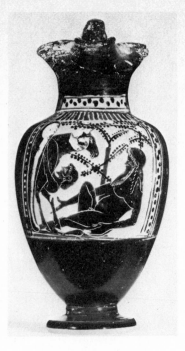

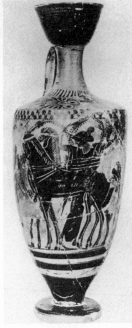

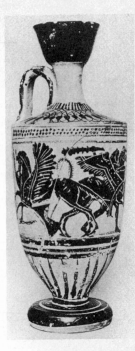

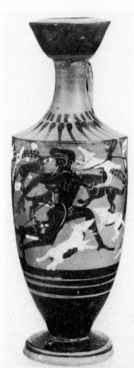

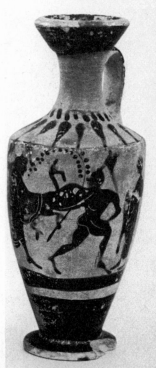

255 *Oinochoe by the Athena Painter.*
Escape from the Cave of Polyphemos.
H. 19·5

256 *Lekythos by the Marathon*
Painter. Chariot of Dionysos. H. 26

257 *Lekythos by the Marathon*
Painter. White ground except shoulder.
Herakles and the Horses of Diomed.
H. 19·8

258 *Lekythos of the Class of Athens*
581. Aktaion torn by his dogs. H. 16

259 *Lekythos of the Class of*
Athens 581. Athena fights a Giant

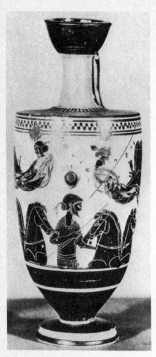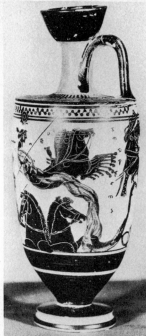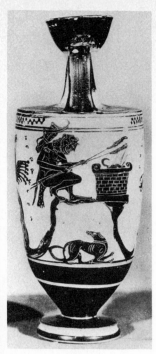

260.1,2,3 *Lekythos by the Sappho Painter. White ground. Herakles' dawn sacrifice.* H. 17·5

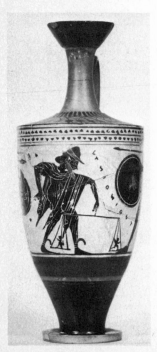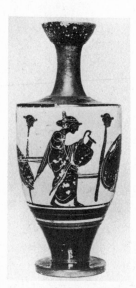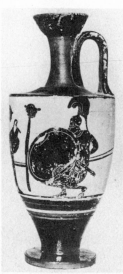

262.1,2 *Lekythos by the Sappho Painter (Little Lion Class).
White ground body scene. Achilles (bis) ambushes Polyxena.*
H. 11·8

261 *Lekythos by the Sappho Painter (Little Lion Class). White ground body
scene. Hermes weighs souls (psychostasia).* H. 14·6

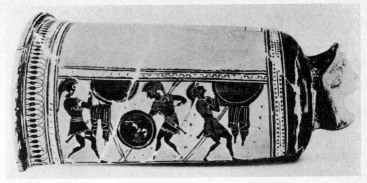

263 Epinetron by the Sappho Painter. Amazons arm. L. 29

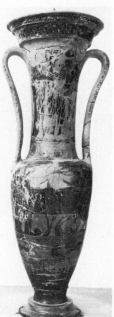

264.1,2 Loutrophoros by the Sappho Painter. Mourning and interment. H. 64

265 Funerary plaque by the Sappho Painter. Laying out the dead (prothesis). W. 26·5

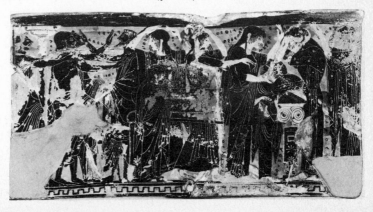

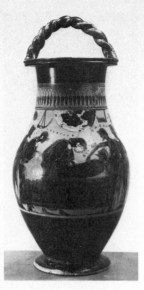

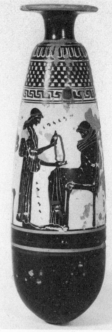

266 Bail-handled vase by the
Sappho Painter. The dead
consigned to his coffin

267 Nikosthenic pyxis. Wedding procession

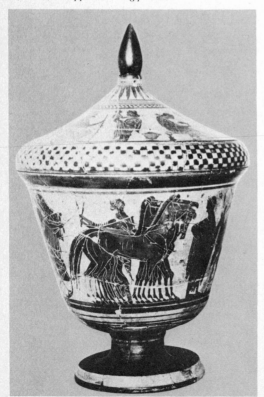

268 Alabastron by the Diosphos Painter.
White ground. H. 17

269 Lekythos by the Diosphos Painter. White
ground body scene. Perseus flees from Medusa
who bears Pegasos. H. 25·5

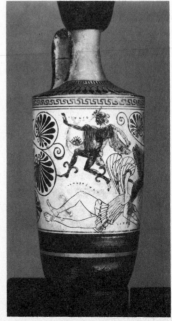

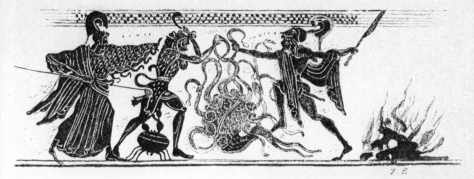

270 *Lekythos by the Diosphos Painter. White ground, Herakles fights the Hydra*

271 *Doubleen neck amphora by the Diosphos Painter. Eos carries Memnon*

272 *Neck amphora by the Diosphos Painter (name vase). Zeus with the infant Dionysos (?)*

273 *Lekythos by the Haimon Painter. White ground body scene. The Sphinx carries off a Theban youth (Haimon?)*

274 Mastoid cup by the Haimon Painter. Herakles with the Cretan Bull. H. 8

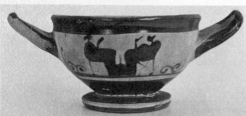

275 Cup skyphos of the Haimon Group

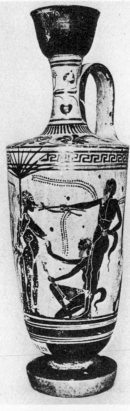

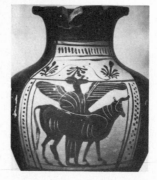

276 Hydria (kalpis) by the Haimon Painter. Nike with a bull

277 Lekythos by the Beldam Painter (name vase). Satyrs torture a woman. H. 31·7

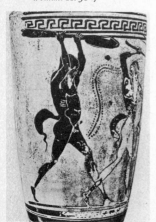
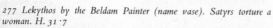
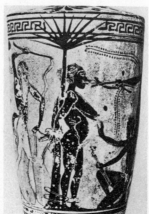

278.1,2 *Lekythos by the Beldam Painter. The daughters of Pelias boil a ram. H. 22·5*

279 *Lekythos by the Beldam Painter. White ground body scene. Soldiers hold severed heads. H. 22*

280 *Lekythos by the Beldam Painter. H. 32*

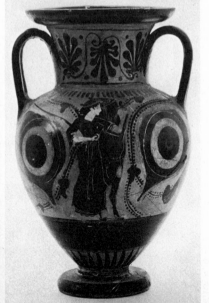

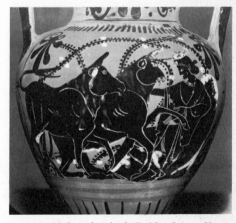

282 *Neck amphora by the Red-line Painter. Hermes and the cattle of Apollo*

281 *Neck amphora in the manner of the Red-line Painter. Pan and a woman. H. 25*

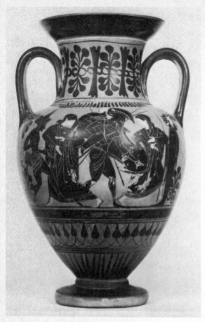

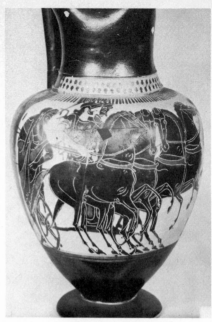

283 Neck amphora of the Class of Toronto 315. Aeneas carries Anchises from Troy. H. 24·5
284 Oinochoe of the Altenburg Class. Athena and Herakles in a chariot to fight the Giants

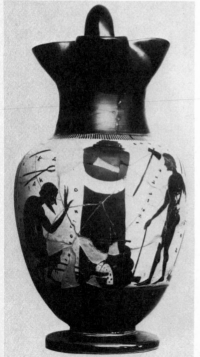

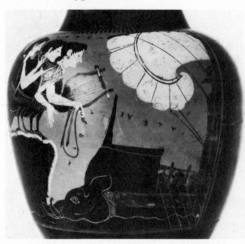

286 Oinochoe of the Keyside Class. Odysseus and the Sirens

285 Oinochoe of the Keyside Class. Foundry. H. 25·7

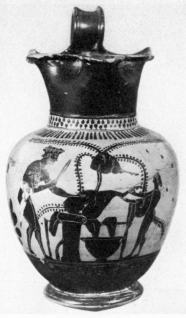

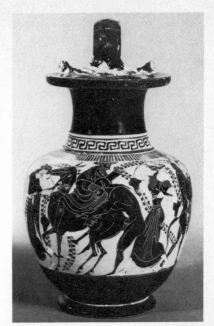

287 Oinochoe of the Class of Vatican
G 47. Butcher. H. 25

288 Flat-mouthed oinochoe (Kuhn
Class). Dionysos with satyrs and
maenads. H. 26·1

289.1,2 Oinochoe of the Guide Line
Class. Actor with Dionysos, satyrs
and maenads

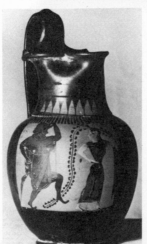

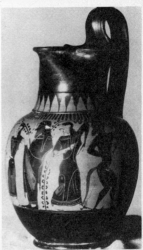

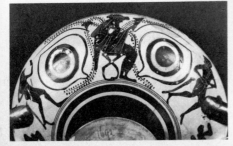

290.1,2 Cup of the Leafless Group. Dionysos and
satyrs. W. 22·1

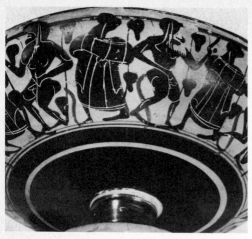

291 Cup of the Leafless Group. Satyrs and maenads

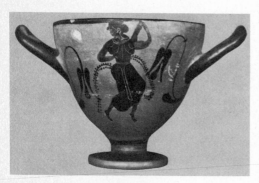

294 Cup of the Pistias Class. H. 11·7

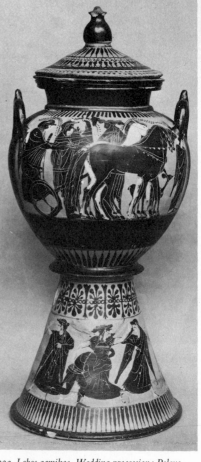

293 Lebes gamikos. Wedding procession; Peleus
wrestles with Thetis. H. 39

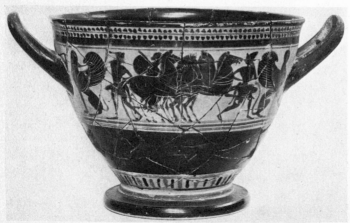

292 Skyphos of the CHC
Group. Chariot with
Amazons

Chapter Seven

PANATHENAIC VASES

One series of black figure vases is distinguished by their shape, decoration and usually the inscriptions upon them, as prize vases for the Panathenaic Games at Athens. They were big oil vases (usually 60–70 cm. high), and the distinctive tight handles, narrow necks and feet derive from a type of Attic storage vase which appeared first in the Late Geometric period, the body usually painted black, the neck sometimes with a simple pattern which has earned them the name SOS amphorae. The Panathenaics are decorated by black figure artists whose other work we can recognise, but they were especially commissioned by the state. Moreover, the shape, decoration and black figure technique were retained for them long after black figure was abandoned for ordinary ware, as we shall see.

The canonical shape and decoration was established by about 530 B C and we may look at typical examples of these years before considering their origins, later development, and purpose. [297] and [298] give the front and back of two Panathenaics by the Euphiletos Painter, the earliest artist of whose prize vases any number has survived. The neck carries a normal floral. On the front Athena stands, her shield and spear raised, striding forward but not actively engaged against an enemy, and surely here representing a cult image which may have been installed on the Acropolis and played some role in the ritual of the games. At either side are Doric columns supporting cocks. There were votive sculptures on columns on the Acropolis, but the cocks are rather unexpected and are generally explained as symbols of the spirit of competition (cock fights figure on many earlier vases). By the left-hand column is the inscription, 'ton Athenethen athlon' – 'one of the prizes from Athens'. On the reverse an event from the games is shown – here a foot race. Other contests commonly shown are the horse race, chariot race, boxing and other events in the pentathlon (jumping, javelin, discus, wrestling and the foot race). Sometimes the trainer is introduced or a victor is shown bringing his horse in [145.2] or being crowned and decorated with fillets.

The Panathenaic Festival had been reorganised, it seems, in 566 B C and the Greater Panathenaia were then held every four years with games including athletics, the Lesser annually in the years between. The vases refer to the former. The prize vases earlier than the Euphiletos Painter show some variety.

The earliest stylistically and so perhaps of the later 560's is the Burgon Amphora [296] where we see Athena's owl on the neck, a squatly Archaic Athena and the inscription with an added 'eimi', 'Iam . . .'. The event shown on the reverse is a synoris team (two-horse or -mule carts). Since this is not athletic it could be earlier than the reorganisation but it is likely that the new series of vases was inaugurated at the same time. Other early inscribed prize vases are also more informative than the later ones. A fragment in Halle [295], close to Lydos, shows the foot race and says 'andron', 'of the men': this is usually taken to be the earliest to show athletics, but the lotus on its neck has already lost its central spike and there is another early fragment from the Acropolis, similarly inscribed for runners, one of whom has still the old-fashioned red face. Other vases name the two-length foot race (diaulos) showing armed runners: they announce ownership, 'diaulodromo(u) emi', or victory in the stadion, 'stadio(u) andron nike'. Lydos puts a victor before Athena and relegates the inscription to the reverse. These early prize vases omit the cock columns and the Athenas stand flat-footed.

The cock columns are seen first on Panathenaics near Group E, by Exekias [106] and by the Swing Painter. Exekias' one surviving example is a prize vase, but with the inscription by the right hand column. The Swinger's are not inscribed as prizes. On one he puts a Hermes beside Athena and on another [145], where a mortal joins the deities, the reverse records 'the horse of Dysniketos wins'.

There are a number of other amphorae whose shapes approximate to the prize vases in varying degrees and which carry the Athenas, often the columns, and the athletic events as well as musical contests (pipes players) which had probably been admitted in the sixth century, and even acrobats and spectators on a vase inscribed as a 'vessel for the tumbler', 'kados toi kybisteitoi'. Some of these might be prize vases, but musicians did not win oil at this date, and there are ordinary amphorae and other shapes which borrow the Panathenaic scheme of decoration and must be merely souvenirs. The non-prize Panathenaics often deviate too by omitting columns and adding an owl or other figures, while a few replace the cocks by cauldrons, lions, owls or disci and once by male figures.

With the Leagros Group [299, 300] we see that greater uniformity had been established for the prize vases and the artists commissioned to produce them more often repeat the same shield device for the Athenas of one series. Possibly the devices were dictated by the magistrate who ordered the vases from different painters to help identify a batch. The first generation of red figure artists seems not to have been invited to produce prize vases, although one fragment has been thought perhaps the work of Euphronios. The Eucharides Painter is the first red figure artist to have painted any number, in the years around and after 500, and he is followed by some of the most distinguished names in red figure – the Kleophrades Painter [301] (Pegasus bla-

zons), perhaps the Berlin Painter [302] (gorgoneia) and the Achilles Painter [303] (gorgoneia). The Athenas stand in the traditional pose but their dress is modernised and the athlete figures render all the new skills in drawing but in the old technique. The vases themselves have higher shoulders with more swinging contours and heavier lips and feet. In the second half of the fifth century it is not so easy to identify painters of prize vases with known red figure artists but groups can be distinguished (the Robinson Group, the Kuban Group [304]). We do not look for signatures on prize vases but Sikelos could not resist incising his on the column of one in the late sixth century and potters sign one or two in the fourth century (Bakchios, Kittos and another). In the sixth century there was at least one kalos inscription ([297] on the shield; after which the Euphiletos Painter is named).

With the fourth century come innovations. By the right hand column appear inscriptions naming the archon for the year. The earliest which can be plausibly restored names Hippodamas, of 375/4 BC, but Beazley suspects that a stylistically earlier vase named Pythokles, of 392/1 BC. On the columns the cocks are replaced by symbols, different each year, usually a statuary figure or group. The amphora shapes become more feminine, with generous lips, sloping shoulders, slender necks and ankles. The columns slim to an impossible architectural form and in the 360's the individual letters of the inscription turn horizontal. The Athenas were already becoming pin-headed and grotesquely elongated in the late fifth century and the process continues. Some time between 359 and 348 BC Athena turns to face right, her shield raised to be seen obliquely from within [305]. She wears a cloak draped over her upper arms, its end flaring in swallow tails which also affect the hems of her overgarment and chiton: like an early twentieth-century fashion plate, Beazley remarks, and the Hobble Group of 336/5 BC needs no explanation [307]. But while she is mannered, archaising, the athletes represent faithfully the new sculptural proportions and poses of the fourth century. Beside them may appear trainers, Nike or, once, a personification of the Olympic Games, a compliment to the senior festival and games.

The latest dated vase is of 312/11 BC but Panathenaics are still being made in the third and second centuries [308], naming other officials – a treasurer (tamias) or steward of the games (agonothetes). The shapes exaggerate and elaborate the old simple forms and the style is a faint perfunctory reflection of what black figure had been. But the vases were still valued, and are shown on wall paintings and mosaics, on Delos of the first and second century BC. Aristotle explains for us that the archons were responsible for providing oil for the prizes from the sacred olive trees. The dated vases are only of years in which the Greater Panathenaia were *not* held and it was the duty of officials in these years to lay up the stock for the year of the games and to commission the production of the vases, which dated the harvest in the same way that vintages were dated by archon stamps impressed on the handles of wine amphorae

(but not in Athens). Something of the order of one thousand vases were required for prizes at each games – a sum which brings home the appallingly low survival rate of our most plentiful archaeological evidence for Archaic and Classical Greece.

The vases and their contents might be sold by the victor, which explains the wide distribution of them through the Greek world and outside it, but some must have accompanied victors to their graves – like the vases at each corner of a sarcophagus in Tarentum – and many were dedicated in sanctuaries. When the estates of Alcibiades and other desecrators of the Herms were sold up in 415 BC over one hundred were disposed of at an average price of half a drachma. Another measure of their popularity was the way in which the shape was copied in stone, for jewellery, for small perfume vases and for red figure vases decorated with various scenes. Official measures of this shape bear an Athena head and owl painted in black figure, labelled demosion ('public'): these are fifth/fourth century in date.

295 Fragment of Panathenaic amphora, related to Lydos

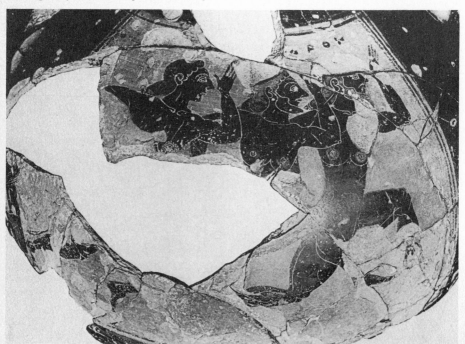

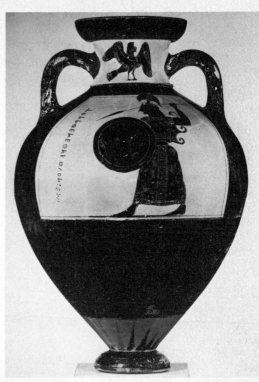

296.1,2 Panathenaic amphora of the Burgon
Group (name vase). H. 61·3

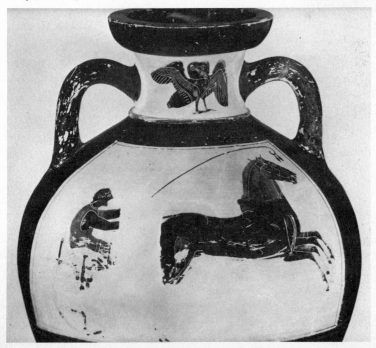

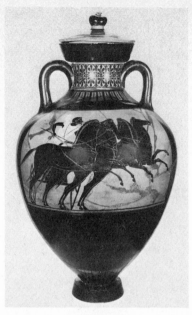

297 Panathenaic amphora by the Euphiletos
Painter (name vase). H. 62·5

299 Panathenaic amphora of the Leagros
Group. H. 64

298 Panathenaic amphora by the Euphiletos Painter

300 *Panathenaic amphora of the Leagros Group*

301.1 *Panathenaic amphora by the Kleophrades Painter*

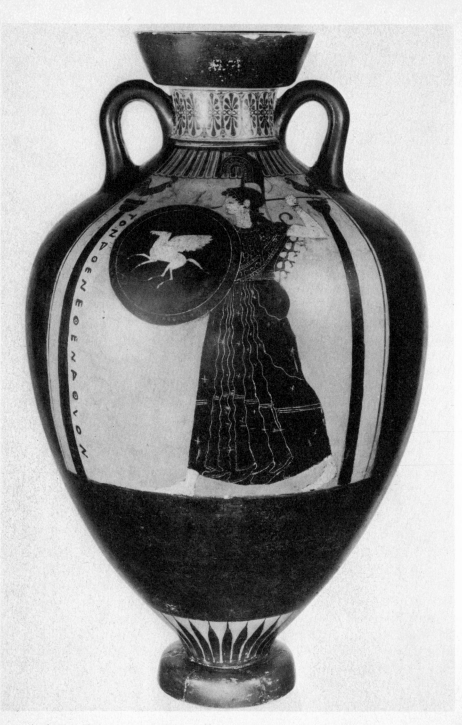

301.2 *Another view of 301. 1*

302 *Panathenaic amphora by the Berlin Painter*

303 *Panathenaic amphora by the Berlin Painter*

304.1 *Panathenaic amphora of the Kuban Group. H. 57*

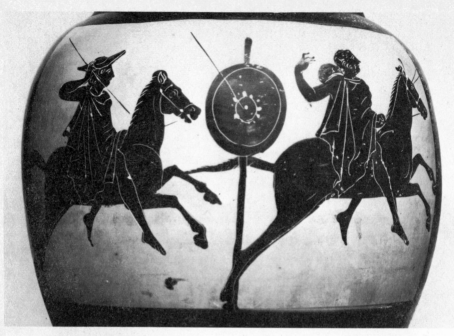

304.2 Another view of 304.1

306 Panathenaic amphora of the Nikomachos Series. Archonship of Kephisodoros, 323/2 BC

305 Panathenaic amphora of the Nikomachos Series. Archonship of Pythodelos, 336/5 BC. H. 83

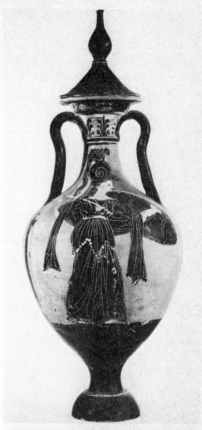

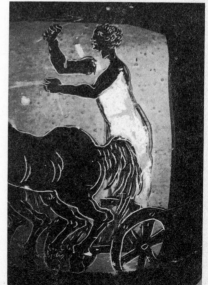

307 *Panathenaic amphora of the Hobble Group. Archonship of Pythodelos, 336/5 BC*

308.1,2 *Panathenaic amphora, Hellenistic. H. 78·4*

Chapter Eight

ODDS AND ENDS

Six technique

This technique is named after the scholar Jan Six, who discussed it in 1888. In its simplest form it involves laying on figures in white or red on an all-black surface and incising details so that the black, not the clay, shows through. The technique had been used in details on Athenian black figure vases for women's faces with features incised, and for some shield blazons from the first half of the sixth century, as [47], but it is not used for complete figures or the whole decoration of a vase until about 530. The general effect is, of course, that of red figure, but it had already been used outside Attica (in Corinth, Boeotia and East Greece) for whole figures and major elements of decoration. One of the first uses in Athens is on a Nikosthenic amphora (was this another of his innovations?) for studies of naked girls [309], and in this case the all-black vase recalls the all-black Etruscan bucchero it is copying. Psiax was another user and the potter Sosimos. A small group of stamnoi and neck amphorae [312] of the end of the century used the same red that was used for details in black figure, but the main period for the technique is the late sixth and early fifth century and most examples are on lekythoi by the Sappho and especially the Diosphos Painter. These seem to have introduced the use of a pink colour for the bodies of men instead of white, more closely resembling nature and red figure, and they incised some detail as in outline, on the black. It is not only used for small vases, and the Sappho Painter's name vase is a hydria (kalpis) with the poetess drawn in this technique [311]. It is the technique used in the fifth century by Etruscan vase painters when first they take note of red figure and try to imitate it (Praxias Group) since it dispenses with delicate brush-work and the tedium of background filling, but the pale paints used are fugitive. Finally there is a small group of mid-fifth-century oinochoai (choes), mainly from the Haimon Painter workshop with unincised red figures on the black.

Polychrome

There are a number of late sixth-century phialai [313–4] including many from the Athenian Acropolis, decorated in white and red over black, with

little or no incision, on their interiors. The subjects are dolphins, ships, octopuses, florals, rarely figures. There are earlier Chian phialai decorated with white and red florals within, inspired by the relief patterning of bronze examples. Sosimos made a phiale including a floral band of red with incision on the black, which is a technique used earlier on Rhodian Vases (Vroulia Group). So it seems possible that these rare all-colour essays in Athens were inspired by East Greek work or artists.

Miniatures

Miniature versions of major vase shapes were used for dedication in temples and tombs or for toys. The most important Athenian sixth-century series is the SWAN GROUP, roughly decorated with swans and lines of dashes. Almost all shapes are represented, even odd ones like eggs and bells, but in cups there are only skyphoi of Corinthian shape ('kotylai': the swans on these are painted upside down [315]) perhaps because Corinth was herself an active exporter of miniature skyphoi. The shapes copied indicate a range in date from the second quarter of the century, perhaps to its end, to judge from finds in Athenian graves. Other sixth- and early fifth-century miniatures decorated with stripes and blobs (notably kothons, jugs and feeders) seem to have been destined for funerary deposits in Athens, perhaps all for children. Many other small, but not strictly impractical versions of common shapes were made and decorated in the ordinary manner throughout the black figure period.

Miniature Panathenaic vases were made in the early fourth century, presumably as souvenir vases, and naturally decorated in the old technique, like their models. This is the BULAS GROUP [316] to which many other miniatures, not black figure, are assigned.

Black vases

We might have expected that the figure decorated vases which have been discussed in this book represented only a minority among the clay vases used by sixth-century Athenians. It is remarkable, however, that the unpainted pottery of Athens in these years was designed for storage or the kitchen, not for the table. We must make allowance, of course, for wooden cups and platters which have not survived, but there is one series of clay vases which served much the same purposes as the figured ware and is often of high quality. These are the black vases, painted all over with the fine black gloss paint, sometimes with added red lines or with reserved bands bearing the simplest decoration of stripes or rays. The production of these black vases does not, however, exactly tally with that of the figured vases and may be briefly summarised here.

The big black oil or wine vases which in the seventh century had SOS decoration on the necks are usually plain in the sixth century – all-black or

309 Nikosthenic amphora. Six technique. H. 32

310 Oon. Six technique

312 Neck amphora. Six technique

311 Hydria (kalpis) by the Sappho Painter (name vase). Six technique. Sappho

313 Phiale. Six technique. W. 19·8

314 Phiale. Six technique

315 Skyphos of the Swan Group. H. 5·6

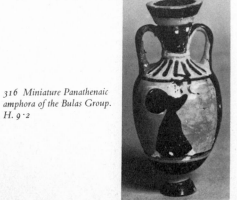

316 Miniature Panathenaic
amphora of the Bulas Group.
H. 9·2

317 Crater from Brauron H. 21·5

banded with thinned paint (decoration 'à la brosse'). The standard amphora, hydria and crater shapes are poorly represented in black, but there are many oinochoai, several pelikai and psykters and in general the late sixth century sees an increase in the production of black vases. Specialities in black of these years and later are stemmed plates and dishes. In the first half of the sixth century, however, black amphoriskoi were common (some retaining the SOS neck), although rare in black figure, while black lekanai long outlive the shape's popularity for figure decoration in Athens, and survive to about 500. Among lekythoi only the early 'Deianira' shape is common in black, but in the early fifth century some current shapes have black bodies with ordinary shoulder decoration (Little Lions and from the Athena Painter's workshop). Of cups the Corinthian skyphos shape and its Attic derivatives are common together with cup skyphoi. The whole range of footed cups, from the komast to eye cups, is well represented in black (but not lip cups). The earlier ones owe much to an older East Greek tradition (the so called Ionian cups), and those of Siana shape have reserved lips, handle zones and body bands, often with close set groups of red lines within the reserved lip or tondo.

Athens or Attica?

The common practice of calling Athenian vases Attic disguises the possibility that there were potteries producing figure decorated vases elsewhere in Attica than in Athens' potters' quarter. There were many rich townships in the Attic countryside in the sixth century, marked by the fine statuary and vases recovered from their cemeteries, and many sources of clay other than the main clay beds at Amarousion some twelve kilometres from the city. There is unlikely to have been any appreciable difference in style, other than in the work of different hands, so the possibility of detection lies in distribution, and this can be a misleading guide, but we have seen that some early black figure painters are so far represented only at Vari, in southwest Attica, which was clearly an important centre.

It is easier when the production is more specialised – votives for a local sanctuary. Thus at Eleusis, there are some vases of distinctive shape [31] and plaques of the first half of the sixth century, by painters not represented elsewhere and showing ritual scenes appropriate to the worship of Demeter. And at Brauron in east Attica, where there was a sanctuary of Artemis, there have been found a number of footed craters in an unincised style of fifth-century date, showing naked girls dancing [317] and clearly relating to the local cult only.

Emigrants and Imitators

While Athens' black figure set a standard for other Greek studios to follow or emulate it is not easy to trace Athenian influence outside Attica in the work

of emigrants or direct copyists. Of the former class there is the Painter of the Dresden Lekanis who moved to nearby Boeotia. This seems to have been a receptive area, where we can also detect the work of painters imitating the Athenian Gorgon Painter and the KX Painter. In the second half of the century an Athenian, TEISIAS, signs as potter two skyphoi and a kantharos which were made in Boeotia and one of them decorated in a Boeotian manner – black polychrome, with incision and colour on an all-black ground. The CAMEL PAINTER is an artist who has hitherto been taken for Athenian, painting cup skyphoi in a Lydan style, but he was probably working in Boeotia.

In Euboea, another close neighbour to Attica, a strongly Atticising style of black figure has been identified, a speciality being animals or figures lacking much or all incision. Eretria was the principal centre, and it seems likely now that some groups of vases which had been taken for Attic properly belong over the water, in Eretria or some other Euboean town. This seems true of many of the DOLPHIN GROUP of lekythoi (shoulder lekythoi of the mid century and later) and several other hydriae and amphorae which have passed for Attic. Clay analysis by emission spectrography has helped to isolate these pieces from the Athenian series, and the same technique helps us to place the HYBLAEA CLASS of small neck amphorae in Sicily. It is likely that other adjustments to our judgement of what is Athenian will have to be made.

Finally, at either side of the Dardanelles, in the Troad and at Elaeus where Athens was active during the sixth century, there are many small animal frieze vases, often lekanai and usually with unincised birds as their only decoration, which are related to the Swan Group miniatures and probably of local manufacture.

318 Standlet

319 Kothon-plemochoe. H. 18·5

Chapter Nine

SHAPES, NAMES AND FUNCTIONS

Athenian potters of black figure vases were not the first in Greece to sign their works with pride, but it is with Athenian sixth-century vases that we can begin to suspect a more conscious interest of the potter in his work. This is revealed by refinement of lip and foot profiles, and attention to, for instance, the modelling of less important areas like the underfoot – features which can serve as criteria for the identification of potter work as effectively as details of drawing can the painting. Refinement, invention, imitation, may all reveal the potter as aware both of the commercial and practical value of a good shape and of its value as a 'work of art' (if not quite in our sense of the term). But modern commentators perhaps have been quicker to observe all this than the potter would have been, and as a result it is with Athenian black figure that several recent investigations have begun in an attempt to recover the principles of proportion or 'dynamic symmetry' which governed the shapes and details of the finer vase shapes. Where these studies imply a knowledge of geometry far beyond the wit of any ancient potter they can be ignored without more ado. The most they may demonstrate is that a 'natural' curve which pleases the eye may be expressed mathematically. Certainly the shapes in their overall proportions and details may often be understood in terms which we can as readily apply to other works of the Greek artist, in architecture or sculpture. All this brings us too rapidly, too far from the basic truth that Greek vases are functional, that shape was determined by simple needs – to store, not to spill, to suit the lip, to hold heavy liquid, to keep cool, and so on. Obeying these needs the shape can also be adjusted to echo function – as in the baggy outlines of liquid containers – and defy the 'architecture' of lip, neck, body, foot. Just as in the decoration, the painter may try to enhance the effect of shape or – as is normally true in black and red figure – convey through pictures his view of myth or life in original interpretation of stock themes.

There was undoubtedly some measuring and standardisation, quite apart from the special requirements of a few shapes intended to hold set quantities. The necks, bodies and feet of large vases and of the more articulated small ones were normally thrown separately on the wheel, then joined. The potter must have made batches of necks, bodies, and indeed lids, and then matched

them up. To avoid waste he would have made the parts to a standard size and there is close correspondence of measurement in vases which seem, from details of potting and painting, to have been produced from one workshop in a short period. Overall changes in proportion can also be observed – a general transition from stout forms to slender ones, with a return to more robust and unified forms by about 510, soon after the introduction of red figure, when several new shapes which are purely potter-inspired (pelikai, kalpis-hydria, stamnos) also make their appearances.

The influence of metal vases on the shapes of clay vases is worth a moment's attention. The former, especially the decorated vases, must always have been the more valuable. Some shapes in Athenian black figure, like the phiale and dinos, had been borrowed by earlier potters from the metal-worker's repertory. Of the new shapes the volute crater in particular probably owes its origin to metal prototypes, but not Athenian ones. Otherwise there may be decorative features copying metalwork. These are most prominent on hydriai and oinochoai, both popular bronze shapes, and we see rotelles at the junction of handle and lip, where too a human [230] or animal head in the round may look into the vessel. The scheme with the head is borrowed for some kyathoi [171]. Palmettes and similar devices for attaching metal handles to the body of the vase are also copied in paint or relief. The borrowings are never slavish and there is a return traffic – with a bronze psykter.

The rest of this chapter is devoted to an account of the functions and names of the vase shapes whose decoration has been studied already. Sometimes the development of a shape or the invention of a new one has proved an important element in the story of the development of style, and these observations need not be repeated at length. So the following entries summarise and cross-refer, and they dwell only where no explanation has been called for already.

Amphorae

The large *neck amphorae* of the late seventh century [5] derive from Protoattic shapes and do not long continue to be made. The usual form of the first half of the sixth century and little later is smaller, ovoid, with simple cylindrical handles to mid neck. Soon after the mid century the common form has triple-reeded handles which run more smoothly into the neck, and the body's centre of gravity is higher [186]. There are some fine plump examples by Exekias and Amasis [85, 97] but the type is soon standardised, with palmette cross patterns beneath the handles (an older East Greek pattern), emphasising the florals rather than the spirals which better artists managed so well, and the larger vases gradually give place to a crop of small neck amphorae around and after 500 BC [243-4] including a number of 'doubleens' with double-reeded

handles. Of special varieties the Nikosthenic and its successors may be noted [149, 214], and the neck amphorae of Elbows Out [158], where the splaying neck, high body and strap handles may owe something to bronze shapes.

The *belly amphora*, with a continuous profile from lip to foot, is represented in a few massive examples of the late seventh century [8] and remains a popular large vase, acquiring by about 600 its usual scheme of decoration, with panels set in the black ground on either side. The earlier variety (Type B) has a straight lip, rounded foot and cylindrical handles [18], and continues to be made into the early fifth century. Soon after 550, however, a more elaborate shape is introduced (Type A) with strap handles having flanged and decorated (ivy pattern) edges [*Frontispiece*], soon a palmette drawn in a reserved patch below each handle, and a stepped foot with the 'riser' to the step left plain after about 520 [163]. The Affecter has some amphorae with rolled lips and simple feet [156], a type continued in red figure (Type C).

The name amphora, or rather the Greek form – amphoreus, conveys its shape: 'carried on both sides', so with two upright handles. The types we have noticed are mainly storage vases, the plain examples of which are the neck amphorae with narrower necks and feet, which inspired the shape of the decorated Panathenaic amphorae and later the occasional black figure 'pointed amphora', which may be provided with a cylindrical stand [209]. They could have held oil or wine, or small solids. The ordinary belly and neck amphorae are commonly lidded, the former with mainly black lids patterned around knob and rim, the latter often with broad-striped lids, matching the overall patterning of the vases. Rarely they carry figure friezes. The knobs are usually like fruit, sometimes drop-shaped.

Pelikai are decorated like belly amphorae but are generally smaller, with rolled lips and a sagging profile [210-2]. They appear first about 520, and to judge from the scenes on some of them a common use was the storage of oil [212], perhaps perfumed rather than culinary. A minor variety is the neck pelike.

Hydriai

Water jars are identified by the arrangement of one upright handle for pouring, with two horizontal, for lifting. The tall slim variety, or loutrophoros-hydria, has a long history in Athens. The more practical variety, with globular body and cylindrical neck [51], is borrowed from Corinth in the early sixth century. About the middle of the century it develops a shoulder [74], which becomes progressively flatter, while the mouth flares, the side handles curl up more and more, and the upright handle has knob and rotelle attachments inspired by metalwork. This is the standard black figure type [201]. The so-called *kalpis* is introduced by about 520, with a continuous

body profile and rolled lip, and there are many small late examples of this shape in black figure [*276*].

Oinochoai

The earliest of the common pouring vases in Athenian black figure is the *olpe*, its profile from lip to foot a flat S, usually with a broad trefoil mouth, sometimes straight, and with a high-swung handle [*13*]. These are frequent from the Gorgon Painter on, and in late black figure the lip may be a heavy 'echinus', sometimes decorated [*232*].

Oinochoai with a sharp junction between neck and body may have high (Class I) [*289*] or low (Class II) handles and often boast a pronounced collar. They appear no later than the olpai, but are relatively scarce until the second half of the century. Plump oinochoai with a pronounced S profile and trefoil lips (the later '*chous*': Class III) are rarer, and not earlier than the mid century. Even less common are beaked jugs (Class X) which copy a metal shape, and Cypro-Jugs, for the Cyprus market and copying an eastern shape with bulbous body and narrow conical neck.

Wine mixers and coolers

The sixth century sees the establishment or invention of all the open wine-mixing vessels except the bell crater. The old *skyphos-crater*, like an enormous cup, often with conical lid and foot [*6*], does not survive the early sixth century and may never have been a vase for the symposion. The *column crater* was copied from Corinth by potters serving the Komast Group and was known as the 'Corinthian crater' in antiquity. It has a flat, often decorated rim with rectangular handle plates over the hoop handles, which eventually separate into two supporting 'columns'. It is most popular in the second quarter of the century [*65*] and then loses favour, but is never forgotten. The François Vase [*46*] is the earliest Athenian *volute crater* preserved complete. Later examples usually have all-black bodies. The neck is higher than that of the column crater and the junction of handle and lip is effected by a heavy, rising scroll. The shape may copy Peloponnesian bronze vases. The earliest surviving *calyx crater* is by Exekias (*c.* 530) [*103*], who may have invented the shape. It is like a heavy cup with high straight walls, offering the painter a good field with only a one-way curve. A broader, squat variety has a short vogue [*227*].

The *lebes* or *dinos* copies the metal shape, with rounded base, but may be provided with a high stand [*11*, *24*]. The Gorgon Painter's name vase is the earliest Athenian black figure example and it is an important shape for the better painters before the mid century. The *stamnos* has a low neck, high body and horizontal side handles. It is a red figure shape but there are black figure examples of the end of the century [*193*, *219*, *221*].

A *psykter* is for cooling wine. Standing in a crater, full of well water or snow it presented a maximum surface area to the coolant by being pear-shaped with a fat 'stem'. It appears first by about 520, one of the earliest and most elaborate being by Nikosthenes [*154*]. In black figure a few, mainly' miniatures, are lidded and have pierced lugs or ears at either side. A rare earlier cooler takes the form of a neck amphora with an inner wall open to the neck, and a shoulder spout for the outer enveloping cavity. There are examples of the third quarter of the century (decorated by Lydos [*66*] and the Swinger).

Cups

The development of the Athenian cup has been adequately discussed and described in the earlier chapters and I give here references only to text and pictures: komast cups, p. 18 [*21–2*]; Siana cups, p. 31 [*34–6, 39–42, 44–5*]; merrythought cups, p. 32 [*37*]; Gordion cups, p. 58 [*108*]; band cups, p. 59 [*109*]; lip cups, p. 59 [*113*]; Type A cups (eye cups), p. 107 [*178*]; Type B cups, p. 107, as [*84*]; Droop cups, p. 61 [*128*]; Cassel cups, p. 62 [*130*]; Chalcidising cups, p. 107 [*176*].

There are one or two covered cups of about 530 on, with a decorated cover made in one piece with the bowl, leaving a mouth hole.

Of the deeper cups with horizontal handles the straight-lipped type which copies the Corinthian *kotyle* (often called *skyphos* in this period) belongs to early black figure down to the earlier Siana cups [*23, 315*], and Nikosthenes revives the shape but without figure decoration. Other skyphos types are developed by the Little Masters and have been discussed already: band skyphoi (p. 62, [*132*]) and Hermogenean skyphoi (p. 62, [*131*]). From about 530 on the heavier-walled skyphos [*181–2; 245–7*] becomes popular and remains so into the fifth century, and there are stemlesses whose body shape is that of the footed cups [*184–5*].

The *mastos* cup is shaped like a breast, with nipple base [*167*]. The form is borrowed from Corinth, and shown hanging on the wall in a scene by the KX Painter, but the few surviving Athenian examples are all of the second half of the century. *Mastoid* cups have a narrow flat foot, flaring lips and one, two or no handles [*274*]. They are produced about 500 and later but Amasis made a skyphos of roughly this shape, with vertical handles. The shallow *phiale*, with or without a central navel (omphalos), copies the metal shape and is rarely decorated (only within) by the latest black figure artists although there are some decorated in Six's technique or polychrome [*313–4*], perhaps copying East Greek types, some miniatures of the Swan Group, and Nikosthenes made plain black ones with a tongue pattern around the navel. It was a vessel especially for libations to the gods but could be used also on ordinary occasions to judge from representations on vases.

Of cups with vertical handles the *kantharos* is the most important, although

it is not common as a shape in Athenian black figure and more often seen held by a Dionysos. Nor is its immediate origin clear, but it had a very long history in Boeotia. The best are quite early – Komast Group and Nearchos – with few later [122]. Some dozen surviving one-handled kantharoi belong to the years around 500. These, like the *kyathoi* [171] (dippers with single, high vertical handles and straight walls) which seem to have been invented by Nikosthenes about 530, were for export to Etruria, and both copy Etruscan bucchero shapes. In these circumstances it is odd that two of the one-handled kantharoi bear Athenian funerary scenes since vessels so decorated were usually for local use, but these travelled west [220].

Standlets for cups are small rimmed discs on splaying feet [318], and the earliest surviving one is from the hands of Kleitias and Ergotimos, no less.

Bowls

The *lekane*, a heavy dish with ribbon handles [19, 29], is an early black figure shape which survives to the period of Lydos. Some are lidded (for these the name lekanis is often preferred by scholars), and there are a few bowl lids only of about 500 (Edinburgh Painter). The shape had been known in Athenian Geometric and a version had survived in the islands. The Anagyrus Painter made one with high walls [30] and in the first half of the century there are occasional other open chalice-like bowls with straight sides. Sophilos makes one vase with a body like the Chian chalice [28].

The so-called *kothon* is another early shape [33]. It is characterised by its inturned, dipping lip which prevents spilling, and may have been used to hold perfumed water or oil, although some scholars have taken them for lamps. Figure-decorated examples last to the mid century and have broad tripod feet [38]. Later ones have splaying feet and are all black except for a pattern round the mouth [319]. Some are lidded. The ancient name for the shape may be *exaleiptron* or *plemochoe*.

Oil flasks

The earliest Athenian black figure *lekythoi*, by the Gorgon Painter and his followers, may owe a little to Corinth, since some have spherical bodies [14], but their pronounced feet and cup-shaped lips are new. The elongated Deianira shape [15-6] lives longer, beyond the mid century, but by about 560 the variety with an offset shoulder is invented [77-8]. These shoulder lekythoi acquire straighter, but still flaring walls, but after about 530 they are soon replaced by lekythoi with cylindrical bodies [250], the type which survives through the fifth century. Some classes of the latest black figure lekythoi replace the swelling lip with a slim chimney mouth [278-9], and the Little Lion shape [261-2], perhaps invented for the Sappho Painter, has sloping

lower walls which hark back to the earlier shoulder lekythoi. For more detail about lekythos shapes see pp. 114–5, 147–9.

The Corinthian spherical *aryballos*, with disc lip and no foot, was copied by Nearchos [50], Amasis and one Kealtes (who adds a foot). One has two handles. It is carried on [*84, Frontispiece*]. Amasis introduced the true Egyptian (not the Corinthian, which was ignored) *alabastron* shape [*79*]. Psiax painted some and was followed by the lekythos painters [*268*]. On these a white ground is preferred, imitating the stone vessel. There are a very few black figure examples of the *lydion* [*159*], copying the shape of the Lydian perfume pot, of about the 530's.

All these shapes are for perfumed oil, the lekythoi and alabastra are shown handled by women or for funeral use, the aryballoi for men. One lekythos (by the Diosphos Painter) has the word 'hirinon' painted on its rim, indicating its use for iris-scented oil. The Beldam Painter's larger lekythoi are the first to be given false inner compartments so that all need not be filled with oil. This is an understandable economy when gifts for the dead are in question, but the scenes on some of the earliest so equipped (including his name vase) suggest a wider practice. No deceit was intended, simply the accommodation of impressive decoration and shape to small capacity.

Ritual shapes

The *louterion*, commonest in early black figure, is a spouted basin, sometimes with a conical stand, associated with funerary cults. The *loutrophoros*, in either amphora or hydria form, has the body of an elongated neck amphora. The shape resembles Early Protoattic vases by the Analatos Painter and others but the series seems interrupted in the seventh century. In early black figure it attracts ritual or mourning scenes, sometimes with modelled mourners as handles, later (as by the Theseus and Sappho Painters) mainly funerary ones [*264*], being used sometimes as a grave marker. In the mid century some carry stock scenes of myth but also a wedding procession (Lydos) and this is a common subject for them in the fifth century since the vessel was used to carry water for the bridal bath. The *lebes gamikos*, also for the bridal bath water, is like the lebes but with a distinct neck, upright and usually double handles, and a conical stand in one piece, usually with lifting holes at its top. It commonly shows a wedding procession [*293*], the earliest, of the Sophilos period, being of Helen and Menelaos.

In all periods there are a few vases, of unusual form, which were intended as grave offerings. In earliest black figure we find deep lekanai and tables, both shapes decorated with modelled mourners. In late black figure the uncanonical vases destined for burials carry funeral scenes: they are basket-handled vessels [*266*], and small vases shaped like an egg (*oon*) [*310*] or a pear-shaped rattle (sometimes called a *phormiskos*). With the exception of the lebetes

gamikoi and louteria none of these ritual shapes travelled outside Attica.

Votive plaques are rectangular, pierced for suspension or nailing onto walls or trees, and varying in height from about 5 cm to over 30 cm. They are common on the Acropolis, with some from other Attic sanctuaries, showing the deity [*172*] or a range of myth, sacrifice and genre scenes. Few are bespoken with painted inscriptions. *Funerary plaques* show scenes of the laying out of the dead (prothesis) and were presumably fastened to above-ground tomb monuments. 'Plaque series' start by *c.* 600 and comprise friezes of big slabs, between 35 and 55 cm high and about 4 cm thick, showing prothesis and processions, and there are groups painted by Sophilos, Lydos [*71*] and Exekias [*105*]. One has a painted verse inscribed on the top border naming the dead man, and so was bespoken for a particular burial. About 530 (there is also one of *c.* 560) they are replaced by 'single plaques', between 16 and 45 cm wide, showing the prothesis alone: the Sappho Painter is fond of these and on one names the relationship of the mourners [*265*]. None are red figure or later than about 500.

Other shapes

Lidded boxes, *pyxides*, come in various forms. The commonest (Type A) was borrowed from Corinth. It has concave sides and is made throughout the sixth century [*320*], into the fifth. Nikosthenes introduces a new variety with straight splaying walls and a domed lid [*153*, *267*], and there are flatter versions in the fifth century (Haimonian). Tripod pyxides are found early and the powder-box type, with slip-over lid, late; and both in miniatures (Swan Group).

Epinetra (often miscalled *onoi*) are knee-pieces over which wool is worked. A few of around 500 and just after are decorated in black figure along the straight sides of the hemicylinder, with moulded female heads at the knee ends [*263*]. *Plates* have black figure decoration from the Gorgon Painter period on [*69*].

Figure vases, part decorated in black figure, are very rare, and where figure decoration is added to head vases (generally of women or negroes) it is usually executed in red figure. There is one late kantharos with a donkey's head in the round on one side [*321*]. An earlier East Greek and Corinthian tradition of figure aryballoi is represented by the Little Master Priapos' vase in the shape of male genitals, decorated with a courting scene, and perhaps by a larger group of sandalled-foot vases, with palmettes or gorgoneia on their handles, which may be Athenian. Male genitals also serve as base for some eye cups [*177*].

Various Greek words have been used to describe vase shapes in this chapter, and they appear regularly, although not always consistently, in

books on Greek vases. Convenience and the conventions of recent scholarship have generally outweighed considerations of accuracy.

Of the Greek words I, and others, have used to describe shapes, the following seem specifically correct for the shapes indicated here: amphoreus (the Latin form, amphora, is more commonly used: kados and stamnos were also applied to the shape in antiquity), hydria, psykter, lekythos (but used mainly for our 'aryballoi'), kantharos (perhaps also and better called kotylos), crater, lebes, lebes gamikos, phiale, alabastron, oinochoe, plemochoe, mastos, oon.

The following are generically correct: skyphos, kotyle, louterion, kyathos, olpe (applicable to a wider variety of shapes including our 'aryballos'), stamnos (also applicable to amphorae and probably our 'pelikai'), kalpis, aryballos, pyxis, chous, lekane, exaleiptron; and kylix for a cup of any form, especially what we call 'skyphoi', usually applied nowadays to stemmed cups.

The following are wrong, but in common use for vase shapes (the real meaning is indicated in brackets): loutrophoros (a mortal water bearer), kothon (a cup), pelike (cup, jug or bowl), dinos (cup), phormiskos (small basket), onos (footrest).

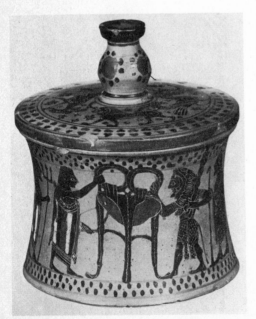

320 Pyxis of the Group of the Oxford Lid. Herakles fights Apollo for the tripod

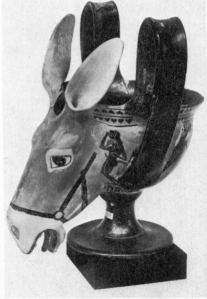

321 Donkey-head kantharos. H. 21·5

Chapter Ten

RELATIVE AND ABSOLUTE CHRONOLOGY

Dates for Athenian black figure vases have been given in this book in approximate but absolute years B C, and not according to any scheme of Early, Middle and Late, such as necessarily dominates most studies of prehistoric pottery. They could easily be converted to such a scheme but the move would be retrograde since any attempt to define closely the 'style' of a sub period is bound to be second best to the successful identification of painters and workshops, which can make it possible to distinguish and place accurately both the old fashioned and avant garde and can observe the master-pupil relationships. Much of the work on painter attribution can then be seen to have served to stabilise a reliable relative chronology for the vases. This is fortified and confirmed by many parallel studies: the evidence of developing shapes; the evidence of developing decorative motives, such as florals, or the drawing of figures and drapery; the kalos inscriptions. In the chapters of the first part of this book this relative chronology has been accepted and, where opportune, been demonstrated. The possibility of error remains. If vase A is dated 'about 520' and vase B 'about 510' this means no more than that in the observed progress of style or relationship of the painters involved A is slightly earlier work than B, but if the painter of A was a young innovator, the painter of B an older artist or one unwilling to change his style, the vases could be near-contemporary; while if these qualities were reversed the absolute gap might be greater. We use the time scale as a convention and convenience, but in this period and with these vases the sequence and rate of change proposed can be treated with some confidence. One last factor affecting this 'rate of change' is the volume of surviving pottery assigned to different periods. There are obvious dangers in the wish to spread styles and painters evenly through a given number of years, but there are equally obvious deficiencies in any scheme which assigns dates in such a way that appreciable gaps of non-production appear without explanation. The stylistic sequence in Athenian black figure is secure enough to avoid this danger, but there is a harmless tendency to assign dates close to the middle or end of centuries B C or to work in quarter centuries B C, which are obviously meaningless.

The absolute dates B C proposed depend on other factors. Briefly, there are a few fairly reliable fixed points to which the stylistic sequence can be pegged,

the gaps then filled by judicious observation of the probable rate of change, progress of painters and workshops, and volume of work produced. The criteria for establishing these 'pegs' are of varying merit and can be roughly classified as follows:

(1) Vases or styles dated by events. This usually means their presence in contexts which can plausibly be associated with dated historical events. There are few of this type in Athenian black figure and the historical 'dates' are sometimes imprecise. Marseilles (Massalia) was said to have been founded in 600 and the earliest of the early Athenian black figure pottery which has been found there is in the manner of the Gorgon Painter. In 566 the Panathenaic Games appear to have been reorganised. If the earliest surviving Panathenaic prize vases [295–6] belong to the first or the second of the new games, then Lydos began painting in the late 560s. An Egyptian frontier post at Tell Defenneh was probably overthrown in the Persian invasion of 525. In it were found pieces of standard neck amphorae of the general style of the Princeton Painter. After the battle of Marathon in 490 the Athenian dead were buried in a tumulus which contained several lekythoi by the Marathon Painter [256] and some with early Haimonian elements, and the Plataeans (if rightly identified) in a tumulus which has two late black figure plates, a loutrophoros and more work of the Marathon Painter and from the Class of Athens 581. In 480 the Persians sacked Athens' Acropolis and city, and in the following years the tidying-up filled pits, wells and Acropolis terraces with the debris. The latest material from the Agora includes Little Lion and many Haimonian lekythoi, CHC skyphoi and a few Leafless Group cups. The Acropolis evidence is confused.

Another type of dating by event might be from the naming of contemporaries on vases – but the kalos names prove of limited use in this respect (p. 201); or from the identification of select myth scenes used symbolically to celebrate particular events, but for these we should require some literary confirmation.

(2) Vases or styles may be dated by their excavated context with other objects, usually vases, for which a chronology has been established on other grounds. Down to the early sixth century it is the Corinthian series which is adequately dated by criteria discussed under the last head. There are many tombs and sites where Athenian and Corinthian are found side by side, but most are sixth-century, when, for absolute dates, the Athenian take priority, although the correspondence of contexts with the stylistic sequence of Corinthian is always a useful check. Although plenty of Corinthian pottery reached Athens in the early black figure period it is remarkable how seldom Athenian and Corinthian are found together in tombs in Athens. In these years we find the earliest Corinthian pottery at Naucratis in Egypt is of Transitional to Early Corinthian, dated about 625 to 620, and the earliest

Athenian is related to the Nessos Painter. Rather later the site of Old Smyrna was reoccupied after its sack by the Lydians, and the earliest pottery in use was late Middle Corinthian, dated about 680 to 675, with Athenian in the manner of the Gorgon Painter, examples of the Komast Group, and a Sophilean vase.

(3) Vases or styles may be dated by stylistic comparison with other arts or vases for which a chronology has been established. Our dating of earlier Athenian black figure relies almost wholly on observation of features and motives derived from the Corinthian series, such as were picked out in Chapter Two. Later in the sixth century, if the name vase of the Spartan Arkesilas Painter represents Arkesilas II of Cyrene, it must have been painted in the 560s. His other work is found with and broadly resembles Athenian Siana cups. The earliest sculpture from the columns of the temple of Artemis at Ephesus is likely to be of the period of King Kroisos of Lydia, who paid for many of them and who was deposed in 546. It shows that styles of drapery, with splaying three-dimensional folds, were current in the 540s, at least in East Greek sculpture. On Athenian vases this corresponds with Exekias and middle period works of the Amasis Painter. The Siphnian Treasury at Delphi was erected little before 525 and its relief sculpture very closely matches the early red figure of the Andokides Painter, easily related to his and other black figure work. In the same way rather more advanced red figure can be related to the sculptures on the new Temple of Apollo at Delphi, built about 510. Some other near-absolute dates have been proposed for Athenian sculpture in the sixth century, notably for the breaking of grave stones, but these depend as much as anything on comparisons with the apparent dating of comparable pottery, and form no secure basis for argument.

Chapter Eleven

GENERAL DECORATION

The decoration of Athenian black figure vases was determined by a variety of factors, not the least being the inventive skills of a number of gifted artists who found in this comparatively humble craft a satisfactory and effective means of expressing their views of myth and life, on objects of everyday use. But most vase painters were little better than hacks, endowed with varying degrees of competence and originality, whose work fills out for us this rich conspectus of the decorative and narrative art of an influential city through more than a century.

The earlier history of the craft in Athens played its part, but the quality of the monumental narrative scenes on Protoattic vases of the seventh century is for a while subdued by another influence, that of the prolific schools of Corinthian vase painting. These, as we have seen, introduced the new technique, as well as new shapes and styles of decoration, notably the animal frieze style. For the content of figure scenes Corinthian vases and other arts, as of relief bronze work, helped define the repertory of scenes drawn upon by Athenian painters, but apart from some stock scenes of myth or stock figures like komasts, the Athenian seems to have been quick to invent new scenes or establish new conventions; quick to observe novelties in other parts of the Greek world – an awareness perhaps enhanced by the arrival of artists from outside Attica (see pp. 12, 16, 54); quick to observe consumer demand; more ready too, we might expect, to look to poetry and story-telling whether written down or not, for fresh inspiration, and to exploit myth in the interests of political symbolism, although this is difficult to judge and impossible to prove (see pp. 216, 221 ff.). Despite the limitations of technique a master like Exekias could raise his craft to the status of a major art and prepare the way for the achievements of early red figure.

The reasons for the choice of figure decoration on a black figure vase are sometimes obvious – funeral scenes on a ritual vase intended for the grave, deities on votive plaques, conviviality on drinking vessels. But when, for instance, deities or cult scenes appear on vases of ordinary domestic shapes we may not assume that they were decorated for a specific purpose. A high proportion of the surviving complete vases were found in graves, but when these vases are of ordinary shapes there is no discernibly deliberate choice of

the scenes painted on them which suggests that they were made for this purpose only. Some ritual vases certainly were so designed, and some oil flasks may have been bought for a burial, but many of the other funeral vases show signs of previous use, even of repair. Many, indeed most, are from non-Greek, Etruscan graves. Particular vase scenes may well have been bespoken for a customer, and there are rare examples of a scene apparently aimed at a market – like the many Aeneas and Anchises scenes which reached Italy, where the myth had a special local relevance. But the frequent repetition of a scene by an artist suggests that the choice usually lay with him. Even when the scene is topical or of possible local symbolic significance, or names an Athenian youth, the vase often travelled to Etruria where all these points were probably missed and they may only have been appreciated during a brief period of display in Athens. I imagine the Athenian potters' quarter to have been much frequented by the ordinary observant Athenian. It lay between their market place and a gateway, beyond which was one of the principal cemeteries: a good place to walk, talk, and look.

Interest in the content of decoration led away from a proper interest in the accommodation of decoration to shape, which we may regret. However, the range of decoration and the gradual stereotyping and development of scenes and conventions in Athenian black figure, make possible here as in no other field of Greek art, a detailed study of the evolution of a 'Classic' style. In the following sections an attempt is made to define and to describe these conventions and their development.

For convenience of discussion consideration of the work of red figure artists has been avoided, except in so far as it affects the style of black figure and despite the fact that for part of the period covered it was the new technique that attracted the best artists. This anomaly has little or no detrimental effect on this part of the book. Apart from a few shared scenes, and a very few copied, the later black figure repertory, especially of figure scenes, has remarkably little in common with the contemporary red figure repertory. But it should be remarked that it is only with the red figure of the fifth and fourth centuries that it becomes possible to prove a more deliberate interest in the choice of scenes for vases of common shapes.

Conventions

As in any art mainly concerned with narrative scenes involving human figures, Athenian black figure became subject to conventions of painting, pose and composition, which require somewhat more application from us to understand than they did in antiquity.

The colour conventions are simple. White paint is used for women's flesh, although there were always some painters who drew these parts in outline at least on some vases (e.g., Sophilos [25], Kleitias [46], the Amasis Painter

[*85, 87, 89*]) and especially for isolated heads like gorgoneia [*69, 290*] or on head cups [*115, 121*]; while there are rare mid-sixth century examples of black 'male' flesh for women, and after 500 women's flesh has to be black on white-ground vases. Women's eyes are usually almond-shaped, not the male saucers, and often have red pupils. Only the isolated pairs of eyes on eye cups and the like are carefully shaped with the tear duct marked and even some of these are 'female', almond-shaped. The observant reader will have noticed that the white paint often has not survived on the vase, and that many women have black faces, blank because the incised detail on the overlying, now missing, white did not go deep enough (nor should it) to score the black. The lost white can be detected – on women's flesh or shield blazons, for instance – by the dulled black beneath it. It lasts better on the clay ground itself. Male flesh is 'plain', in this case black, but on early vases it is more often over-painted red, indicating a weather beaten tan: when komasts undress we see that they have sunny chests too [*21*]. But this disposition of colour is not always logical, and in the second quarter of the century we see some red chests below black faces. The red may be used for early monster faces, even female (sphinxes, sirens [*82*]), but is abandoned for males by about the middle of the century although even Amasis offers two red-faced Athenas and there is a red-faced Herakles on a Nikosthenic eye cup. Red and white are otherwise used for pure pattern, or for a rough indication of light and shade – stripes on drapery, animal ribs and haunches, or the pale hair and flesh of mane and bellies. On vases of Group E, Exekias and some followers we sometimes see a warrior's greaves painted one black and one (the farther) red, but this does not seem an obvious case for distinguishing light and shade and the purpose is obscure, since the decorative value is slight. There is less feeling for the use of compensating colour masses than there was in Corinthian vase painting, and broad areas of abstract pattern were avoided although there are a few amphorae and cups of the third quarter of the century on which much of the body is covered with fat stripes.

Indications of age are very simple. The young are smaller but in the same proportions as adults [*Frontispiece*]: small children are not given larger heads. Young men are beardless. Old men have white hair, which may show as thinning or as a mere fringe. They may stoop on sticks. The occasional older lady is more portly. Expression hardly goes beyond an open mouth or staring eye and is better rendered by gesture. There are very few grotesque or malformed mortal faces and only in the second half of the century are Africans given curly hair, thick lips and snub noses [*99*] (compare the earlier pygmies on the François Vase [*46.8*], who are little men). Frontal faces are generally grotesque, or separated from their bodies, or both (satyrs [*50.2, 177*], gorgoneia [*69, 177*], Dionysos [*178*]); but on whole figures they may serve to 'punctuate' a scene, as by Exekias at the side of one funeral plaque in a series.

Development in the representation of anatomy and of figures in action has been adequately described in the first part of this book. It is worth remembering how very slow it was and how only with the advent of red figure was the profile or combined frontal-profile convention effectively broken, and even then not for heads, although there were occasional and successful attempts to show oblique, forshortened views of shields [223] or wheels. The marionette-like figures of black figure fight, run, mourn, converse with poses and gestures which are repeated from generation to generation, artist to artist. Sometimes greater subtlety is admitted or an artist tests nature with the figure of a collapsing warrior or horse, but we never have the impression that he bothered to look at live models when he drew whole figures. However, the representations of running afford a good example of how a figure-drawing convention can be adopted and eventually abandoned in favour of realism. In the seventh century runners on vases are generally stiff legged but the kneeling-running pose (Knielauf) is soon adopted, probably from the East where it served figures demonstrating power rather than movement. The Greeks use it to imply action, running or flying, arms and legs bent like a whirligig swastika, and it is very effective – even when anatomically impossible since most early runners are shown moving their right (or left) arms and legs forward together [295]. One or two artists could get it right before the mid sixth century but it was still possible to make this mistake in the early fifth century. By this time, however, the kneeling pose had been abandoned and already in the last quarter of the sixth century runners may be shown with their legs only slightly bent [298] and sometimes with their elbows well tucked in. They still run with the front leg raised from the ground [302–3], rather than the back leg [306], which gives a more realistic attitude only gradually observed in the fifth century.

The language of gestures in black figure is not a very subtle or extensive one and there is more to observe in red figure but there are a few gestures worth mentioning: the raised hand, palm out, for the valediction of male mourners [265]; hand to forehead for grief or dismay [202–3]; hand to chin in supplication – from the threat of death [67] or for lovers [124; 87]; and many gestures of remonstrance or demonstration such as still enliven the conversations of our Mediterranean contemporaries. The women's gesture, holding the cloak before the face, is a little enigmatic. It is sometimes explained as a ritual gesture of display, but often affected by goddesses or women in moments of modesty or embarrassment (for contestants at the Judgement of Paris, Helen recovered [67, 90] and in wedding processions [77]). The Archaic artist does not like obscuring human features (which is why warriors so often fight with their helmets pushed back) and the women are perhaps to be thought of partly veiling their faces in a gesture familiar enough still in Mediterranean and Arab countries where sun, dust and the view of men are to be avoided by the fair-skinned. The degrees of

nudity displayed by warriors, even in action, demonstrate a convention of some importance in Greek art of all periods.

Whole scenes of both genre and mythical content acquire conventions of composition and pose, some already established in the seventh century. Within these the artist is free to introduce innovations or vary figures, sometimes perceptibly to alter the action or mood of a particular story in accord with his own view of it or with a poem on the subject, or even for purposes of symbolism. It is never easy to judge which if any of these motives determine the development of particular scenes and stories, but the generally accepted conventions do make it possible to observe and speculate on deviants and this is what makes the study of Classical iconography, especially of Athenian black figure and red figure vases, so very rewarding. There will be opportunity enough to demonstrate this in later chapters but it may here be remarked that artists also frequently presented excerpts from the stock scenes – pursuers without a quarry (Gorgons), ambush without victim (Achilles and Troilos), competition without a judge (the Judgement of Paris) – which could still readily be recognised because the conventions or the story were well known. When a new story is shown and no inscriptions are provided to explain figures, some Greeks may have been as much at a loss as we are to explain the circumstance of the actions. There are few such puzzles in black figure, but on occasion there is reason to suspect that the artist (the Swing Painter is one such offender) has forgotten or ignored the point of a scene, secularising myth (with ordinary club-men attacking a chimaera) or leaving out vital elements (lay figures miming Herakles fighting Apollo for the tripod, with no tripod but with Apollo's deer between them).

Inscriptions

Before about 575 inscriptions naming the persons shown in scenes or naming the artists are exceptional on Athenian vases, but within a few years we see the most lavish example of their use, on the François Vase [46], where every mythical figure and most animals are named, potter and painter sign twice, and even some objects of furniture are labelled. On no later vase are the inscriptions so profuse. Some artists avoid them altogether and others are usually inconsistent in their use, sometimes being wholly explicit, sometimes selective, sometimes silent. It is still a minority of vases which carry them, but they can be seen to acquire a certain status value since mock inscriptions are on occasion supplied where either the artist's literacy failed or no proper names were required. These nonsense inscriptions appear already on Tyrrhenian vases and later painters can sometimes be found thoughtlessly to repeat nonsense formulae (the Sappho Painter's lilislis, loloslos, etotot, etc.). On Little Master cups the signature or bibulous motto has decorative value and may be replaced by nonsense or blob letters to preserve the decorative effect.

There are examples too of scenes where sense and nonsense stand side by side suggesting a mixture of copying and imagination.

The inscriptions name figures, rarely adding an epithet, and they are placed in the field near the relevant figures, although once in a separate register over the scene. General captions, like Sophilos' 'Games of Patroklos' [26] are very rare, and legends hardly ever appear (they are rare enough in red figure). Some exceptions are the cry of a mourner at the laying out – oimoi; or Odysseus tied to his mast as his ship passes the sirens – 'lus(o)n', 'let me go' [286]; or the oil merchant's 'Father Zeus, would that I might get rich' [212].

The kalos inscriptions form a special class. They are painted in the field, without reference to the figure scene, with few exceptions where the intention may have been so to designate a youth, athlete or hero as 'beautiful'. Sometimes we see just the word 'kalos'; sometimes the praise is generically for 'a boy' ('ho pais kalos'); but usually the boy is named. These were contemporary Athenian youths, several of whom are identifiable. It does not need to imply familiarity on the part of the painter rather than a general acknowledgement of some favourite of the day, but their true character is elusive and we can hardly dismiss them as flippantly amorous when they appear, for instance, on some of Exekias' 'serious' vases. On the other hand they had not become by then a mere convention since they only begin to appear on vases after the mid century. A lad was likely to qualify for the epithet for only a limited number of years, we might imagine, so vases by different painters naming the same boy are likely to be near contemporary, which is a help for relative dating of painters' work. I give a few examples, with numbers indicating the number of vases on which the inscription appears:

Onetorides kalos: Exekias (5); vases related to the Andokides Painter (2); Three Line Group (1); Princeton Painter (1).
Hippokrates kalos: Manner of the Andokides Painter (1); Three Line Group (1); Psiax (1).

Leagros kalos: Leagros Group (5); (many red figure – Euphronios (12); Euthymides (1); Phintias (1); Eleusis Painter (4); Chelis (1); Colmar Painter (5); early Onesimos (1); and 31 others!).
Sostratos kalos: manner of Acheloos Painter (1); (red figure – Phintias (1)).

If Onetorides was archon in 527/6 (no younger than thirty) he probably could not have qualified as a beauty after about 530. If Leagros is the general killed in 465 he might well have been kalos in the last decade of the sixth century, which is where on other grounds we would place the Leagran vases. A very few women are similarly honoured by name, and extremely rarely a god or hero.

	A	B	Γ	Δ	E	Z	h	Θ	I	K	Λ
625-575	A	ß	Λ	Δ	⸦	I	⊟	⊗ ⊕	I	K	V
575-550	A A	ß	Λ	Δ	⸦ E	I	⊟	⊗ ⊕ ⊙	I	K	V V
550-525	A A	ß	Λ	Δ	E E	I	⊟ H	⊙	I	K	V V
525-500	A A	ß	Λ	Δ	E E	I	H	⊙	I	K	V
500-475	A A	ß	Λ	Δ	E	I	H	⊙	I	K	V

	M	N	O	Π	Ϙ	P	Σ	T	Y	Φ	X
625-575	M	N N	O	Γ	Ϙ	P	� S	T	Y	Φ	X
575-550	M	N	O	Γ⁺	Ϙ	P	S	T	V Y Y	Φ	X
550-525	M	N	O	Γ		P	S	T	V Y	Φ	+
525-500	M	N	O	Γ		P R	S	T	V Y	Φ	+
500-475	M M	N N	O	Γ		P R	S	T	V	Φ	+

NO H OR Ω Ξ = ΧΣ Ψ = ΦΣ

The lettering is done in black, rarely red (see p. 36) and spelling is sometimes shaky. Often inscriptions run retrograde in common with many Archaic inscriptions on stone, and there is very rarely triple dot punctuation between words. I give a rendering of the common letter forms in Athenian sixth-century vase inscriptions since some may be unfamiliar even to the Greek-reader. This is based on a table kindly checked by Lilian Jeffery. Note that in Athens of this period no separate letters are used for long *e* and long *o*, and there are other occasional idiosyncrasies of spelling, peculiar to Athens or to early Greece in general, which again might puzzle a Classical Greek reader. For instance: ει becoming ε or ι (Chiron); ευ becoming υ at name ends (Nerus); εης for ης (Heraklees); δ becoming λ (especially Olysseus); δμ becoming σμ (Asmetos, Kasmos); single consonants for double (rarely the reverse) and ττ for σσ (Netos); the loss of nasals before consonants (Adromache, Sphichs); additional aspirate – θ, φ, χ for τ, π, κ (less often the reverse).

Dedicatory inscriptions naming the deity appear on votive plaques but it is unusual to find a bespoke inscription naming the dedicator, purchaser or mortal dead. Exceptions are on one or two funeral plaque series. Some special painted inscriptions are discussed elsewhere – artists' signatures (p. 11), Panathenaic prize vases (p. 167). Incised inscriptions added after firing do not normally refer to the painted scene but record personal dedications or gifts. Exekias added to one of his vases an incised signature in Attic letters and a gift motto in Sicyonian letters for the purchaser. Keian and Samian letter forms have been detected on other vases. Graffiti underfoot may record prices, but many are monograms or symbols which have to do with the marketing of the vase or of other vases in a batch, and seem to have been put on early in their

career rather than by a retailer. These are most common in the second half of the sixth century. In the same position red dipinti may serve the same purpose and some are found earlier than the 'mercantile graffiti'.

Florals

Some late cups have floral bands as their only decoration; otherwise florals fill subordinate friezes or serve as the decoration of vase necks. The commonest pattern is a combination of lotuses and palmettes, a type already developed by Corinthian painters. In early Athenian black figure the lotus has a broad splaying form with the spiky central leaf shown over the tiny palmette which Greek artists of the seventh century had persuaded to grow there. This lotus type progressively narrows and the sequence can be followed as a useful criterion of date – [5.2, 11.2, 12, 24, 25.2, 42.1, 47, 52, 56]. Before the mid sixth century the central spiky leaf may be omitted [51.1] and the added wavy lines which could cross the calyxes or palmette hearts had been abandoned by about 560. The body of the lotus becomes little more than a support to the spreading outer leaves which frame the intermediate palmettes. Lotus and palmette usually alternate and are often opposed, but we do not see friezes of lotus alone and rarely of palmette alone (e.g., on a handle of the François Vase and work by the Ptoon Painter [51.1]). The interlace is linked by tendrils, but from about 560 these are increasingly often replaced by round chain links [51], which become normal by about 540, and with these the floral elements are normally opposed [92], not alternating. Added colour disappears, the palmettes become more angular with time and their leaves eventually separate [103]. The lotuses progressively thin [188, 209]. The palmettes have a new lease of life with the red figure period, composed in neat circles within scrolls [199, 202].

The lotus and palmette patterns are formal but non-realistic. Friezes of pear-shaped buds are, in their simple elements, more plausible, and alternating buds may be given curling outer leaves like opening flowers, as [142]. Arc links above the buds hint at these opening leaves, and the arcs are regularly repeated below, again as links, as [146]. Some of these bud and flower friezes appear in the second quarter of the century [47, 54], as on Siana cups, and are often brightly coloured, but the more mechanical friezes are later and are persistent. Base rays had once been a floral pattern and are sometimes treated more like leaves than a geometric scheme.

The only plausible florals are the laurel or myrtle friezes which sit like wreaths on the lips of some Siana cups, and the ivy in the same position [35, 40], but also often framing later black figure panels. The ivy leaves soon become mere blobs, and ivy and vine leaves are seldom differentiated in figure scenes. Generally the black figure painter is not very observant of botanical forms, and even where a tree or vine is relevant to the scene it is

usually strictly subordinated to the figures [88] and only rarely given its full value [186].

Animals and Monsters

The wild life of the early animal friezes was borrowed from Corinth, and Corinthian types are observed and followed right to the mid century. Rather more common in Athenian friezes, perhaps, is the grazing horse, which had long been a popular motive on her vases, and from the mid century the odd boar may have his bristles 'broken' at mid-back in the East Greek manner. A feature of the early Athenian animals, not seen at Corinth, is the common double shoulder line, especially for felines.

Animals may appear in figure scenes as attributes (Athena's owl or Hermes's goat), protagonists (magnificent horses, as by Exekias, or hunting dogs) or subsidiary detail (flying birds; running dogs, especially with horsemen). Small flying birds in battle scenes are more probably omens than souls, if indeed they have any significance at all (cf. [75, 271]). Of marine life only dolphins commonly appear, leaping in cup interiors [108] or in friezes. As shield blazons we see whole animals, heads or foreparts. One unusual blazon is a wolflike head with wings attached [93], which looks like a version of a Scythian metal appliqué; a common one is the flying eagle carrying a snake, an obvious omen, and this may appear in fighting scenes (cf.[48]). Snakes are bearded [238], as regularly in Greek art.

Animals in action may occupy the field on their own. We think especially of the fine groups of lions attacking bulls, stags or boars [68, 120] – sometimes rams or goats. The motif is an old orientalising one, but the new compact schemes with crossing or closely engaged bodies win sudden popularity about 570 and appear also in Athenian monumental sculpture. This suggests fresh inspiration from eastern sources, where such groups had a symbolic significance, perhaps not entirely lost in Greek art. Cocks fight on many Little Master cups [109], while on other vases we can see that youths favour the 'sport'.

Of monsters the commonest are sirens and sphinxes, rare the griffin [8, 46.6], as well as those occupied in myth – Chimaera, Pegasus, Kerberos, with centaurs and satyrs, the part-animal immortals. The Arimasps, dressed like Scythians, who fought the griffins for the gold they guarded, are seen on two mid century cups. There are one or two late nameless concoctions, generally for Herakles to deal with [253]. On Tyrrhenian vases some monsters compounded from animal foreparts attached to cocks' bodies shoulder their way into the animal friezes, but of such only the cock-horse (hippalektryon) has substance and may be seen ridden by a boy or warrior [150].

Chapter Twelve

SCENES OF REALITY

Myth was by no means the only source of inspiration for figure scenes in Athenian black figure. On earlier vases the only views of contemporary life were either associated with cult, like the funeral scenes, or of a type where it is not always easy to judge whether some epic occasion was in mind, like fighting scenes. This remains true of Athenian black figure. In some scenes of warriors with squires, or warriors departing, especially with chariots, it appears that we are being shown courtly versions of everyday events which find their exact parallels more readily in the world of Homer than in sixth-century military manners. It requires only inscriptions naming heroes to translate these to the world of myth. This probably explains too why slaves are very rarely depicted or differentiated from free men although they represent a very common and necessary element of everyday life and work. Whatever the mood, however, the action remains 'in modern dress', and whole studies are devoted to purely secular behaviour. These give a valuable picture of life in Athens and the countryside, and in their details they tell us much of antiquarian interest which, through the accidents of survival, has escaped the excavator.

Everyday life

If men dress at all in black figure, the invariable garment is the himation, a rectangle of cloth wrapped around the body with one end over a shoulder [71]. Beneath it may be worn a chiton, a full length belted dress with short sleeves. The short chiton, thigh-length, suits workmen, warriors, or the generally active, including many heroes. A smaller cloak fastened at the neck or draped over the forearm is usually called a chlamys, a name more properly reserved for the short but heavy cloak worn by horsemen. This may be gaily patterned in the North Greek or Thracian manner [196], when it is presumably woollen.

Some late black figure has explicit views of the women's chiton with the fastenings along the upper arm, full sleeves and loose folds over the belt [191]. Earlier representations of better-fitted short-sleeved dresses are also generally, but perhaps not rightly, taken for chitons. Tailoring was no important part of

Greek costume, which made do with basic rectangular shapes, stitched or pinned together. The alternative female costume which could also be worn over a chiton, if need be, was the peplos (sometimes misleadingly called the Doric chiton). This has a looser skirt and a plain overfall from the neck which ends in a straight edge at the waist [46]. It is fastened by pins or brooches at the shoulder [64.2], but they are rarely shown on the vases. The arms are thus left bare, which is one criterion for identifying the dress, but a box-like treatment of the overfall is another indication. One side may be left open, but for the belt, and this explains the one full bare leg shown by some running figures [119] in all but late black figure. Over peplos or chiton a himation may be worn, as by men, but women often draw it over the back of the head and may hold an edge of the garment before the face which is then silhouetted (white on black) before it [67, 90]. Sometimes two or three (rarely more) women share one himation [147]. Some may be groups of goddesses but this is not necessarily true of all. In the second quarter of the century the women often stand holding the edge of their himatia before them, the hem trailing – Beazley's 'penguin women' [73].

Men and women may have their hair bound by a fillet. The broad brimmed travelling hat for men is the petasos [210]. Details of dress, jewellery and coiffure are best observed in red figure but we see spiral bracelets and earring pendants, often tri-lobed [87]. Hunters wear laced boots with prominent tongues to help them on, which may be stylised into wings for favoured figures of myth (Hermes, Perseus, Gorgons, Ikaros).

There are few scenes of the domestic life of women, none much before the mid century. Amasis shows women at the loom [78] and in the latest black figure there are more scenes of them at their ease, in the gynaikeion, spinning, with beside them the characteristic wool baskets with flaring sides (kalathoi) or in an orchard, seated or fruit-picking, where they might be taken for nymphs. The Swinger's name vase shows another pastime [142], rather than ritual. After about 530 there are many scenes, normally on hydriae, of women visiting a fountain house to draw water [224], and waiting by it to chat. A few of the scenes introduce youths washing themselves. The architecture is elaborate even if not particularly consistent, and the scenes may well be inspired by Peisistratid work on the Athens' water supply – Enneakrounos: a system which seems to involve the construction of several new fountains with columnar façades, of the type shown on the vases. On two we read 'Kallirhoe', the name of a revered Athenian spring, and these pictures are good sources for the familiar names of Athenian girls. There is little by way of architecture otherwise on the black figure vases. The Walls of Troy on the François Vase may be mentioned, and their battlements on some late scenes of the dragging of Hector's body, the death of Troilos [201] and the Sack of Troy; the house of Peleus, also on the François Vase and the fountain houses in Troilos scenes [46.5]; a mortal homecoming [77]. Generally a column with

or without entablature is enough to indicate the porch of a house (as for the laying out of a body [265]), the proximity of a temple (three on [225]) or the Hall of Hades [162–3]. The type of capital shown for some columns, with the volutes springing from the shaft, is not one which is normal in the stone architecture of Athens and may indicate a painted wooden form. Most are recognisably 'Doric'.

Male activity when not war-like, athletic, commercial, paederastic or bibulous, is usually concerned with horses – riding them, leading them, harnessing them, or driving chariots, more often for a procession than for a race. The standing frontal chariot is a popular symmetrical composition [54, 92, 190]. A few scenes show what appears to be aimless discussion and are not so much indicative of an Athenian delight in conversation as of the painters' lack of imagination. In the same spirit male and female onlookers may fill the wings for a mythological centre-piece. In red figure only does the artist take a serious interest in relaxed genre scenes involving no special activity or preparation.

It is remarkable how few direct references there are to contemporaries in black figure. The kalos names are the obvious examples, but are not related to the pictures. Some of the women named in funeral or fountain scenes might have been recognisable Athenians for all we can tell. Sappho was named posthumously [311].

Fighting

The vase pictures are a good source of information about armour and weapons. The usual offensive weapons are a thrusting spear or sword. Sometimes the sword is curved and one-edged: the 'machaira' or 'kopis'. Throwing spears are generally carried in pairs and in action, even from horse-back, a throwing thong may be seen fastened to the shaft [121.1]. The shield is of the round hoplite variety, emblazoned, and interior views show the central 'porpax' through which the forearm is passed and the hand-grip, 'antilabe', sometimes with cords also hanging within the rim, perhaps to fasten its cover [56, 141]. Rarely a cloth is shown hanging from the shield to protect the owner's legs from arrows. The 'Boeotian' shield is fitted like the circular variety, but is oval in shape with cut-outs at the waist, and may also have a baldric. Some believe it non-functional, heroic equipment, and it is certainly popular with heroes (as delivered to Achilles), deities or as parade armour [53, 73, 87]. Shield blazons are usually painted white, sometimes incised. They figure animals, heads, limbs, thunderbolts, gorgoneia, to name the more interesting. Commonest are mere blobs, a tripod or a bull's head. A few, like a lion's head or a snake, stand free of the shield, in the round [64.3, 121]. They are rarely if ever significant of identity or allegiance.

There are several basic helmet types. The Attic can be no more than a cap,

as worn by Athena [121.2], and some Amazons [204], but with a high crest. However, its more practical form includes a neck guard and cheek pieces ([162, 188, 236]; Amazons [56, 98]) which are sometimes shown folded up over the temples. The Corinthian helmet [16.1, 52 right, 86, 100, 121.1] with high or low crest, covers the face leaving only the eyes exposed and a slit before the mouth, but it is often worn 'at ease' on the back of the head, even in action (at least in art). The 'Chalcidian' helmet (an inaccurate title) is similar but it leaves room for the ears and the cheek pieces may have a curved outline [52 left]. The stilted crests may have ornate crest holders like animal heads or wheels [47, 86], but the low crests become the rule and a special variety is placed across the helmet, not fore and aft, and is favoured for frontal or rear views. There are also double, half-crests [201 top, 206, 217] to be seen, sometimes attached to antlers [47], and for special effect feathers or bulls' horns may be attached to the crown [47].

The all-metal bell corselet protects chest and back and is often shown with spirals and rib-cage marked on the chest [49, 67, 98]. In about 550 a leather corselet appears, and by the early fifth century has taken over in popularity [86, 141]. Its shoulder pieces are tied across the chest and there are rectangular flaps below the belt. A short sleeveless chiton is worn beneath both types of corselet. Greaves protect the shins and some patterned thigh guards [64.3, 68, 100, 217] (parameridia) and arm guards [100] are shown.

Archers come to have special dress of Scythian type with the pointed leather cap (as [144]) and the close fitting tunic, long sleeves and leggings, often gaily patterned. The pointed cap already appears on the François Vase [46.3; cf. 83 left] and one of the figures wearing it is called 'Kimmerios', 'Cimmerian' – kin to the Scythians whom the Greeks were coming to know on the Black Sea shores. After about 540 the full dress appears [160.1] and may be worn also by Amazons. Quivers have a top flap to keep the arrow flights dry, usually folded back, and some quiver bow-cases of Scythian type are also shown. The Scythians, like the northern horsemen with their patterned cloaks, are thought to have been introduced to the streets of Athens by the tyrant Peisistratos.

There are lighter arms too – a slinger (cf. [95]); and lighter shields of wicker and skin, either of the 'Boeotian' shape, but seen in profile worn on their backs by charioteers [126], or the crescent-shaped pelta carried by Amazons and others. Trumpeters usually merit separate studies, standing to blow [169], left hand on hip.

Sometimes much of the armour is omitted and with near-naked combatants it is hard to say how much is due to the Greek artists' interest in 'heroic nudity', how much to contemporary practice dictated by hot weather or the price of a bronze panoply.

Combat schemes are stereotyped and without inscriptions it is not possible to tell whether a heroic encounter is being portrayed. When we are so guided

we can see that victorious action is normally shown from left to right and the dead bodies normally lie with their heads directed towards their friends. Mêlées with chariots may be seen, but not often with horsemen. Collapsing and fallen figures of men and horses are rendered with varying success.

Popular related scenes are of arming, where a characteristic pose is stooping to clip on a greave [237], or the warrior departing [196]. For the latter a chariot may be shown and wife and child attend. By the end of the century the scene is usually more realistic, with a wife pouring from a jug for her husband to make a libation, or simply standing with a father or brother as he sets off. A common participant in these later groups is an archer in full rig as also in [187] where omens are being taken by inspection of entrails.

On some mid century vases we see a mounted squire leading his master's horse or accompanying his fully armed master [48], presumably an indication of contemporary practice in training or service. On occasion the warrior himself is seen jumping from his moving horse in the military exercise of the 'anabates'. Chariots, whether for racing or fighting, are two-horse, sometimes with one or two trace horses, and there are some fine harnessing scenes from Exekias on (cf. [83, 225]).

Wine, women, boys and song

'Komast' dancers appear on Corinthian vases before 600 and are introduced to Athenian vases by the Komast Group artists, remaining popular beyond the mid century. They wear short, tight, padded chitons [23] and perform their bottom slapping, kicking dance often with drinking horns or cups in their hands. Some may be naked (more often as time passes) or with a shoulder ring like the sleeve of the chiton but probably intended for a wreath or ribbon [21], as it is seen worn by men dancers later in black figure (on the Affecter's vases). Komasts are mortal, and may dance with naked women who rarely themselves don the distinctive costume [22]. Before the mid century in Corinth they become assimilated to satyrs and can intrude in Dionysiac scenes. In Athens the transition is less clear and it may simply be that men gave up the special dancing costume, but later Athenian komasts impersonating satyrs contribute to the early history of the Greek theatre, and the padded costume is seen again in the fifth century for actors in comedy.

A few vases of about 500 show men dressed up as horses supporting riders [137], or as birds, in dances which seem to anticipate New Comedy choruses, while one dressed as a satyr, dancing for Dionysos, might be our earliest real actor [289]. Other late vases show men riding dolphins and ostriches, or dances of 'minotaurs'. Since a pipes player attends once these too might be 'live' translations of mummery. Scenes of pick-a-back (ephedrismos) and men on stilts [144] may be in like case and there are late vases with warrior dancers – pyrrhichists (cf. [184]).

Greeks climbed onto couches for their feasts by about 600, leaving the women to sit at their feet, or apart on chairs, except where some more intimate service was required of them. The couches on Athenian vases usually have block legs with cut-outs below, painted with palmettes [161, 265], but a few have the turned legs, which are probably an eastern feature. Below (that is, beside) them a three-legged table usually stands with cakes or strips of meat upon it [36], but this is often omitted in later scenes, where drinking and songs are the prime concerns. The men recline on their left elbows, supported by cushions [177, 219]. The full paraphernalia of the symposion is best studied in red figure and there are comparatively few black figure scenes except on some Siana cups and later, in the red figure period, but the musical instruments used here and in other scenes may be mentioned. The double pipes are played with the help of a mouth band which is not always shown [137, 182, 220, 222]. The pipes case, with a side pocket for the mouth piece, may be seen hanging in the field or from an arm, or elsewhere [235.1], but early ones are a whole small animal skin. Men or women may play pipes; clappers are held only by women, maenads or nymphs [218, 221] and understandably accompany dance, not song. Of the stringed instruments there is the ordinary lyre with horn shaped arms and tortoiseshell sound-box [36 left, 77 above], or the barbiton which is more heart shaped with long arms. The kithara is a heavier instrument with angular sound-box and elaborate arms, its protective cloth often shown hanging from it [140.1, 165, 193, 214, 222]. This is for more serious playing and it is often carried by Apollo, or by a soloist who mounts a stand (bema) to perform between judges (compare Herakles, [165]). Such contests appear on some Panathenaic and related vases – for pipes players in the sixth century, for a kitharode in the fifth.

Mortal love-making is usually shown as a group activity with couples performing on couches as at a feast, or more often standing in various poses [61]. Entry from behind is the preferred posture. Male masturbation is occasionally shown [82.2], fellatio rarely. These scenes are commonest on Little Master cups (as by Elbows Out) and the Tyrrhenian vases. On the latter the men may have red bodies like komasts, and some scholars take them for satyrs, although tailless. But while everything in the earlier history of komasts seemed likely to lead to this licentious behaviour, there is nothing in the later habits and appearance in black figure of satyrs and maenads (always dressed) to suggest that they had ever so cavorted. It could be that these komasts are beginning to claim some standing as satyrs, with the occasional ivy wreath, vine or large kantharos, which are Dionysiac, but these have nothing to do with their sexual gymnastics.

Male homosexual activity is so commonly shown that it acquires icono-graphic conventions of its own, and is promoted to being a main scene on large, fine vases – a status very rarely achieved in black figure by the heterosexual encounters, except of maenad and satyr, or a well-mannered

embrace of man and wife [211]. The suppliant lover approaches with one hand raised to the boy's chin, the other lowered towards his loins [124, 183], or bearing the love gift of a cock [136] or a dead hare. Consummation is achieved standing, from the front, intercrural [136], rarely under cover of a cloak, and there are usually male onlookers. The scenes appear regularly from about 560 on.

Sport

Most representations of athletics on black figure vases fall into one of three classes. On vases of the middle two quarters of the century we see a few stock scenes – pairs of boxers squaring up, their wrists and hands bound in thongs of leather; a pair of wrestlers grappling; a foot race, jumpers with their jumping weights (halteres) [151]. These are treated as genre scenes simply, with no specific association. Where chariot races are shown it is always possible that a heroic event was intended, like the funeral games for Patroklos on the François Vase and on a dinos by Sophilos [26]. The early, grotesque treatment of runners has already been discussed (p. 199).

The second class comes with red figure and the growing interest in the patterns of anatomy. In black figure there are fewer and less successful attempts at showing the athlete's posturing with the discus, testing the straightness or tip of their javelins, or practising wrestling throws, but there are some, and the popularity of athlete scenes painted on vases in the new technique encouraged a comparable range of similar scenes on vases painted in the old.

The third class comprises the scenes shown on the reverses of Panathenaic amphorae or on vases of Panathenaic type referring to events in the games at Athens. The earliest have the foot race [295, 298], horse race [300], a chariot [299] or boxers. In the last quarter of the sixth century we see the full pentathlon range–discus, javelin, jump, foot race, wrestling. Special events on these and other vases involve the race in armour (for 'hoplitodromoi') usually wearing only a helmet and carrying shield and spear [306], and javelin-throwing from horseback [304.2], from about 400 on. Panathenaics of the 330s and later show the new heavy boxing gloves in use.

The athletes are usually naked and the odd white loin cloths worn in the Perizoma Group are exceptional [219]. The toilet gear of strigil (scraper), oil bottle and sponge, is rarely shown in black figure, common in red figure. Trainers attend or intervene with their long canes [301.1], and there may be admiring bystanders – never women. A tripod cauldron is the most valuable prize shown, and a victor may be seen beside it or carrying it [145.2; cf. 139], but often only wreaths or fillets, which may be tied around the head, arms and legs, indicate success.

Commerce and industry

The black figure vase painter observed a wide variety of banausic activities but depicted them rarely – possibly on demand by professional customers.

In Amasis' scene of women busy at the loom [78] wool is being weighed out, and at about the same date Taleides shows men weighing bundles, perhaps of wool [125]. A generation earlier a Laconian painter had shown the Cyrenean king, Arkesilas supervising similar activities. As usual in this period, like is weighed against like, not against weights. Of other scenes of retailing there are few until the last quarter of the sixth century and the early fifth, when we see oil being dispensed into alabastra from pelikai via funnels [212], for men or women customers. But such scenes were never very popular and late studies of a fishmonger (cf. [216]), butcher [287] or cooks are exceptional.

Industrial activity was closer to the interests of the potter/painter who was well placed to observe them. Smiths at work on tripods are seen soon after 550 and there are a few later scenes of forging showing a good range of the expected tools [285]. Carpenters are shown also, and cobblers, their clients standing on the work table so that the leather can be cut or marked around their feet, and with a bowl beneath the table for water with which to soften the leather for cutting [229]. These scenes too are rare, but there are rather more of potting, from a Little Master cup showing work on the wheel being turned by a squatting boy, to a late scene of the whole shop with work on the wheel, inspection, and the kiln being raked out.

Of farming activities ploughing and sowing are seen most often, earliest on a Siana cup (Burgon Group) where the association may be religious. Otherwise we have olive picking [186], the olive press and several scenes of the vintage with the grapes being picked (on an Acropolis plaque) or more often being trodden. The personnel may be satyrs but the equipment is sixth-century Athenian. Amasis offers the earliest and best of these scenes [89].

Warships with a ram prow, sometimes in the form of an animal snout, and a raised stern, are sometimes chosen to decorate the inner rim of dinoi [102] or craters, from Exekias on. The steering oars and ladder-gangplank are shown at the stern, and the sails are turned fore and aft so as to appear in the profile view. Some of the oared ships show two banks of oars and on one vase a piratic attack is perhaps being mounted on heavier, round-bottomed mer-chantmen [180].

Religious occasions

We see little enough of temples in black figure: at most a token column, but altars appear quite often, sometimes in myth scenes [67, 135, 143], like the deaths of Priam or Troilos, or the labelled altar on the François Vase outside Peleus' house [46.5]. They are generally block-like, sometimes with one side

raised as a form of wind break for the burning surface [67, 135, 143] and sometimes with the architectural elaboration of scrolls. In sacrifice scenes offerings are carried in baskets, and animals are led up to the altar, often with musical accompaniment. The bones and fat are burnt on the altar itself and we may see the tail of the sacrificial animal twisting in the flames. The deity invoked rarely attends, in 'live' or statuary form. It is usually Athena [135] but there are several late scenes where an image of Dionysos is attended by dancing women, rarely characterised as maenads and with satyrs. Earlier the mask of Dionysos alone is shown, such as might be attached to a pillar as a cult figure. There are a number of minor religious scenes on late vases only – a bull alone by an altar or laver may be enough to indicate sacrifice; wayside shrines with a herm and sometimes an altar also appear, with men or women attending them. The herm is a pillar topped by a bearded head of Hermes, and with male genitals, usually erect, fastened or carved in front [243].

A libation is commonly poured at the departure of a warrior or on a similar occasion, even by deities [246]. A wife or mother holds the jug, the man a phiale. Or the warrior may inspect the entrails of a sacrificed animal (extispicy) to judge if the omens are good for the enterprise [187].

There is not much indication of special festivals. In some Dionysiac scenes the ritual winnowing fan (liknon) may be introduced, and the monster phallos carried on a lip cup must illustrate a rustic celebration for the same god. His impersonation by the archon basileus and passage through the streets of Athens in a wheeled ship during the Anthesteria festival is also shown [247]. The Dionysiac associations of most decorated vase shapes may account for this interest in the more colourful scenes of his worship, rather than those in honour of the city goddess.

The Greeks had no marriage ceremony. Amasis shows us the procession to the groom's house, accompanied by the wife's mother with a torch, while the groom's mother, also with a torch, waits at the new house [77]. Next morning guests arrive with presents. The great frieze on the François Vase brings all Olympus to Peleus and Thetis in chariots or on foot [46.5; cf. 24–5]. Simpler scenes show the earlier procession with bride and groom in the chariot, accompanied by deities and presents of boxes (of linen, presumably) and cauldrons [267]. Some are mythological – Peleus and Thetis, Kadmos and Harmonia, and the earliest, Helen and Menelaos (Sophilean) – but where there are no inscriptions or attributes we may reasonably think of a secular occasion.

The laying out of a body (prothesis) appears on funerary plaques [265] and some loutrophoroi and phormiskoi. The dead lies on a bier, his head well propped up and the chin strap keeping his mouth closed sometimes also shown. Women are busy or mourning by the bier itself, according to prescribed custom, but male mourners may approach with one hand raised in the ritual gesture. A column may indicate the setting, in the house porch. On

Exekias' plaque series we have also the procession of guests including chariots, mourning in the house and preparation in the courtyard [*105*] for the 'ekphora' to burial. Lydos and some later artists show a procession of male mourners [*71*], hands raised, on foot or horseback. The Sappho Painter is fond of funeral scenes, and apart from his 'prothesis' plaques he shows us preparation at home for the 'ekphora' [*266*], interment [*264*], and mourning by the grave. One or two earlier scenes show the 'ekphora' itself, by cart or pall bearers [*220*]. Rounded or rectangular grave monuments are shown, usually painted white and with some wildlife upon them. They correspond with excavated monuments of the same date. A very few late scenes show these block monuments topped by a sphinx or siren, perhaps a grave marker, with men attending.

Chapter Thirteen

SCENES OF MYTH

The conventions which govern the depiction of myth scenes in Athenian black figure have been discussed in an earlier chapter. Here, by way of introduction to the description of the scenes themselves, it is necessary only to sound some notes of warning.

Athenian black figure gives us by far the richest corpus of mythological scenes in Archaic Greek art, but there are limitations on its value as representative of Archaic Greek iconography as a whole, and although these limitations are not too constrictive, they need to be kept in mind and explained. First, there is the clear indication from other sources in Athens, notably the architectural sculpture, that it was possible for an Athenian artist to set a scene in a different way and possibly with very different narrative details. Secondly, Athens is not Greece. There are, for instance, rich and earlier series of myth scenes in Peloponnesian art on bronze reliefs and Corinthian vases. Sometimes Athens' debt to this tradition can be traced, sometimes her independence of it. The stylistic and technical influence of East Greek artists in Athens in the sixth century is clear, and we may suspect iconographic influence too. Although Ionia so far has offered little with which to control this, it is clear that there was no absolute 'commonwealth' of iconography in Greece, and that Ionian artists too had their own views. So this is an incomplete account of the Archaic Greek artist's view of myth, although it represents the bulk of the available evidence for it.

In this chapter it has proved convenient to group scenes by their protagonists or by thematic association in a poem, like the Trojan cycle of epic. It should not be thought, however, that the artists took a similar view of their sources. Artists may be shown to be individually interested in particular stories but not, for instance, in the Iliad as a source, and the rather haphazard and scant illustration of the Homeric poems shows that the artist's interest was not in the poem as such, but in the opportunities offered by particular episodes, such as the companions of Odysseus, translated by Circe, or well-tried themes like the blinding of Polyphemos. The situation improves, but not impressively, towards the end of the sixth century and with red figure, but not to lead us to believe that a poem alone could have prompted a series or cycle of scenes. The Theseus episodes seen on late vases may well have been

sung in a recent poem, but their general popularity, and that of the poem probably relate to the new political significance of Theseus in Athens. I have argued elsewhere that Herakles, as protégé of Athena, may have enjoyed his enormous popularity in Peisistratid Athens (of the years from about 560 to about 510) because the tyrant Peisistratos identified himself and his fortunes with the hero, protected by the city goddess. So if the pictures cannot always help us towards a better appreciation of current literature (mostly lost) they may have even more to offer on a broader social or political level. This is a subject difficult to explore and fraught with inconclusive argument.

Finally, there is the fact that from 530 on, red figure became the senior vase painting technique in Athens, and here no notice is taken of scenes on red figure vases. But while this means that this account of myth on Athenian vases after 530 is seriously incomplete, it still has a significant unity and independence, since the black figure iconography is generally different from the red figure, both continuing an old tradition and developing new interests.

The Gods

The Olympian deities are seen very frequently on black figure vases: not often as protagonists in myth, but as supporting figures to heroes or in their own right with no action involved. As individual patron deities of towns they had a more important function in the living religion of Greece than heroes like Herakles or Theseus, and it required more ingenuity on the part of the epic poets and their followers to integrate them in the scheme of myth history. But their attributes and separate functions as 'equal' members of a family rather than individual local deities had already been defined in song and literature by the eighth century and this is the spirit of the vase representations, at some remove from contemporary religious practice and reflecting rather their role in myth history. We look at them first separately, with some myths in which they take the lead, then as a family, at home and in battle; but they will recur often in scenes described in later sections of this chapter.

ZEUS, in common with the other mature male deities, is usually shown in black figure dressed, although later he generally appears naked, or nearly so. His principal attribute and weapon is a thunderbolt, stylised from a selection of spikes, wings and florals, as on [62, 206], but he may hold a fine sceptre like a king, and his throne is often a very elaborate piece of furniture. His eagle is not often seen. He is seated for the *Birth of Athena*, who springs fully armed from his head, and who appears emerging from it in several scenes from about 565 on [62, 123.1] and standing on his lap [175] from about 550 on. He may register surprise or pain at her appearance, and Hephaistos is often shown starting away from him, shouldering the axe with which he has just delivered his sister goddess. One or two women [62] may attend Zeus

– the goddesses of child-birth, Eileithyiai [175]. A seated Zeus, attended by the two women (winged on [138]) but without Hephaistos, is presumably taking pre-natal care. Dionysos' 'second birth' from Zeus' thigh where he had been sewn by Zeus for full gestation after Semele's premature delivery, may be shown on the Diosphos Painter's name vase [272]. Here the young god stands on his lap holding torches and is hailed as 'light of Zeus' – Dios phos, but some see young Hephaistos here. For Zeus' amours we have to wait for red figure, which explains a late black figure pursuit of *Ganymede* (a youth with a cock), but *Europa* is seen on some late vases riding the Zeus bull [244] – not to be confused with the maenad who is seen similarly mounted.

APOLLO is usually beardless [193, 214; but 140], dressed and may hold a bow, a laurel branch or a kithara. His sanctuary may be indicated by a tripod (Delphi) and he is once shown riding a tripod over the sea, or by the palm tree (Delos) which supported Leto while she bore him and his sister Artemis. On two late vases he draws a bow against the serpent *Pytho*. He acts often with Artemis on family affairs. On Tyrrhenian vases they are seen shooting down the many *children of Niobe* [60], who had boasted of her superiority to a mother of mere twins, and meting out the same treatment to the giant *Tityos*, who tried to carry off Leto. Tityos is shot in the back, and once shown hairy, like a satyr, an indication of his horrid nature. Leto stands between rescuers and attacker [59]. Tityos' fate is seen on few later black figure vases. We shall have to return to Apollo's Delphic disputes with Herakles.

HERMES is bearded and, in his role of messenger and herald, is usually dressed for travel with a short chiton and chlamys, as on [103, 157], sometimes with an animal skin on top, but in a few scenes before the mid century he wears a long chiton ([62], where he identifies himself as of Kyllene). His sun hat (petasos) has a wide brim and sometimes a high conical crown with the brim turned up at the back, Robin Hood style, as on [107, 154.1, 226]. He is booted and carries a herald staff (kerykeion, caduceus) with the open 8-shaped terminal which is only later stylised as entwined snakes. His hat and the tongues of his boots may be winged, and once or twice he is winged himself [140]. He is sometimes accompanied by a dog, ram or goat, and may even ride the last two. His only regular following is a group of nymphs [218]. Generally his function is to attend divine and heroic scenes, not to become involved, and as a result he is probably represented as often as any major deity except Athena and Dionysos. But he takes an active part with Kerberos when Herakles has to fetch the monster from the underworld [163], and sometimes has to hold Paris to his Judgement. As a baby he stole *Apollo's cattle* and is shown as an adult with a herd of bulls on a Tyrrhenian amphora and late vases [282]. His slaying of *Argos*, who had been set to watch Io, translated by Hera into a cow, is another rarity in black figure. Argos is shown as a two-faced man, while Io and Hera are in the picture too [107].

DIONYSOS, god of wine, is bearded, fully dressed and usually heavily wreathed with vine or ivy and holding a cup (normally a kantharos or drinking horn), and sometimes a vine tendril. His ship with the vine mast on Exekias' famous cup [104.3] probably refers to his encounter with the pirates whom he turned into dolphins. Otherwise he rides a donkey or travels by chariot [242, 256], often with a woman, bride (Ariadne) or mother (Semele), and since he was a comparative newcomer to Olympus these scenes which begin about the mid century, may allude to his arrival there. Most commonly he stands, sits or reclines [235] (late) often with a consort [81, 171], placidly, while his troop of satyrs and maenads dance or play about him, and on the Amasis Painter's vases he watches his satyrs at the vintage [89]. The most important Dionysiac procession was the one that escorted the drunken Hephaistos back to Olympus. The François Vase gives the earliest and fullest version [46.7] of the Return of Hephaistos with the gods attending, and with Hera pinned to her throne waiting to be released by Hephaistos who had prepared the trap for her before Zeus cast him from Olympus. From the right Dionysos and his followers escort the god whose reluctance had been overcome by wine. This is the prototype for many later less explicit processions where the gods in Olympus are omitted [65]. Dionysos' facing head or mask forms the centre piece on a number of vases [178], and he and Athena are the only Olympians whose worship was at all often shown in Athenian black figure [247]: Athena as city goddess, Dionysos probably because of the function of so many of the vases involved.

On the François Vase HEPHAISTOS is bearded, fully dressed, his lameness shown by a twisted foot [46.7]. As craftsman god his attribute is commonly a double wood axe, especially in action scenes, as at the birth of Athena [62, 123.1]. On the later vases is he given shorter working dress and tongs which refer more directly to his role as smith.

The sea god POSEIDON figures little, looking like Zeus but holding a trident [103 left, 112, 140], a fish or a dolphin. The figure with a trident riding a horse-fish (not a true sea-horse) on late vases [250] might be Poseidon, Nereus or another marine power.

ARES, in the Kyknos affair (see under Herakles) or fighting giants is simply a hoplite warrior. On Olympus he was rather an outsider and his position in the François Vase scene of the return of Hephaistos [46.7 left] indicates his failure to achieve by force what Dionysos had achieved by wine.

Of the goddesses ATHENA is naturally the most popular. She does not regularly appear armed before the second quarter of the sixth century – spear only on [94] and in the Judgement [38]. Her helmet is of the Attic variety, often in its most summary form – a mere cap to support a high crest [135]. She wears a peplos and, especially on Panathenaic vases [145.1], a knee-or calf-length over-garment [135, 139, 162, 223] (ependytes) sometimes open at the sides. The Aegis, a scaly magic goat skin given her by Zeus, is worn like a

bib, its curly edges stylised like snakes [*297, 301.2*], but not usually bearing the gorgoneion commonly shown later [*227*]. Her owl seldom appears, and on a few late vases she is shown winged [*?207*] – a trait learned from East Greece. Apart from her birth, already considered, her appearance in black figure is usually in her role as patron of heroes – of Herakles and to a lesser degree of Perseus. By the mid century her association with a chariot may have been established by the scene of Herakles' Introduction to Olympus (see below) but is used again later in gigantomachies [*284*]. It is interesting to notice how the Amasis Painter seems to insist on a friendly relationship with Poseidon, while Classical art dwells on their struggle for possession of Athens, as in the Parthenon pediment.

HERA is given no special attributes in Athenian black figure except for an occasional finer crown and sceptre. She is attacked by satyrs on a vase of around 540 – an event recalled in red figure by the Brygos Painter. APHRODITE, the third of the goddesses in the Judgment of Paris, is hardly better served. As early as 570 she is shown with Eros in her arms, but *Eros* is to be the darling of red figure not black figure.

ARTEMIS is more interesting to the iconographer. In the seventh century she had been shown as a Mistress of Animals, often winged, holding one or two beasts, usually lions. She appears thus on the François Vase handles [*46.2*] and a few other Athenian vases, but not much after the mid century; last on a lekythos by the Amasis Painter. In myth she is identified by her bow or deer and appears often in support of her brother Apollo [*59, 60*]. She caused the hunter *Aktaion* to be torn by his dogs for an offence variously specified in antiquity (boasting, lusting or viewing her naked) and he suffers this fate alone, on occasional vases [*258*] from about 560 on.

IRIS carries a caduceus like Hermes. On the François Vase she is wingless, but later usually winged, and on some late vases she attends Hector's dragging round the walls of Troy. The Diosphos Painter has her carrying a letter and on a late cup she appears with satyrs, recalling the assault on Hera (see above).

DEMETER and her daughter PERSEPHONE carry torches or ears of corn, but they are infrequent on Athenian black figure. There are, however, occasional pictures of their male partner at Eleusis, *Triptolemos*, seated in his wheeled throne [*146*] (soon to become a winged chariot in Greek art) and holding ears of corn on his mission to carry the blessings of agriculture to earth.

The gods acting and fighting together as a family provide many important black figure tableaux. Most deities, even Demeter, may be seen with a chariot (as [*226*], *Leto*) and on the analogy of the Athena and Dionysos scenes, we may suppose them to be on their way to an Olympian council, or preparing for that other great muster of the gods at the wedding of Peleus and Thetis. The gods sit together to greet the return of Hephaistos on the François Vase [*46.7*] and often later for no specified occasion. More often they stand, converse, or accompany each other's chariots [*103, 112, 140, 153, 193*]. There are some

popular twosomes which are easily explicable: Artemis and Apollo, Zeus and his chamberlain Hermes [155], Athena and the newly promoted Herakles.

The battle of the gods and giants appears first on Athenian vases in the 560s and the finest scenes of the mass action are early – on fragmentary vases from the Acropolis by Nearchos, Lydos [64] and others. On later vases the action around Zeus' chariot, or separate encounters occasionally grouped in twos or threes are preferred. It is the early scenes which come closest to the spirit of the fine stone relief frieze from the Siphnian treasury at Delphi which is appreciably later (about 525), and on these only is Ge, the earth mother, seen supplicating Zeus for her giant children. The giants are dressed and fight as hoplites, but a few may have scaly corselets and some throw stones. The centre piece is generally Zeus' chariot, with Athena fighting beside it and Herakles upon it, with one foot on the chariot pole, plying his bow, which is his only weapon in this action [206]. Herakles' intervention on the side of the gods was decisive and Athena naturally keeps close. On many vases after 530 she is seen handling a wheeling chariot herself, riding down a giant. The scene is then an isolated one, but once Herakles stands beside her [284]. Her special adversary is Enkelados [121]. Zeus is seldom shown in armour. He wields a thunder bolt as he mounts his chariot, or, later, fights on foot. Hermes is sometimes in armour, but rarely fights in a separate duel, while Ares appears as an ordinary warrior. Poseidon is armed only in the early scenes but is most often naked or lightly dressed. He fights with his trident, rarely a spear, and his special contribution is to crush the giant Polybotes with an enormous rock, broken from the island of Kos which, when it falls, will become the island Nisyros. Apollo and Artemis rarely fight, with bows. Dionysos, wreathed and wrapped in an animal skin, fights with spear and shield and is helped by lions. Hephaistos, on an Acropolis vase, plies the sacks of his bellows to heat the coals which he will hurl at the giants, as on the Siphnian treasury frieze, but he is not to be looked for in the later versions. Hera dons helmet and shield and fights with vigour by her consort's side. A good example giving most of the scenes is [154] where our illustrations show in action Hermes, Hera and Dionysos wearing an animal skin and helped by a snake and lions; then a god in a chariot and a goddess (not shown); finally Poseidon, another goddess, and Athena in her chariot.

The whole spirit of these scenes of the Olympians as a family is a new one in Greek art, although long familiar in the Homeric poems. The scenes begin to appear about the time of the reorganisation of the Panathenaic Festival in 566. This possibly involved Homeric recitals or competitions, and the peplos robe brought to Athena on the Acropolis at the Great Panathenaia was embroidered with scenes from the war with the Giants. The vase scenes which belong to the early years of the reorganised festival, and were many of them dedicated on the Acropolis, surely refer to it.

Herakles

Herakles, by origin a Peloponnesian hero, became the most popular mythological figure on Athenian black figure vases probably because his patroness was Athena who was the city goddess and is regularly shown with him. The association may have been exploited politically also and Peisistratos, the Athenian tyrant, returned from his second exile with a charade recalling nothing more than Athena's introduction of Herakles to Olympus by chariot. Theseus' eventual challenge to his popularity in Athenian art also had its political overtones.

On the vases he is a bearded figure, often wearing his lion skin with the paws knotted across his chest and usually with its mask as his cap. The skin may be held in by a belt, or, later, fly free like a cape [228]. Beneath may be a short tunic or chiton. He is often wholly naked, rarely dressed as a hoplite and never helmeted. His usual weapon is a club (not before about 570 on Athenian vases) bow or sword, not a spear (but note [68]). As an archer he may appear in Scythian dress but not with a Scythian cap. There are rare examples of a beardless Herakles after 520, becoming commoner in the fifth century.

Athena is very often shown helping or encouraging him. The only other regular attendant figure is Iolaos, his charioteer, who may be waiting with the chariot, holding Herakles' useless weapons while he wrestles with the lion, or simply watching [192, 194]. His only active help is against the Hydra. Most of the scenes are of violent action and involve the Labours set by King Eurystheus of Mycenae. They appear first in Athenian black figure in the second quarter of the sixth century, but the canonic Twelve Labours of the Classical period and later were not all equally popular in earlier days. Most of the other Herakles scenes are also no earlier than the second quarter of the century except for some involving Nessos, other centaurs, Nereus and Prometheus.

We take the Labours first. *The Nemean Lion* was invulnerable to ordinary weapons. From the mid century on Herakles sometimes takes a sword to it, once his bent sword is shown, and often his useless weapons are hung up, laid aside or held by Iolaos who is commonly in attendance. Standard schemes for the fight are as follows:

(a) the Lion rears up against Herakles who threatens it, grasps a paw, or may not touch it at all [189]; (b) a standing fight with the bodies crossing, Herakles' arms around the Lion's neck and the Lion sometimes clawing Herakles' leg [97]; (c) as the last but with the Lion's head turned away; (d) with both bodies going right, the Lion beyond Herakles [94]; (e) wrestling on the ground, Herakles kneeling with his arms around the Lion's neck, their bodies extended in opposite directions, or (f) in the same direction; (g) Herakles kneels and throws the Lion forward over his shoulder (very rare).

The last three of these versions are seen only after about 530. All these groups resemble ordinary wrestling throws or holds. The artists occasionally show the hero wearing a lion skin, forgetting that he acquired it from this very Lion. Once he is shown gutting the creature. This is the most popular of all the Labours and well over five hundred black figure representations are known – perhaps more than those of all the other Labours put together.

The Hydra has from two to nine (usually nine) snake heads emerging from a plump, coiled body, sometimes with a forked tail, like a massive shell-less snail. Herakles usually attacks with a sword, sometimes with a sickle (harpe) and is often helped by Iolaos. The Athenian artist seldom admits the crab, sent by Hera to create a diversion by nipping Herakles' heel, or Iolaos' torch with which he seals the severed necks, or the waiting chariot, which are often shown in non-Athenian scenes; the monster too is normally intact. [*270*] is unusually explicit.

Herakles captures the *Erymanthian Boar* with his bare hands and may be shown grappling with it, lifting it, carrying it on his shoulder, or trundling it wheel-barrow fashion [*166*]. Eurystheus, observing his return, hid in a part-buried storage jar and Herakles is often shown about to tip the boar in on top of him [*192*] – the only Labour which lends itself to humour. The capture is shown barely before the middle of the century; the confrontation with Eurystheus barely before the last quarter.

The Kerynitian Deer was Artemis' beast and had a golden horn. Herakles captures it alive [*209*] and is once shown breaking off its horn. Both Artemis and Athena may attend (see also below with Apollo). Of his other animal quarries the Stymphalian Birds are rarely shown, attacked by sword, bow or sling [*95*], and the Thracian Horses of Diomedes are as scarce [*? 170.1*], once shown winged and attacked with a club [*257*]. The Cretan Bull, which had to be brought back alive, is far more common, from the mid century on. Apart from scenes of the capture, the most characteristic group, of the late period, shows the Bull brought to its knees [*194, 274*] and being tied by its muzzle, legs and sometimes genitals.

Herakles' encounter with *Geryon* and theft of his cattle, was one of the more commonly represented Labours. Geryon appears as a triple warrior, joined at the waist, and Herakles advances on him with bow or club having already dispatched with an arrow one of the three bodies, which is col-lapsing [*96*]. Other figures shown may be the skin-capped herdsman Eurytion who has already been struck down, his monster dog Orthos, who may be two-headed, and the cattle.

Orthos' brother, the dog *Kerberos*, had to be brought out of Hades [*162–3*]. The monster is usually shown with two heads and sometimes with snaky excrescences. Herakles negotiated his surrender and does not have to fight him, merely to lead him, but he keeps his club ready, as well as the chain.

Hermes may be shown coaxing the monster, and Persephone watching. Few late scenes show Herakles' acquisition of the *Apples of the Hesperides*, either supporting the heavens while Atlas fetches the fruit [*252*], as on the famous Olympia metope, or himself attacking the serpent coiled around the tree [*233*]. On his way west he met *Helios* (the Sun) and a few late vases show the confrontation, Helios in his winged chariot, often frontal [*260*], and two have Herakles sailing in the Golden Bowl which Helios provided [*232*]. There are no scenes of the cleansing of Augeas' stables.

Herakles' fight against the *Amazons* is generally conducted as a regular battle, and the hero has warrior companions who often fare far less well than he. Herakles' opponent, often shown falling away from him, is sometimes named – Andromache [*56*]. The fight is second in popularity only to the Lion and better represented than most Labours in the second quarter of the century.

So much for the Labours, but there are subsidiary episodes. To discover his route to the Hesperides Herakles grapples with *Nereus*, the Old Man of the Sea. This is a scene current already in the first quarter of the century. Nereus has a human forepart and long fishy body from which break out manifestations of his skill at mutation into snake, lion or fire. Herakles turns his head to observe these [*16*]. Before the middle of the century the mutations disappear, Herakles faces forward, and the monster seems to have changed identity and is later named *Triton* [*213*]. The point of this change may have been a matter of political symbolism rather than mythology. On a few late vases Nereus reappears, but wholly human [*202*], with fire starting from his body and animals around, like his daughter Thetis attempting to fight off Peleus (see below).

Another episode associated with a Labour was the fight with the *Centaurs*. On his way for the Boar he persuades the centaur *Pholos* to open the centaurs' communal wine jar to let him drink. The jar is shown as a sunken pithos with its slab lid removed while Herakles and Pholos stand by or the fight begins [*197*]. The aroma attracted the other centaurs who attack, and are routed by Herakles, so we have many scenes with simply Herakles fighting centaurs [*122*]. The simple centaur fight is shown before 600 but in some later centauromachies the context or even the identity of a Herakles may be questioned [*94, 117*]. The certain Pholos episodes begin in the 520's.

There are other encounters, less often shown: once with *Geras*, Old Age, shown as a wizened dwarf; with the giant *Antaios* with whom he wrestles [*199*]; with the giant herdsman *Alkyoneus* who is usually shown recumbent or sleeping, holding a massive club [*205*] with the small winged figure of Hypnos (Sleep) perched on him and the Cattle of the Sun, which he had stolen, near by; with the twin robbers, *Kerkopes*, whom he pursues or, more often, carries off like game, suspended upside down from a pole across his shoulder [*234*], a position from which they jibed at his hairiness until he freed

them; and shooting down the family of *Eurytos* for their double dealing. For the fight with *Kyknos*, which is more popular, Herakles may wear divinely provided armour (but no helmet) and is often supported by Athena while Kyknos is helped by Ares [*223*]. Rarely our hero is fighting Ares himself (as on the Kolchos Jug [*68*]) with Kyknos dead already. Athena or Zeus may be shown separating the combatants, and later Zeus' thunderbolt alone is shown hovering between them. *Busiris*, an Egyptian king, sacrificed all foreign visitors, but Herakles turns the tables on him and his African staff. The scene is rare (unique?) in Athenian black figure [*143*].

Herakles had to fight both to win and to keep his bride Deianira. He fights the river god *Acheloos*, who is like a centaur but with a bull's body, or, rarely, shown as a human-headed bull. The creature's horn is often grasped [*208*], but not, in black figure, broken off as it should be in the story. The centaur *Nessos* tried to rape Deianira having ferried her across a river. Herakles kills him with sword, arrow or club. In these episodes Deianira herself may stand to watch, is in Nessos' arms, on his back [*74*], or is omitted. Herakles and Nessos appear in black figure already before 600 on the Nessos Painter's name vase [*5.1*]. The girl Hesione has also to be rescued, by killing a sea monster, and there are late scenes of Herakles entering its gaping jaws, to cut out its tongue [*179*].

There are two special encounters with Apollo in which they dispute possession of either *Apollo's tripod or a deer*, which may be taken to be Apollo's animal, or his sister Artemis'. Both Artemis and Athena are usually shown in support, and the protagonists either face each other with the prize between them, or Herakles holds it beneath his arm and Apollo follows to wrest it from him [*188, 228, 320; 191*]. The tripod scene is commoner and may have held some symbolic significance in Delphi after the First Sacred War.

Prometheus, bound and impaled on a stake, is freed by Herakles who shoots down Zeus' eagle which comes daily to eat Prometheus' liver. The scene appears already by 600 [*6.2*], and on a few Tyrrhenian vases.

Herakles' only quiet moments in black figure are with his patron or at his apotheosis. His *Introduction to Olympus* is effected by Athena who leads him before Zeus. Other gods may be in attendance, notably Hermes who can lead the procession as usher [*123.2*]. A few early scenes show his approach by chariot, but Athena herself takes the reins only from the 550's on and either figure may be shown mounting or dismounted [*168*]. Iolaos is sometimes unexpectedly present, usually as charioteer. Other gods may accompany the procession, copied or inspired by Peisistratos' return to Athens and the Acropolis in the early 550's (Herodotus i 60). Sometimes the harnessing is shown, and with a setting of columns which suggests the Acropolis it-self [*225*]. On Olympus [*153*] Herakles plays the intellectual, entertaining with the lyre or kithara, and may appear mounting a platform (bema) to perform [*165*], but once a burning altar is shown, so the setting may not

always be Olympus. He married well, and is shown in a chariot with the goddess Hebe. In the last quarter of the century he is shown alone with other gods especially Athena [246], who congratulate him as he reclines at feast [161], sometimes with Dionysos and served by satyrs, occasionally himself contributing to the revels on the pipes. His other association with satyrs on black figure is on two late vases where he is robbed by them, and leading them as prisoners. Scenes of him sacrificing (at dawn on [260], as a victor [139]) or leading a bull to sacrifice holding a bundle of spits [164] presumably refer to his life on earth.

Theseus and other heroes

Only the Cretan adventure of Theseus figures importantly in Athenian black figure, with the slaying of the Minotaur and the victory dance. The latter was shown by Kleitias – once on the François Vase where the ship coming to pick up the girls and youths rescued by Theseus is also seen [46.4]. Theseus here leads on the lyre and is a bearded, stately figure. This is how he is shown by Exekias (on a fragment) who also paints a quiet scene of his sons with their horses. Beside Theseus at the dance on the François Vase stands Ariadne, holding the skein of thread which had led him through the labyrinth and a wreath, and to her side her nurse. Ariadne and nurse also attend the slaying of the *Minotaur* on the signed band cup by Archikles and Glaukytes [116.2], where Athena waits with the lyre and young Athenians watch the encounter which should have taken place out of their sight in the isolated recesses of the labyrinth. They, or representatives, are shown in other depictions of the fight, which was very popular from about 560 on. The monster has a human body, sometimes hairy, with a bull's head and tail and may brandish a stone. Theseus, beardless, attacks with a sword, holding the beast's horn, wrists or neck. The commonest schemes have the Minotaur running from him, or grappled and with its head turned towards or away from him. On very late vases the monster has fallen to the ground or is being dragged from the labyrinth in the red figure manner. Theseus usually wears a short chiton, with an animal skin on the cup cited, but on vases of around 540 by Lydos [66.2] and a companion, he wears what must have been recognised as a Cretan loin cloth, and in some of these scenes his cloak lies folded over a stone.

Of his amours, the rape of Helen has been suspected in scenes with two youths accosting a woman (Amasis Painter) or taking her to a chariot (Leagros Group), but the Amazon Queen *Antiope* is identifiable by her dress and once by inscription. She too is carried to a chariot, twice with Poseidon abetting on Leagran vases [200]. Theseus is named on the François Vase centauromachy, helping Peirithoos and the Lapiths, but not in others.

In the sixth century Athena is not much interested in the hero who is to become her city's hero par excellence. His new status is hardly achieved

before about 510, which sees the end of Peisistratid rule in Athens. Then Theseus' exploits on the road from Troezen to Athens begin to appear often on vases, especially red figure, but the Theseus Painter shows him with *Procrustes* [245] (lopping him), *Sinis* [245] (preparing to stretch him on his pine tree) and *Skiron* (toppling him). He is also now seen binding the *Marathonian Bull* [249] in the scheme used by Herakles with the Cretan beast, but there is a mid-century vase showing a naked youth attacking a bull with a sword (?) and this might be he.

PELEUS' wooing of and marriage to Thetis formed the prologue to the Trojan war and was sung in the Epic Trojan cycle (see below). Of his earlier misadventures one, where he was treed, by a *lion and a boar*, appears on two late vases [230] on one of which his rescuer the centaur Chiron is also shown. He wrestles with the sportswoman *Atalanta* on a vase of about 560 and some late vases.

PERSEUS decapitated the Gorgon *Medusa* and made off with her head, pursued by her two sisters. The pursuit occupies black figure artists rather than the attack, because the running Gorgons were so decorative, indeed in the late seventh century the Nessos Painter gives us only them with their dead sister on his name vase, the dolphins below indicating pursuit over sea [5.2]. On a fragmentary bowl we have his Perseus and protectress Athena, while the Gorgon Painter, on his name vase, has the whole scene and adds Hermes [11.2]. This is the usual scheme, but the subject loses popularity during the third quarter of the sixth century. Perseus is dressed in a short chiton, for speed, his magic cap of darkness is a petasos and his magic boots are sometimes winged. He uses a sword or 'harpe'-sickle. The Gorgon head is carried in a bag (kibisis) slung round his neck [170.2]. The Gorgons also wear short chitons, boots – sometimes winged, and are themselves winged. Their grotesque frontal heads follow the Corinthian invention of a lion mask with tusked jaws, lolling tongue, squashy nose, but human ears and eyes. Snakes appear often in their hair, sometimes in their hands or as a belt. The Amasis Painter shows the actual decapitation [80], with Perseus carefully looking away, and it appears rarely later in black figure. The dying Medusa gave birth to Pegasos and the humanoid Chrysaor from her severed neck and these figures, or the former alone, are very occasionally seen emerging or already free of her body [269]. The Gorgon head alone [69] is a favourite tondo device from the Nessos Painter's lekanai to late cups [290.2], where we often see forehead dots which may derive from the hairy warts in this position on orientalising lion masks. Gorgoneia also appear as the principal decoration on a group of skyphoi of the 520s and as shield devices.

BELLEROPHON riding the winged horse Pegasos, attacks the Chimaera with a spear. The monster's normal form is a lion, with a goat's head and neck springing from its back and occasionally breathing fire, and with a snake tail [39, 152]. This is another story which was illustrated by the earliest of the

Athenian black figure artists, but the Nessos Painter in his earliest days (as the former Chimaera Painter) forms the monster in more close accord with the Homeric formula, and makes the whole of the hind quarters into a serpent [7]. The subject does not survive into late black figure but Pegasos alone does, as an isolated motif (notably as the shield device on the Kleophrades Painter's Panathenaics [301.2]), just as both Bellerophon and the Chimaera may appear in isolation earlier and even Pegasos alone with the Chimaera.

ADMETOS had to yoke a lion and boar to a chariot to win his bride, and Apollo, temporarily obliged to serve him, performs the task for him. There are a few late scenes of the chariot group, with Apollo [240]. A hero fighting a serpent is possibly KADMOS with the dragon which he killed and whose teeth he sowed. But the scenes, mainly late, are not explicit and there is the possibility of confusion here with Herakles with the snake guarding the apples of the Hesperides, or with an abridged Hydra.

On the François Vase the CALYDONIAN BOAR hunt is shown in a single frieze with the boar at the centre having brought down a dog and a hunter [46.3]. Facing it are Peleus and Meleager, Melanion and Atalanta, and among the other hunters we find the Dioskouroi. This is the usual scheme for the hunt, which with rare exceptions is depicted only in the second quarter of the sixth century [116.1]. The heroes are more usually not named and even the fair Atalanta may be omitted but the scheme of the dogs attacking the boar becomes standardised. The trident boar spear is sometimes used against the beast. Some boar hunts with horsemen are less certainly identified as the Calydonian.

Interest in the story of the SEVEN AGAINST THEBES is sporadic, beginning on Tyrrhenian vases with the heroes Adrastos and *Amphiaraos* setting out in chariots. On a later vase Hippomedon is seen with his wife at an altar, and other 'warrior departing' scenes with chariots may refer to the story, especially when the women and children are present, since they are important. Amphiaraos' wife Eriphyle had been bribed with an amber necklace (which she is once at least shown clutching) to send him to his death. Another common figure is a seated and sorrowing man before the horses, presumably a seer, and there may be other expressions of grief or dismay. Eriphyle went on to behave in a similar way to her son Alkmeon in the second expedition and his vengeance on her, by killing her at her husband's tomb, may appear on another Tyrrhenian vase [63.2]. A snake fury rears up against the matricide. Anonymous scenes of warriors fighting and being separated by a man (in the scheme of Herakles, Kyknos and Zeus) are doubtfully referred to the fighting at Thebes (as [141]).

The C Painter once, and late artists more often, show the THEBAN SPHINX carrying off a youth, clinging beneath her belly. The Theban prince Haimon was one victim and gives his name to the late lekythos painter who favours

this scene [273]. The encounter with Oedipus appears only on a few late vases following the red figure schemes, with the sphinx on a rock or column.

MEDEA demonstrated to the Daughters of Pelias how they could rejuvenate. their father by cutting up a ram and boiling it. We see the women and the ram (whole) in a pot over the fire on some very late vases [278]. Pelias succumbed, and the funeral games on a few vases of about 575 are inscribed as for him.

The Trojan Cycle

Scenes from the Trojan Cycle are treated here in the order of the story. Of the epic poems the Iliad and the Odyssey may be the earliest compositions, and have survived intact, but they are not the earliest in the narrative, nor the most popular with black figure artists. Other post-Homeric epics completed the story of Troy, starting with the remoter causes, including the courtship of Achilles' parents and ending with the return of the Greeks after the war.

Of the poems the KYPRIA deal with Achilles' parentage and early life, presenting the hero of the Iliad; with the Judgement of Paris and Rape of Helen, which was the immediate cause of the war; and with the opening shots on the Trojan Plain. Several episodes are well illustrated by black figure artists from about 575 on. *Peleus wrestling with Thetis* appears first in about 570, in the Corinthian scheme with the hero surprising her and putting her to flight with her Nereid companions. He grapples with her first in the mid century, and later scenes display her ability to change into different forms with either figures of lions and snakes or the flames which spring from her body [195, 293]. The centaur Chiron, who had advised Peleus, and a party of fleeing Nereids may also be shown as well as the seashore palm tree setting. Thetis' reluctance is overcome, by force, and the nuptials are celebrated. The *Wedding of Thetis and Peleus* was the occasion for the challenge which led to the Judgement of Paris and the Trojan War, but black figure artists show us only the magnificent procession of deities in chariots and on foot, who attend the couple on the morning following Thetis' first night in Peleus' home. Sophilos [24-5] (twice) and Kleitias [46.5] (on the François Vase) make this the prime scene of large and costly vases which may have celebrated mortal marriages. Peleus greets the guests before his home where Thetis waits modestly. From the mid century on a married couple, themselves in a chariot and with an escort of divinities, may again be Peleus and Thetis, first approaching their new home. Their *child Achilles* was taken to the centaur Chiron for his early education. The Heidelberg Painter shows the scene twice about 560 with Peleus holding his infant son [40], and there are several later versions. Chiron was an important figure in the story and Kleitias places him at the head of the procession of guest divinities on the François Vase.

The *Judgment of Paris* appears on Athenian vases by about 575. The basic scene shows the three goddesses led by Hermes to Alexandros (Paris). At first

the three goddesses are not differentiated, but after the mid century Athena is indicated by her armour, and Hera who usually leads the trio may carry a sceptre. Aphrodite may hold a sceptre. Paris is bearded, sometimes with a princely sceptre or lance. He makes off alarmed at the divine apparition [*38*] and sometimes has to be restrained by Hermes, but from the beginning of the series it is also possible to show him quietly greeting his visitors. The full scene may be excerpted, omitting Paris, or one or two of the goddesses.

At Troy the first episode sung and shown is the *Ambush of Troilos*, represented in several stages. Achilles crouches behind the fountain where Polyxena fills her hydria while Troilos, her brother, waits with two horses, on foot or mounted [*55*]. Or Achilles leaps out pursuing the mounted Troilos, still with two horses, while Polyxena runs away, her hydria abandoned and sometimes broken [*46.5*]. Both versions appear before about 560 in Athenian black figure. The fountain, or Polyxena, or both, may be omitted (on [*262*] Achilles is doubled), and towards the end of the century stage one is often shown omitting Polyxena. Troilos was killed in a sanctuary of Apollo [*201*] and with the help of red figure scenes and some black figure we see that the story the artists knew had Achilles drag him from his horse by his hair and behead him at the altar. Already on Tyrrhenian vases he fights Hector over the decapitated body of the young prince. (See also below on the Death of Priam and Astyanax.)

The ILIAD is poorly represented in Athenian black figure, the scenes being all from the last part of the poem, after Achilles' return to the battle field, and they are better represented in contemporary red figure. These include the Greeks' Mission to Achilles, a Capture of Dolon, and various duels or warriors setting out, only identified by inscriptions. *Achilles dragging dead Hector* behind his chariot is another popular late scene [*203*] in which Iris may also appear and a tiny ghost of Patroklos (sometimes winged) beside his tomb. Two winged demons, *Sleep and Death*, carrying a body, are seen on some fifth-century vases and may be bearing Sarpedon or Memnon from the field [*251*]. In about 570 there are two versions of the chariot race in the *Games of Patroklos* (by Sophilos [*26*] and on the François Vase [*46.3*]). There are a number of scenes of *Achilles receiving his armour*, but the earliest [*20*] (about 570 on) may refer to his arming at home before sailing to Troy, attended by figures in whom we might recognise Peleus, Thetis, Patroklos and attendant Myrmidons (as by the Camtar Painter [*53*] and the Painter of London B76). After about 550, with Thetis handing over the armour, the scene must be Troy and the armour that which replaced the suit lost with Patroklos [*86*]. The main piece of armour is usually a finely emblazoned Boeotian shield. Notice too Achilles harnessing his horses, by Nearchos, and the Painter of London B76's frontal chariot identified by inscription as a departure of Hector [*54*]. Two other frontal chariots of this date and earlier are for Achilles and Diomedes. Also appearing first earlier than the mid century are rare

scenes of the *Ransom of Hector's* body with Priam approaching Achilles' couch beneath which the body lies; and in the 540s the fight over Patroklos' body. On [*241*] the ransom is represented by the bowls carried by the boy behind Priam. So there seems an early interest in scenes involving Hector's death. The new interest in the Iliad later in the sixth century may be the result of Hipparchos' promotion of Homeric recitals at the Great Panathenaia, but the fullest harvest of this is reaped by red figure artists.

The AITHIOPIS followed the Iliad. Interest in it or at least in Achilles, seems Exekian. The master twice shows *Achilles killing Penthesilea* [*98*], the Amazon queen (an episode not certainly attributed to this epic), and a Leagros Group vase has him carrying her from the field [*204*]. He shows Memnon with his negro followers [*99*] once killing Antilochos, and Memnon appears too later in the century. In Achilles' fight with *Memnon* the heroes are regularly seconded by their mothers, Thetis and Eos [*217*]. These appear from Group E on, possibly earlier, and there are a number of other fights with women watching which may be associated with the event. Hermes is seen weighing in the balance the lives of Achilles and Memnon [*261*] (*psychostasia*), an act perhaps more familiar to us from the Iliad where Zeus weighs the lives of Achilles and Hector. The name vase of the Painter of the Vatican Mourner [*134*] may show Eos with her dead son, but her removal of the body [*271*] is a subject only for the latest black figure of the early fifth century (but cf. [*207*], wearing his helmet?).

We come now to the events sung in the LITTLE ILIAD. The death of Achilles is not shown on Athenian black figure vases but *Ajax carrying Achilles'* body over his shoulder had long been popular in Greek art, as is seen from the François Vase [*46.2*] on, especially in the work of Exekias, the Antimenes Painter and on Leagran vases. *Ajax' quarrel with Odysseus* over Achilles' armour is seen before about 500, but other heroes quarrelling and restrained by their friends [*141*], of the second half of the sixth century, might be they, and they are parted by Athena on late lekythoi. Exekias' study of mad Ajax preparing suicide [*101*] is unique and there is only one mid century *Wooden Horse*. The LITTLE ILIAD also dealt with the Sack of Troy (Ilioupersis), which was treated by other poets, with variations possibly to be identified in the differing treatment of particular episodes by artists (as for the recovery of Helen and death of Priam). The Siana cup painters offer the earliest *Death of Priam*, Rape of Kassandra and recovery of Helen. Priam is struck down at or often on an altar, by Neoptolemos, who sometimes swings at him the dead body or even the head alone of his grand-child Astyanax [*67*]. Where a Priam is not being attacked it is possible that such scenes represent rather Achilles' treatment of Troilos [*201*] at the altar. Ajax (the Lesser) seizes *Kassandra* from her suppliant position before or clasping the statue of Athena, which after the mid century is shown in the striding Panathenaic pose [*93*]. The prophetess is often shown almost or wholly naked. *Aeneas carries Anchises* on his back [*283*],

fleeing from Troy with his son Askanios and sometimes with his wife and friends. The group belongs to the last quarter of the century and many may have been especially intended for the trade to Italy, where the myth had a special relevance and a high proportion of the vases showing it have been found. *Menelaos recovers Helen* threatening her with his drawn sword [67], holding her cloak and facing her, or leading her away [90], rarely pursuing her. *Polyxena* is carried to sacrifice at the tomb of Achilles on a Tyrrhenian vase [57], led to it on a Leagran.

There is one other Trojan scene which is popular on black figure vases but for which no literary authority survives. *Achilles and Ajax* play a board game seated, fully armed or with some of their armour put aside [100, 227]. Sometimes they are alone, calling the score, but often Athena appears between them, apparently summoning them to their duty. The occasion may be at Aulis where the heroes waited for a wind to carry them to Troy and Palamedes invented games to while away the time, or more probably on the Trojan Plain itself (a palm tree is sometimes shown). Exekias introduces the scene in black figure and it remains very popular into the early fifth century, shown also in a sculptural group on the Acropolis.

The ODYSSEY seems to offer even less scope than the Iliad, but the *Polyphemos* (Cyclops) story had appealed to Athenian vase painters in the mid seventh century. The painter of the Boston Polyphemos (little before 550) has an odd scene showing the giant being made drunk, and on the same cup (and another) he shows *Circe* with Odysseus. He has her naked, mixing a cup for the companions who are all human, but for animal heads, while Odysseus approaches with a drawn sword. In the scenes of the end of the century she is dressed and either she or Odysseus may be shown seated [231]. By this time the Blinding of Polyphemos is shown in the usual way, with the giant seated on the ground but not monocular [248]. Throughout the second half of the century we have groups showing a Greek escaping from the Cave of Polyphemos, clinging or tied to a ram [255], and the later examples have several rams and Polyphemos seated before them. Late too are scenes of Odysseus with the *Sirens*, the hero tied to his mast, the Sirens perched on rocks playing pipes and lyres. On the one I figure Odysseus begs to be freed [286].

Other figures of myth

Amazons are identified by the colour of their flesh. They do not have prominent breasts and are equipped like any male warrior or archer. On late vases they may often be light-armed with a pelta shield, and only their battle-axes which are rarely shown in black figure, are strictly non-Greek weapons (one held by an archer on [204 right]). Apart from the common fights with Herakles there are very many scenes of them fighting anonymous Greek warriors, from about 570 on [126, 174, 292]. All types of combat are admit-

ted – on foot, with horses or chariots, and they have their complement of subsidiary military scenes – arming [263], harnessing, carrying off the dead from the field of battle.

Winged figures are not always easily identified. Of the males there are a few of the first quarter of the century who carry implements or a bag and are thought to be *Aristaios* [17], a minor benefactor of mankind, and there is an *Ikaros* on an Acropolis fragment of about 570, but we have only his legs and winged boots. Winged runners in pairs are the *sons of Boreas*. We have their quarry alone, the Harpies (winged women), on an incomplete vase by the Nessos Painter, and no full version of the chase. A tiny winged warrior may represent the 'soul', as of Achilles, freed for his journey to the Isles of the Blest by the sacrifice of Polyxena. Some winged males with serpentine lower parts, and sometimes more than one torso, may be the monstrous *Typhon*, but his fight with Zeus is not shown.

Of the winged women, *Iris* and *Nike* (Victory) are not readily distinguished unless the former has her herald's caduceus, or where the latter, on very late black figure, is seen with a bull [276], by an altar or with a wreath in the red figure manner. *Eris* is once named. Of other figures mentioned already, the following may on occasion appear winged: Hermes, Athena, Artemis (often early), Thetis (perhaps once at the fight with Memnon), Sleep (with Alkyoneus), Eros (normally), Eos.

Centaurs we have met already involved with Herakles (Pholos, Nessos), and with Peleus (Chiron). At the wedding of the Lapith King Peirithoos they assaulted the women and this led to a general combat, with the Lapith warriors helped by Theseus. The Athenian hero is named only on the François Vase, which is the earliest black figure representation. One special episode occurs here and occasionally in later centauromachies: *Kaineus*, an invincible Lapith, has to be literally beaten into the ground by his adversaries, and appears partly buried. We occasionally see centaurs attacked by other youths or out hunting [94, 117]. In Athenian black figure they have all-equine legs, except sometimes for *Chiron* who displays his superior status with a wholly human forepart, and even clothes. A centaur's hair is usually wild, his nose snub, his ears sometimes animal; his weapons are branches and stones.

Satyrs are like abbreviated centaurs, without the horse body, but with a horse's tail and ears and usually snub noses and wild hair, while some have hairy bodies too. On the François Vase [46.7] and rarely later [167] they have wholly animal legs, and once in Athenian black figure they appear in the East Greek manner with human legs but equine feet. Under the more sober eye of their master Dionysos and often without him, they make music, dance, work at the vintage [89], pursue or rape animals [288]. With maenads they are generally more circumspect, at most carrying them off, but they regularly display proud erections, with or without any goal in view, and are quite often exercising them themselves [50.2]. The maenads – wild women who dance

for Dionysos – also make music, sometimes with clappers, and are usually fully dressed, sometimes with an animal skin over all, as on [65, 85].

Satyrs seem to have been invented by Athenian artists by about 580 BC. They are never really involved in myth – even the attack on Hera (see above) can be taken as 'everyday life' for satyrs – but they attend Dionysos on events such as the Return of Hephaistos or on late vases, even in gigantomachy, which may explain some armed satyrs. Their contribution to drama is a fifth-century phenomenon but there may be a black figure satyr actor, dressed in a himation, with tail attached, and watched by Dionysos together with a 'real' satyr and maenads, on a vase of about 500 [289]. The occasional very late armed satyr dancing or the gang cruelly torturing a woman [277] may also be stage satyrs.

Silenos is a real figure of myth and represented as a senior and individual satyr, not part of Dionysos' troop. He was intoxicated by a fountain flowing with wine, caught, bound and led to king Midas. We see him with his escort on a few vases from the mid century on, and on two he is surprised at the fountain itself [210]. The name could also, however, be used generically for satyrs, as on the François Vase [46.7], and some scholars distinguish between the part-animal silenoi and komast satyrs.

Pan is not seen before about 500 and then in a form far from his familiar Classical appearance. He is all-goat, standing on his hind legs, beside a maenad on one vase [281] and piping for a feast on another. It will take his intervention at Marathon to establish him in Athenian art.

One story, neither quite fact nor fiction, is shown occasionally in the second quarter and the middle of the century. It is the fight of *Pygmies and Cranes* [46.8, 50.1]. On the foot of the François Vase the Pygmies ride goats and ply slings as well as the useful curved sticks which are their usual weapons in these scenes. Cranes go for their eyes. The Iliad mentions the fight, but a new poem or picture may have reawakened this interest, which lapses again for half a century.

The *Underworld* held little interest but there are a few scenes of Sisyphos trundling his rock uphill in the second half of the century. He is on his own or watched by Persephone, and on one vase there are also souls pouring water into a Leaky Pithos like the Danaids [198].

CHRONOLOGICAL CHART

B.C.

						LITTLE MASTERS

Gordion cups

Droop cups

Cassel cups

E Group Exekias P. of Berlin 1686 Princeton Painter Swing Painter

Antimenes Painter Leagros Group Priam Painter Acheloos Painter

Amasis Painter Elbows-Out Affecter Euphiletos Painter Theseus Painter Athena Painter Class of Athens 581 Haimon Painter

Gela Painter Edinburgh Painter

Lydos Nikosthenes Paseas Sappho Painter Diosphos Painter Beldam Painter

Andokides Painter Psiax

560	550	540	530	520	510	500	490	480

SIANA CUPS

C Painter Heidelberg Painter

Nessos Painter Piraeus Painter

Gorgon Painter Sophilos

Komast Group

Kleitias Painter of Acropolis 606

Nearchos

Ptoon Painter Camtar Painter

P. of Berlin A34

630	620	610	600	590	580	570	560	550

ABBREVIATIONS

AA	Archäologischer Anzeiger	BSA	Annual of the British School at Athens
AAA	Athens Annals of Archaeology		
ABL	E. Haspels, Attic Black-figured Lekythoi (1936)	CVA	Corpus Vasorum Antiquorum
		Dev.	J. D. Beazley, The Development of Attic Black Figure (1951)
ABV	J. D. Beazley, Attic Black-figure Vase-painters (1956)		
		Hesp	Hesperia
ADelt	Archaiologikon Deltion	JdI	Jahrbuch des deutschen archäologischen Instituts
AE	Archaiologike Ephemeris		
AJA	American Journal of Archaeology	JHS	Journal of Hellenic Studies
AK	Antike Kunst	MWPr	Marburger Winckelmannsprogramm
AM	Athenische Mitteilungen		
Ann	Annuario della Scuola Archeologica di Atene	ÖJh	Jahreshefte des österreichischen archäologischen Institutes in Wien
Ant. Class.	L'Antiquité Classique	Para	J. D. Beazley, Paralipomena (1971)
Arch. Class.	Archeologia Classica		
BABesch	Bulletin Antieke Beschaving	RA	Revue Archéologique
BCH	Bulletin de Correspondance Hellénique	REA	Revue des Études Anciennes
		RM	Römische Mitteilungen
BICS	Bulletin of the Institute of Classical Studies, London		

NOTES AND BIBLIOGRAPHIES

GENERAL BOOKS

J. D. Beazley, *The Development of Attic Black Figure* (1951) – brilliant lectures, quite well illustrated; *Attic Black Figure Vase Painters* (1956) – lists of painters and groups, supplemented in *Paralipomena* (1971).

J. C. Hoppin, *A Handbook of Greek Black Figured Vases* (1924) – pictures of signed and some attributed vases.

E. Haspels, *Attic Black Figured Lekythoi* (1936).

E. Pfuhl, *Malerei und Zeichnung der Griechen* (1923) – a full survey for its day.

The following handbooks have useful sections on black figure: R. M. Cook, *Greek Painted Pottery* (1972), and B. B. Shefton in P. Arias – M. Hirmer, *History of Greek Vase Painting* (1962); C. M. Robertson, *Greek Painting* (1969).

On the general artistic background: G. M. A. Richter, *Archaic Greek Art* (1949); J. Boardman, *Pre-Classical Style and Civilisation* (1967).

Enciclopedia dell'Arte antica (1958–1966) – for brief accounts of individual painters and groups.

Corpus Vasorum Antiquorum (*CVA*) is a series designed to publish illustrations of all decorated Greek vases in separate groups of fascicules for each museum, organised nationally.

I. INTRODUCTION

History – R. M. Cook in *Greek Painted Pottery* ch. 15. Technique – J. V. Noble, *The Techniques of Painted Attic Pottery* (1965); P. E. Corbett, *JHS* lxxxv, 16ff. – preliminary sketches.

Signatures and status – J. D. Beazley, *Potter and Painter in Ancient Athens* (1944); R. M. Cook, *JHS* xci, 137f.; C. M. Robertson, *JHS* xcii, 180ff.

Prices – D. A. Amyx, *Hesp* xxvii, 287ff.

Export pattern – B. L. Bailey, *JHS* lx, 60ff.

Solon – Plutarch, *Solon* 24.

I give no references to *ABV* or *Para* for individual artists or groups since these works must be the basic tools for student work in a library and give full references for each vase; nor, usually, to the other general books already listed. Articles and books are cited which will lead the reader to discussions of style or useful collections of pictures. References to par-

ticular points in the text are given only if they are not easily recoverable from *ABV* or *Para*.

II. EARLY ATHENIAN BLACK FIGURE

The transition from Protoattic – J. M. Cook, *BSA* xxxv, 198ff.; K. Kübler, *Altattische Malerei* (1950) – well illustrated; E. Brann, *Athenian Agora* viii.
H. Payne, *Necrocorinthia* (1931) ch. 13 and Appendix 2 – early work on groups and chronology.
J. D. Beazley, *Hesp* xiii, 38ff. – preliminary lists; and *Dev*. ch. 2.
Vari vases – S. Karouzou, *Aggeia tou Anagyrountos* (1963).
Aegina vases – *CVA* Berlin i; W. Kraiker, *Aigina* (1951).

PIONEERS
Nessos (Chimaera) Painter – D. Ohly, *AM* lxxvi, 5ff.; F. Brommer, *Jahrbuch der Berliner Museen* iv, 1ff.
T. J. Dunbabin, *BSA* xlv, 193ff. – Corinthian painter in Athens.

THE GORGON PAINTER TO SOPHILOS
S. Karouzou, *AM* lxii, 111ff. – conflating some painters, good pictures.
Gorgon Painter – I. Scheibler, *JdI* lxxvi, 1ff.
Komast Group – A. Greifenhagen, *Eine attische schwarzfigurige Vasengattung* (1929).
Sophilos – J. Boardman, *BSA* liii–liv, 155ff.; W. Johannowsky, *Ann* xxxiii–xxxiv, 45ff.; A. Birchall, forthcoming.
Polos Painter – J. M. Hemelrijk, *BABesch* xlvi, 105ff.
Horse-head amphorae – M. G. Picozzi, *Studi Miscellani* xviii (1971); A. Birchall, *JHS* xcii, 46ff.
CVA Louvre ii.

III. KLEITIAS, SIANA CUP PAINTERS AND OTHERS

KLEITAS
J. D. Beazley, *Dev*. ch. 3.
François Vase – the best drawings, by Reichhold, in A. Furtwängler and K. Reichhold, *Griechische Vasenmalerei* i, pls. 1–3, 11–13, p. 62b. Complete but poor photographs in A. Minto, *Il Vaso François* (1960).

SIANA CUP PAINTERS
J. D. Beazley, *Dev*. 21ff., 50ff.
C Painter – J.D. Beazley, *Metr. Mus. Stud.* v, 93ff.
Heidelberg Painter – J. D. Beazley, *JHS* li, 275ff.
Hybrids – D. Kallipolitis-Feytmans, *RA* 1972, 73ff.
'Black glazed' cups – J. Hayes in J. Boardman and J. Hayes, *Tocra* i, 118ff.
CVA Louvre viii; London ii.

OTHER POT PAINTERS
Camtar Painter – D. von Bothmer, *AK* ii, 5ff.
Ptoon Painter – H. R. W. Smith, *The Hearst Hydria* (1944).

TYRRHENIAN AMPHORAE
H. Thiersch, *Tyrrhenische Amphoren* (1899); D. von Bothmer, *AJA* xlviii, 161ff.; and *AK* xii, 26ff. (Archippe Group hydriae); K. Schauenburg, *AA* 1962, 58ff.; *CVA* Louvre i.

IV. THE MID CENTURY AND AFTER

LYDOS
G. M. A. Richter, *Metr. Mus. Stud.* iv, 169ff.; W. Kraiker, *AM* lix, 1ff.; A. Rumpf, *Sakonides* – mainly Lydos and Lydan, pictures; J. D. Beazley, *Dev*. 41ff.
W. E. Kleinbauer, *AJA* lxviii, 355ff. – relations with Corinthian; and for Corinthianising Attic – *Hesp* iv, 226ff.; ix, 146.

THE AMASIS PAINTER
J. D. Beazley, *Dev*. ch. 5; S. Karouzou, *The Amasis Painter* (1956) fully illustrated; D. von Bothmer, *AK* iii, 71ff. and *Madrid Mitt.* xii, 123ff.; J. Boardman, *JHS* lxxviii, 1ff. – name and origin; K. Schauenburg, *JdI* lxxix, 109ff.

EXEKIAS AND GROUP E
Group E – J. D. Beazley, *BSA* xxxii, 3ff.
Exekias – J. D. Beazley, *Dev*. ch. 6; W. Technau, *Exekias* (1936) – fully illustrated; B. Neutsch, *Münchener Jahrbuch* xv, 43ff.; M. B. Moore, *AJA* lxxii, 357ff. – horses.

LITTLE MASTERS
J. D. Beazley, *Dev*. ch. 5, and *JHS* lii, 167ff. – preliminary lists; H. Bloesch, *Formen attischer Schalen* (1940); F. Villard, *REA* xlviii, 159ff. – development of shapes. *CVA* Louvre viii, ix; London ii.
Gordion cups – C. M. Robertson, *JHS* lxxi, 143ff.
Band cups with panels – R. Blatter, *AA* 1967, 12ff.
Underfoot decoration – A. Greifenhagen, *JdI* lxxxvi, 80ff.; K. Schauenburg, *AA* 1971, 162ff.
Droop cups – P. N. Ure, *JHS* lii, 55ff. and *Studies Robinson* ii, 45ff. The Haimonian Droop cup is in Frankfurt.
Cassel cups – J. D. Beazley, *JHS* lii, 191f.

OTHER POT PAINTERS AND NIKOSTHENES
J. D. Beazley, *BSA* xxxii, 1ff. – preliminary lists.
Swing Painter – J. M. T. Charlton, *Mem. Manchester* lxxxiii, 191ff.; R. Blatter, *AA* 1969, 69ff.
Nikosthenes – J. C. Hoppin, *Handbook* 177ff. – pictures; H. Bloesch, *Formen attischer Schalen* 9ff. – cups; R. Blatter, *AA* 1970, 167ff.; H. Giroux, *RA* 1966, 13ff. – amphorae; J. D. Beazley, *Festschrift Schweitzer* 101f. – and Lydos. The cup with signatures of both Anakles and Nikosthenes might be an ancient forgery since the script seems quite different from that of their other signatures.
Affecter – H. Mommsen, forthcoming; amphora by artist of Mastos Group, *ABV* 242, 35.
Elbows Out – D. von Bothmer, *RA* 1969, 3ff.

V. THE AGE OF RED FIGURE

G. M. A. Richter, *Attic Red Figured Vases* (1958) – a survey.

BILINGUISTS I

Andokides Painter – J. D. Beazley, *Dev.* 75ff.; A. Marwitz, *ÖJh* xlvi, 73ff.; K. Schauenburg, *JdI* lxxvi, 48ff. and lxxx, 76ff.; D. von Bothmer, *Bull. Metr. Mus.* 1966, 201ff.
Paseas – C. Roebuck, *AJA* xliii, 467ff.; J. Boardman, *JHS* lxxv, 154f.
Psiax – H. R. W. Smith, *New Aspects of the Menon Painter* (1929); G. M. A. Richter, *AJA* xxxviii, 547ff.; xlv, 587ff.
Coral red – G. M. A. Richter, *BSA* xlvi, 143ff., and *Netherlands Yearbook for History of Art* v, 127ff.; M. Farnsworth and H. Wisely, *AJA* lxii, 165ff.
White ground to red figure – Andokides Painter (*ARV* 4, 13), Paseas (unpublished plaque).

CUP PAINTERS

H. Bloesch, *Formen attischer Schalen* (1940) – shapes; P. N. Ure, *Sixth and fifth-century pottery from Rhitsona* (1927) 57ff. – skyphos groups. *CVA* Louvre x; London ii.
Krokotos Group – A. D. Ure, *JHS* lxxv, 90ff.
Gorgoneion skyphoi – B. Freyer-Schauenburg, *JdI* lxxxv, 1ff.; *AA* 1971, 538ff.
Segment Class – A. Greifenhagen, *Berliner Museen* ix, 2ff.

THE ANTIMENES PAINTER AND LEAGROS GROUP

Antimenes Painter – J. D. Beazley, *JHS* xlvii, 63ff.; *Dev.* 79ff.
Leagros Group – J. D. Beazley, *Dev.* 81ff.; T. Rönne-Linders, *Medelhavsmuseet Bull.* iii, 54ff. – amphorae; K. B. Duplan, *RA* 1972, 127ff. – white necks.

OTHER POT PAINTERS

Priam Painter – K. Schauenburg, *RM* lxxi, 60ff.; J. Boardman, *RA* 1972, 64ff.

BILINGUISTS II

Nikoxenos-Eucharides Painter – C. M. Robertson, *AJA* lxvi, 311ff.

LEKYTHOI

E. Haspels, *ABL* chs. 5, 6; D. C. Kurtz (forthcoming book).

VI. THE LATEST BLACK FIGURE

E. Haspels, *ABL* chs. 6, 7; P. N. Ure, *Sixth and fifth-century pottery from Rhitsona* (1927) 39ff.; *Corinth* xiii, 152ff.
Theseus Painter – M. M. Eisman, *AJA* lxxv, 200.
Athena Painter – S. Karouzou in *Kernos* (Salonika, 1972) 58ff.
Pistias Class – E. Karydi, *AM* lxxvii, 105ff.

VII. PANATHENAIC VASES

K. Peters, *Studien zu den panathenäischen Preisamphoren* (1942); J. D. Beazley, *AJA* xlvii, 441ff. and *Dev.* ch. 8. *CVA* Louvre v; London i; New York iii.
A. Smets, *Ant. Class.* v, 87ff. – the inscriptions; J. A. Davison, *JHS* lxxviii, 23ff. – 566 BC; P. E. Corbett, *JHS* lxxx, 52ff. – Burgon amphora; 'vessel for the tumbler' – Cab. Méd. 243; D. A. Amyx, *Hesp* xxvii, 178ff. – the 415 BC sale; N. Gardiner, *Greek Athletic Sports* (1910) 234ff. – as prizes; D. C. Kurtz and J. Boardman, *Greek Burial Customs* (1971) 313, 315, 326 – in tombs; J. Frel, *AAA* v, 245ff. – dedications at Eleusis; *Athenian Agora* x, 59ff. – measures; *ABV* 417 – Hellenistic.

VIII. ODDS AND ENDS

SIX TECHNIQUE

J. Six, *Gaz. Arch.* 1888, 193ff., 281ff.; E. Haspels, *ABL* 106ff. and *Muse* iii, 24ff.; B. Philippaki, *The Attic Stamnos* (1967) 25ff.; J. R. Green, *AA* 1970, 475ff. – Haimonian.

POLYCHROME

H. Luschey, *Die Phiale* (1939); J. Boardman, *Rep. Dept. Ant. Cyprus* 1968, 12ff. – Chian and Attic.

MINIATURES

Bulas Group – J. D. Beazley, *BSA* xli, 10ff.

BLACK VASES

L. Talcott and B. A. Sparkes, *Athenian Agora* xii (1970); J. Hayes in J. Boardman and J. Hayes, *Tocra* i, 105ff., 118ff.

ATHENS OR ATTICA?

Brauron – L. Kahil, *Neue Ausgrabungen* (*AK* Beiheft i, 1963).
Eleusis – Painters of Eleusis 767 and 397; *CVA* Athens i, pl. 5.1, 2.

EMIGRANTS AND IMITATORS

Teisias – B. A. Sparkes, *JHS* lxxxvii, 122ff.
Euboea – J. Boardman, *BSA* xlvii, 30ff.; A. D. Ure, *JHS* lxxx, 160ff. and lxxxii, 138ff., *BICS* vi, 1ff. and xii, 22ff., *BSA* lxviii; D. von Bothmer, *Metr. Mus. Journal* ii, 27ff.
Elaeus – J. Boardman, *Greeks Overseas* (1964) 276f.; *CVA* Heidelberg iv, 45f.; J. M. Cook, *The Troad* (1973) 121; A. Waiblinger, forthcoming.
Clay analysis – J. Boardman, *BSA* lxviii.

IX. SHAPES

L. D. Caskey, *Geometry of Greek Vases* (1922); G. M. A. Richter, *Shapes and Names of Athenian Vases* (1935); D. A. Amyx, *Hesp* xxvii, 164ff. – names; *Athenian Agora* xii (1970) – plain shapes; H. Gericke, *Gefässdarstellungen auf gr. Vasen* (1970); H. Holzhausen and R. C. A. Rottländer, *Archaeometry* xii, 189ff. – standardisation.

Alabastron – H. E. Angermeier, *Das Alabastron* (1936); *CVA* Fogg/Gallatin pl. 42.1 – near Corinthian shape.

Amphorae – H. Bloesch, *JHS* lxxi, 29ff.; R. Lullies *AK* vii, 85ff. As 'kados' – Cab. Méd. 243 and *Ars Antiqua* (Luzern) iv, no. 131. Belly amphorae – *CVA* Louvre iii, xi; Munich i; London iii; New York iii. Neck amphorae – *CVA* Louvre iv, v; Munich vii; London iii, iv.

Aryballos – *AK* xii, pl. 8.1 – with two handles; D. von Bothmer, *Madrid Mitt.* xii, 125.

Bronze vases – W. Lamb, *Greek and Roman Bronzes* (1929); E. Diehl, *Die Hydria* (1964); *Bull. Metr. Mus.* 1961, 138f. – psykter.

Craters – H. Hinkel, *Der Giessener Kelchkrater* (1967) 38ff. – calyx craters; S. Karouzou, *BCH* lxxix, 196ff. – volute craters; *CVA* Louvre ii, xii.

Cups – H. Bloesch, *Formen attischer Schalen* (1940); F. Villard, *REA* xlviii, 159ff.; *CVA* Louvre viii, ix, x; London ii; New York ii; Villa Giulia iii; Faina Orvieto i.

Dinoi – R. Lullies, *AK* xiv, 50ff.; *CVA* Louvre ii, xii.

Epinetra – D. M. Robinson, *AJA* xlix, 480ff.; G. Bakalakis, *ÖJh* xlv, Beibl. 199ff.

Funeral vases – D. C. Kurtz and J. Boardman, *Greek Burial Customs* (1971).

Hydria – see amphorae (Bloesch); E. Diehl, *Die Hydria* (1964); *CVA* Louvre vi, xi; London vi; Florence v.

Kantharos – P. Courbin, *BCH* lxxvi, 364ff.

Kothons – I. Scheibler, *JdI* lxxix, 72ff. and *AA* 1968, 389ff.

Kyathoi – M. M. Eisman, *AJA* lxxvii, 71 ff.

Lebes gamikos – J. Boardman, *BSA* liii–liv, 160ff.

Lekythos – E. Haspels, *ABL*.

Louterion – D. Kallipolitis-Feytmans, *Les loutéria attiques* (1965).

Loutrophoros – E. Walter-Karydi, *AM* lxxviii, 90ff.

Mastos – H. Payne, *Necrocorinthia* 312; KX Painter – *ABV* 26, 27.

Oenochoe – K. Peters, *JdI* lxxxvi, 103ff.; *CVA* Ferrara ii.

Pelike – D. von Bothmer, *JHS* lxxi, 40ff.

Phiale – H. Luschey, *Die Phiale* (1939).

Phormiskos – O. Touchefeu-Meynier, *RA* 1972, 93ff.

Plate – D. Feytmans, *Ant. Class.* xvii, 183ff.

Plaques, disc – D. Kallipolitis-Feytmans, *BCH* lxxix, 467ff.

Plaques, funerary – J. Boardman, *BSA* l, 51ff.

Plaques, votive – B. Graef and E. Langlotz, *Die antiken Vasen von der Akropolis zu Athen* (1925) nos. 2493ff.

Psykter – J. D. Beazley, *Greek Vases in Boston* ii, 6f. and iii, 92; K. Schauenburg, *JdI* lxxx, 76; A. Greifen-

hagen, *Jb. Berliner Museen* iii, 123ff.; *CVA* Louvre viii.

Stamnos – B. Philippaki, *The Attic Stamnos* (1967).

Standlet – *Athenian Agora* xii, 179f.

Stands – L. Talcott, *Hesp* v, 59ff.

Important publications of large collections (not in *CVA*) representing all shapes and styles are:

E. Langlotz, *Griechische Vasen in Würzburg* (1932).

C. Albizatti, *Vasi antichi dipinti del Vaticano* (1925–39).

P. Mingazzini, *Vasi della Collezione Castellani* (1930; in Villa Giulia Museum, Rome).

X. DATES

E. Langlotz, *Zur Zeitbestimmung der strengrotfigurigen Vasenmalerei und der gleichzeitigen Plastik* (1920) 9–16 (black figure), 17ff. (early red figure and the Siphnian Treasury), 43ff. (kalos names).

Early black figure and Corinth – Payne, *Necrocorinthia* (1931) 344ff.; E. Brann, *Athenian Agora* viii, 7, 25.

Smyrna – J. M. Cook, *BSA* liii–liv, 29.

Marathon – E. Haspels, *ABL* 91–3, 139f.; *AAA* iv, 99ff. ('Plataeans' tumulus': the identification is questionable).

Athens – *Athenian Agora* xii, 383ff. – summary of deposits.

Acropolis – W. B. Dinsmoor, *AJA* xxxviii, 408ff.

XI. GENERAL DECORATION

Conventions

N. Himmelmann, *Erzählung und Figur in der archaischen Kunst* (1967); J. Boardman, *RA* 1972, 57ff. – political symbolism; K. Schefold, *Myth and Legend in Early Greek Art* (1966).

Gestures – H. Kenner, *Weinen und Lachen in der griechischen Kunst* (1960); G. Neumann, *Gesten und Gebärden* (1965).

Red-faced Athena – *ABV* 153, 38 and 41; Herakles, *ABV* 231, 10 (*Para* 109).

Red-black greaves – *CVA* Munich vii, 58, pls. 351–2.

Mistakes and mixed scenes – K. Schauenburg, *JdI* lxxxv, 28ff.

Kneeling-running – E. Schmidt in *Münchner archäologische Studien* (1909); L. Gründel, *Die Darstellung des Laufens in der griechischen Kunst* (1934).

Perspective – G. M. A. Richter, *Perspective in Greek and Roman Art* (1970).

Inscriptions

P. Kretschmer, *Die griechischen Vaseninschriften* (1894); L. H. Jeffery, *The Local Scripts of Archaic Greece* (1961).

Kalos names – D. M. Robinson and E. J. Fluck, *A Study of the Greek Love Names* (1937). Lists in *ABV* and *Para*. K. Schauenburg, *Gymnasium* lxxvi, 49f. – gods and heroes (adding Leto, *CVA* New York iii, pl. 32).

Graffiti – R. Hackl in *Münchner archäologische Stu-*

dien . . . A. Furtwängler (1909). A new study by A. W. Johnston is in preparation.
Inscription in a separate register, CVA Louvre vi, pl. 69.4.
Keian letters – Jeffery, op. cit., 297; 'Samian' – Metr. Mus. Bull. 1969, 432f.

FLORALS
E. Homann-Wedeking, Archaische Vasenornamentik (1938) 37ff.; H. R. W. Smith, The Hearst Hydria (1944); P. Jacobsthal, Ornamente griechischer Vasen (1927); D. C. Kurtz, forthcoming book.
Corinthian precedents – H. Payne, Necrocorinthia (1931) ch. 10.

ANIMALS AND MONSTERS
Griffins – S. Vos, Scythian Archers 3f. – and Arimasps.
Hippalektryon – G. Camporeale, Arch. Class. xix, 248ff.
Sphinxes – H. Walter, Antike und Abendland ix, 63ff.
Lion fights – J. Boardman, Archaic Greek Gems 121ff.
Frontal chariots – G. Hafner, Viergespanne in Vorderansicht (1938).

XII. SCENES OF REALITY

EVERYDAY LIFE
Dress patterns – A. Kloss, Mitt. des Inst. v, 80ff.
Dress pins – P. Jacobsthal, Greek Pins (1956) 106ff.
Fountain houses – B. Dunkley, BSA xxxvi, 142ff.; R. Ginouvès, Balaneutiké (1962).
Slaves – N. Himmelmann, Archäologisches zum Problem der griechischen Sklaverei (1971).
Stilts – F. Brommer, AK xi, 50ff.
Negroes – F. M. Snowden, Blacks in Antiquity (1970).
Horsemen and horses, frontal – K. Schauenburg, AA lxiii, 423ff.
Women sharing a cloak – M. Guarducci, AM liii, 53ff.; K. Schauenburg, RM lxxi, 68f.

FIGHTING
A. M. Snodgrass, Arms and Armour of the Greeks (1967).
Peltasts – J. G. P. Best, Thracian peltasts (1969).
Scythians – S. Vos, Scythian Archers in Archaic Attic Vase Painting (1963).
Shields – G. Lippold in Münchner archäologische Studien (1909).
Warrior's departure – W. Wrede, AM xli, 221ff.
Armed dancers – J. C. Poursat, BCH xcii, 550ff.

WINE, WOMEN, BOYS AND SONG
Komasts – A. Greifenhagen, Eine attische schwarzfigurige Vasengattung (1929); E. Buschor, Satyrtänze und frühes Drama (1943); A. Seeberg, Corinthian komos vases (1971).
Mummers – A. Pickard-Cambridge, The Dramatic Festivals of Athens (1968); M. Bieber, History of the Greek and Roman Theatre (1961); F. Brommer, AA

1942, 65ff. – dolphin riders; J. Boardman, BICS v, 6f. – early actor.
Symposia – J. M. Dentzer, RA 1971, 215ff.; cf. G. M. A. Richter, The Furniture of the Greeks, Etruscans and Romans (1966); B. Fehr, Orientalische und griechische Gelage (1971).
Music – M. Wegner, Musikgeschichte in Bildern (1964); Das Musikleben der Griechen (1949).
Love-making – G. Vorberg, Glossarium Eroticum (1965). Homosexual – J. D. Beazley, Some Attic Vases in the Cyprus Museum, 6ff.; K. Schauenburg, AA 1965, 850ff.

SPORT
E. N. Gardiner, Athletics of the Ancient World (1930).

COMMERCE AND INDUSTRY
Potting – G. M. A. Richter, The Craft of Athenian Pottery (1923); AA 1969, 141ff.
Ships – J. S. M. Morrison and R. T. Williams, Greek Oared Ships (1968); L. Casson, Ships and Seamanship (1971) and JHS lxxviii, 14ff. – pirates?; K. Schauenburg, AK Beiheft 7, 34.

RELIGION
A. B. Cook, Zeus (1914–40) passim, for cult and myth scenes; L. Deubner, Attische Feste (1932).
Masks – W. Wrede, AM liii, 66ff.
Marriage – J. Boardman, BSA xlvii, 34f. and liii–liv, 158ff.
Burial – W. Zschietzmann, AM liii, 17ff.; J. Boardman, BSA l, 51ff.; D. C. Kurtz and J. Boardman, Greek Burial Customs (1971).

XIII. SCENES OF MYTH

The mythological indexes to ABV and Para are basic sources for scenes on attributed vases.
F. Brommer, Vasenlisten zur griechischen Heldensage (1960) lists also unattributed vases and gives a brief bibliography for each scene.
Other useful sources are – W. H. Roscher, Ausführliches Lexicon der griechischen und römischen Mythologie (1884–1937) – now seriously outdated; Enciclopedia dell'Arte antica (1958–1966); Lexicon der alten Welt (Artemis Verlag, 1965) – for recent references; E. Kunze, Archaische Schildbände (1950) – for Peloponnesian scenes and general discussion; E. Haspels, ABL.
In the following notes I refer to useful monographs or collections of pictures, or recent summaries, but reference should also be made to the sources cited above.

GENERAL
K. Schefold, Myth and Legend in Early Greek Art (1966) – mainly earlier.
H. von Steuben, Frühe Sagendarstellungen in Korinth

und Athen (1968) – with valuable comparative discussions.
For the stories in literature see any Classical encyclopaedia; H. J. Rose, *Handbook of Greek Mythology* (1960); Apollodorus (Loeb Library translation with J. G. Frazer's notes).

THE GODS
E. Simon, *Die Götter der Griechen* (1969).

ZEUS
A. B. Cook, *Zeus* i–iii (1914–1940).
Thunderbolts – P. Jacobsthal, *Der Blitz* (1906).
Birth of Athena – A. B. Cook, *Zeus* iii, 656ff.; F. Brommer, *Jb.Röm.-Germ. Zentralmuseums* viii, 66ff.
Birth of Dionysos/Hephaistos – H. Fuhrmann, *JdI* lxv–lxvi, 111.
Europa – de la Coste Messelière, *Au Musée de Delphes* (1936) 153ff.; goddess on bull – W. Technau, *JdI* lii, 76ff.

APOLLO
Niobids – R. M. Cook, *Niobe and her Children* (1964); H. Hoffmann, *AA* 1960, 77; K. Schauenburg, *Kunst in Hessen* vi, 125f.
Tityos – A. Greifenhagen, *Jb. Berliner Museen* i, 5ff.
Pytho – L. Kahil, *Mélanges Michalowski* (1966) 481ff.

HERMES
P. Zanker, *Wandel der Hermesgestalt in der attischen Vasenmalerei* (1965).
As child – N. Gialouris, *AE* 1953/4, ii, 162ff.
Argos – H. Hoffmann, *Jb. Hamburger Kunstsammlungen* xii, 10ff.
Winged – K. Schauenburg, *Gymnasium* lxx, 114f.
Winged boots – N. Gialouris, *BCH* lxxvii, 293ff.

DIONYSOS
Return of Hephaistos – F. Brommer, *JdI* lii, 198ff.

HEPHAISTOS
see Dionysos.
P. Bruneau, *BCH* lxxxvii, 509ff.; J. Wiesner, *AA* 1969, 531ff.

POSEIDON
U. Heimberg, *Das Bild des Poseidon in der griechischen Vasenmalerei* (1968).

ATHENA
see Zeus.
Attributes – A. B. Cook, *Zeus* iii, 747ff.; M. H. Groothand, *BABesch* xliii, 35ff.
Winged – J. Boardman, *Archaic Greek Gems* 100f.

HERA
Attacked by satyrs – Haspels, *ABL* 20.

APHRODITE
With Eros – J. D. Beazley, *JHS* xlix, 262f.

ARTEMIS
see Apollo.
Mistress of Animals – C. Christou, *Potnia Theron* (1968); E. Spartz, *Das Wappenbild des Herrn und der Herrin* (1962).
Aktaion – P. Jacobsthal, *Marburger Jb.* v, 1ff.

TRIPTOLEMOS
C. Dugas, *Mélanges* lxii, 7ff.

ASSEMBLY OF GODS
N. Himmelmann, *MWPr* 1960, 41ff.; H. Knell, *Die Darstellung der Götterversammlung* (1965).

GIGANTOMACHY
F. Vian, *La Guerre des Géants* (1951); J. Dörig and O. Gigon, *Der Kampf der Götter und Titanen* (1961).

HERAKLES
F. Brommer, *Herakles* (1953) – a general account, mainly on the Labours.
F. Brommer, *Denkmälerlisten zu griechischen Heldensage* i, Herakles (1971) – bibliography and lists of scenes *not* on vases. Luce's early articles (see below) are still useful but his lists are incomplete.
v. Lion – S. B. Luce, *AJA* xx, 460ff.; bent sword – Castellani, pl. 65.1; gutting – Munich 563; K. Schauenburg, *JdI* lxxx, 97ff.
v. Hydra – F. Brommer, *MWPr* 1949, 3ff.; P. Amandry, *Bull. Fac. des Lettres, Strasbourg* xxx, 293ff.; K. Schauenburg, *AA* 1971, 162ff.
v. Birds – E. Haspels, *ABL* 27.
v. Bull – U. Hausmann, *Hellenistische Reliefbecher* (1959) 69ff.
v. Geryon – P. A. Clement, *Hesp* xxiv, 1ff.; C. M. Robertson, *Classical Quarterly* xix, 207ff.; B. Neutsch, *Ganymed* (1949) 29ff.
Hesperides and Atlas – F. Brommer, *JdI* lvii, 105ff.
Helios – G. Jacopi, *Boll. d'Arte* xxx, 39ff.
v. Amazons – D. von Bothmer, *Amazons in Greek Art* (1957).
v. Nereus, Triton – E. Buschor, *Meermänner* (1941): J. Boardman, *BICS* v, 7ff. and *RA* 1972, 59f.
v. Centaurs, Pholos – P.V.C. Baur, *Centaurs in Ancient Art* (1912); K. Schauenburg, *AM* lxxxvi, 45ff.
v. Geras – F. Brommer, *AA* 1952, 60ff.
v. Alkyoneus – B. Andreae, *JdI* lxxvii, 130ff.
v. Kerkopes – P. Zancani-Montuoro, *Heraion alla Foce del Sele* ii, 185ff.
v. Kyknos – F. Vian, *REA* xlvii, 5ff.; hovering bolt – *Attic Vase Paintings in New England* 48f., Castellani pl. 87.1–3.
v. Acheloos – H. P. Isler, *Acheloos* (1970); S. B. Luce, *AJA* xxvii, 425ff.; I. N. Lofaro, *Klearchos* viii, 131ff.
v. Nessos – P. Courbin, *BCH* lxxxvi, 347ff.
Hesione – F. Brommer, *MWPr* 1955, 4ff.; E. Diez, *ÖJh* xlv, Beibl. 170ff.; A. Lesky, *Anz. Österr. Akad.* civ, 1ff.

v. Apollo – H. W. Parke and J. Boardman, *JHS* lxxvii, 276ff.

Prometheus – S. Karouzou, *Aggeia tou Anagyrountos* (1963).

Introduction to Olympus – P. Mingazzini, *Mem. Atti dei Lincei* 1925–6, 413ff.; J. Boardman, *RA* 1972, 60ff.

Kithara playing – C. Dugas, *REG* lvii, 61ff.; K. Schauenburg, *JdI* lxxvii, 58f.; beside altar – *CVA* Tarquinia i, pl. 12.3.

with Athena – J. D. Beazley, *AK* iv, 55ff.; G. Beckel, *Götterbeistand in der Bildüberlieferung griechischer Heldensagen* (1961).

Eurytos – G. M. A. Richter, *AJA* xx, 130ff.; K. Fittschen, *Gymnasium* lxxvii, 162ff.

with Satyrs – F. Brommer, *Satyrspiele* (1959) 71ff.

sacrificing – J. D. Beazley, *Boston Vases* iii, 8ff.

THESEUS
E. Kunze, *Archaische Schildbänder* 127ff.; C. Dugas and R. Flacelière, *Thésée, Images et Récits* (1958).

and Helen – L. Ghali-Kahil, *Les Enlèvements et le retour d'Hélène* (1955) 305ff.

and Antiope – D. von Bothmer, *Amazons in Greek Art* (1957) 124ff.

PELEUS
in tree – M. J. Milne, *Bull. Metr. Mus.* v, 255ff.

PERSEUS
K. Schauenburg, *Perseus* (1960).

and Gorgons – R. Hampe, *AM* lx/lxi, 285ff.; H. Besig, *Gorgo und Gorgoneion* (1937); T. G. Karagiorgha, *Gorgeie Kephale* (1970); V. Poulsen, *Meddelelser . . . Ny Carlsberg* xxv, 15ff.

BELLEROPHON AND CHIMAERA
T. J. Dunbabin, *Studies Robinson* ii, 1164ff.; F. Brommer, *MWPr* 1952/54, 3ff.; K. Schauenburg, *JdI* lxxi, 59ff. and *AA* 1958, 21ff.; D. Ohly, *AM* lxxvi, 1ff. (early type); M. L. Schmitt, *AJA* lxx, 341ff.; S. Hiller, *Bellerophon* (1970).

KADMOS
K. Schauenburg, *AA* 1971, 162ff.

ADMETOS
K. Schauenburg, *Gymnasium* lxiv, 210ff.

CALYDONIAN BOAR HUNT
de la Coste Messelière, *Au Musée de Delphes* (1936) 120ff.; D. von Bothmer, *Bull. Mus. Fine Arts, Boston* xlvi, 42ff.; R. Blatter, *AK* v, 45ff.; K. Schauenburg, *AA* 1962, 765ff.; G. Daltrop, *Die Kalydonische Jagd* (1966).

THEBAN SPHINX
R. Lullies, *Festschrift Schweitzer* (1955) 140ff. U. Hausmann, *Jb. Staatl. Kunstsamml. Baden–Württemberg* ix, 7ff.

THE TROJAN CYCLE
K. F. Johansen, *The Iliad in Early Greek Art* (1967).

Wedding of Peleus and Thetis – M. Heidenreich, *Mitt. des. Inst.* v, 134ff.

Achilles taken to Chiron – K. F. Johansen, *Dragma Nilsson* (1939) 181ff.

Judgement of Paris – C. Clairmont, *Das Parisurteil in der antiken Kunst* (1951).

Troilos – M. Heidenreich, *Mitt. des Inst.* iv, 103ff.; K. Schauenburg, *JdI* lxxxv, 46ff.

Hector's Body – E. T. Vermeule, *Bull. Mus. Fine Arts, Boston* lxiii, 34ff.; K. P. Stähler, *Grab und Psyche des Patroklos* (1967).

Sleep and Death – C. Picard, *Compte Rendu Acad. Ins.* 1953, 103ff.

Achilles arming – D. von Bothmer, *Bull. Mus. Fine Arts, Boston* xlvii, 85ff.

Ransom of Hector – J. D. Beazley, *BABesch* xxix, 12ff.

Psychostasia – J. D. Beazley, *Boston Vases* iii, 44ff.

Achilles v. Memnon – J. D. Beazley, *Boston Vases* ii, 14ff.

Menelaus regains Helen – L. Ghali-Kahil, *Les enlèvements et le retour d'Hélène* (1955); P. Clement, *Hesp* xxvii, 47ff.

Death of Priam – M. I. Wiencke, *AJA* lviii, 285ff.

Ajax and Kassandra – J. Davreux, *La légende de la prophétesse Cassandre* (1942); J. D. Beazley, *Boston Vases* iii, 64ff.; K. Schauenburg, *RM* lxxi, 63ff.

Aeneas carries Anchises – K. Schauenburg, *Gymnasium* lxvii, 176ff.; lxxvi, 42ff.

Achilles and Ajax play – K. Schefold, *JdI* lii, 68ff.; J. D. Beazley, *Boston Vases* iii, 2ff.; E. Diehl, *Berliner Museen* xii, 32ff.

THE ODYSSEY
O. Touchefeu-Meynier, *Thèmes odysséens dans l'art antique* (1968).

Polyphemos – B. Fellmann, *Die antiken Darstellungen des Polyphemabentauer* (1972).

Sirens – B. Candida, *Studi Class. e Or.* xix/xx, 212ff.

OTHER FIGURES
Amazons – D. von Bothmer, *Amazons in Greek Art* (1957).

Aristaios – B. F. Cook, *Bull. Metr. Mus.* xxi, 31ff.

Nike, Eris and winged women – C. Isler-Kerenyi, *Nike* (1969).

Centaurs – P. V. C. Baur, *Centaurs in Ancient Art* (1912).

Kaineus – K. Schauenburg, *AA* 1962, 745ff.

Satyrs – F. Brommer, *Satyroi* (1937); S. Karouzou in *Kernos* (Salonika, 1972) 58ff. (armed); J. Boardman, *Archaic Greek Gems* (1968) 57f. (legs).

Silenos – F. Brommer, *AA* 1941, 37ff.

Pan – F. Brommer, *Marburger Jb. für Kunstwissenschaft* xv, 15ff.

LIST OF ILLUSTRATIONS

Photo – Museum.

44 Hanover, Kestner Museum 1954.41. *Para* 28, 2bis. Photo – Museum.

45 London, British Museum B 383, from Melos. *ABV* 71, 1. Photo – Museum.

46 Florence Museum 4209, from Chiusi. *ABV* 76, 1; *Para* 29. Photo – Hirmer, and after Furtwängler-Reichhold, *Griechische Vasenmalerei* pls. 3, 11–12.

47 Athens, Acropolis 606. *ABV* 81, 1. After, Graef, *Akr. Vasen* i, pl. 30.

48 Berlin, Staatliche Museen inv. 4823, from Liosia. *ABV* 81, 4. Photo – Museum.

49 Athens, Acropolis 611. *ABV* 82, 1. Photo – Hirmer.

50 New York, Metropolitan Museum 26.49, from Attica. *ABV* 83, 4. Photo – Museum.

51 New York, Metropolitan Museum 56.171.28, Fletcher Fund, from Camirus. *ABV* 84, 4. Photo – Museum.

52 Basel, Bloch Collection. *Para* 31, 10. Photo – Basel Museum.

53 Boston, Museum of Fine Arts 21.21. *ABV* 84, 3.

54 London, British Museum B 76, from Camirus. *ABV* 85, 1. Photo – Museum.

55 London, British Museum 97.7–21.2. *ABV* 86, 8. Photo – Museum.

56 Boston, Museum of Fine Arts 98.916, from Vulci. *ABV* 98, 46. Photo – Museum.

57 London, British Museum 97.7–27.2. *ABV* 97, 27. After *JHS* xviii, pl. 15.

58 Würzburg, Martin von Wagner Museum 168, from Vulci (?). *ABV* 103, 114. Photo – Museum.

59 Paris, Louvre E 864. *ABV* 97, 33. Photo – Museum.

60 Hamburg, Museum für Kunst und Gewerbe 1960:1. *Para* 40. Photo – Museum.

61 Munich, Antikensammlungen 1432. *ABV* 102, 98. Photo – Museum.

62 Berlin, Staatliche Museen 1704, from Caere. *ABV* 96, 14. Photo – Museum.

63 Berlin, Staatliche Museen inv. 4841, from Orvieto. *ABV* 97, 22. Photo – Museum, and after *JdI* viii, pl. 1.

64 Athens, Acropolis 607. *ABV* 107, 1. After, Graef, *Akr. Vasen* i, pls. 33, 35.

65 New York, Metropolitan Museum 31.11.11. *ABV* 108, 5. Photo – Museum.

66 London, British Museum B 148. *ABV* 109, 29. Photo – Museum.

67 Berlin, Staatliche Museen 1685, from Vulci. *ABV* 109, 24. After Gerhard, *Etr. u kamp. Vasenbilder* pl. 21.

68 Berlin, Staatliche Museen 1732, from Vulci. *ABV* 110, 37. Photo – Museum.

69 Munich, Antikensammlungen inv. 8760. *Para* 46. Photo – Museum.

70 Oxford, Ashmolean Museum 1966.768, from Italy. *ABV* 113, 80. Photo – Museum.

71 Athens, Vlasto Collection, from Spata. *ABV* 113, 84. After Rumpf, *Sakonides* pl. 14.

72 Tocra Museum 1027. *Para* 47. Photo – Author.

73 Vatican Museums 309, from Caere. *ABV* 121, 7. Photo – Museum.

74 Paris, Louvre E 803. *ABV* 120, 1. Photo – Museum.

75 Oxford, Ashmolean Museum 190, from Gela. *ABV* 124, 16. Photo – Museum.

76 Munich, Antikensammlungen 1369, from Vulci. *ABV* 126, 53. Photo – Museum.

77 New York, Metropolitan Museum 56.11.1, gift of W. C. Baker. *Para* 66. Photo – Museum.

78 New York, Metropolitan Museum 31.11.10, Fletcher

Fund, from Vari. *ABV* 154, 57. Photo – Museum.

79 Athens, Agora Museum P 12628. *ABV* 155, 64. Photo – Museum.

80 London, British Museum B 471, from Vulci. *ABV* 153, 32. Photo – Museum.

81 Paris, Louvre F 75, from Vulci. *ABV* 156, 81. Photo – Museum.

82 Boston, Museum of Fine Arts 10.651. *ABV* 157, 86. Photo – Museum.

83 Kings Point, Schimmel Collection, from Vulci. *Para* 67. Photo – Widmer.

84 Oxford, Ashmolean Museum 1939.118. *ABV* 157, 89. Photo – Museum.

85 Paris, Cabinet des Médailles 222, from Vulci. *ABV* 152, 25. Photo – Hirmer.

86 Boston, Museum of Fine Arts 01.8027, from Orvieto. *ABV* 152, 27. Photo – Museum.

87 Berlin, Staatliche Museen inv. 3210, from Vulci. *ABV* 151, 21. Photo – Museum.

88 Würzburg, Martin von Wagner Museum 265, from Vulci (?). *ABV* 151, 22. Photo – Hirmer.

89 Basel, Antikenmuseum Kä. 420. *Para* 65. Photo – Museum.

90 Great Britain, Private. *Para* 65. Photo – Widmer.

91 Munich, Antikensammlungen inv. 8763. *Para* 65. Photo – Museum.

92 Munich, Antikensammlungen 1468, from Vulci. *ABV* 315, 3 (Painter of Cambridge 47). Photo – Museum.

93 Berlin, Staatliche Museen 1698, from Vulci. *ABV* 136, 54. Photo – Museum.

94 Oxford, Ashmolean Museum 1965.135. *ABV* 137, 59. Photo – Museum.

95 London, British Museum B 163, from Vulci. *ABV* 134, 28. Photo – Museum.

96 Paris, Louvre F 53, from

Vulci. *ABV* 136, 49. Photo – Museum.

97 Berlin, Staatliche Museen 1720, from Vulci. *ABV* 143, 1. Photo – Museum.

98 London, British Museum B 210, from Vulci. *ABV* 144, 7. Photo – Hirmer.

99 London, British Museum B 209. *ABV* 144, 8. Photo – Museum.

100 Vatican Museums 344, from Vulci. *ABV* 145, 13. Photo – Hirmer.

101 Boulogne Museum 558. *ABV* 145, 18.

102 Rome, Villa Giulia Museum 50599, from Caere. *ABV* 146, 20. Photo – Museum.

103 Athens, Agora Museum, from the Acropolis North Slope. *ABV* 145, 19. Photo – American School of Classical Studies.

104 Munich, Antikensammlungen 2044, from Vulci. *ABV* 146, 21. Photo – Hirmer.

105 Berlin, Staatliche Museen 1811, 1814, from Athens. *ABV* 146, 22. Photo – Hirmer.

106 Karlsruhe, Badisches Lanesmuseum 65.45, from Vulci (?). *Para* 61, 8bis. Photo – Museum.

107 London, British Museum B 164, from Bomarzo. *ABV* 148, 2. Photo – Museum.

108 Berlin, Staatliche Museen inv. 4604, from Gordion, *ABV* 78, 13. Photo – Museum.

109 Munich, Antikensammlungen SL 462, from Tarentum. *ABV* 180, 44. Photo – Museum.

110 London, British Museum B 421, from Vulci. *ABV* 181, 1. Photo – Museum.

111 Boston, Museum of Fine Arts 98.920, from Vulci. *ABV* 179, 1. Photo – Museum.

112 London, British Museum B 425, from Vulci. *ABV* 184. Photo – Museum.

113 Boston, Museum of Fine Arts 95.17, from Gela. *ABV* 164. Photo – Museum.

114 Oxford, Ashmolean Museum 231, from Bolsena. *ABV* 165, 5. Photo – Museum.

115 Munich, Antikensammlungen 2165, from Vulci. *ABV* 171, 1. Photo – Museum.

116 Munich, Antikensammlungen 2243, from Vulci. *ABV* 163, 2. Photo – Museum.

117 Vatican Museums 330. *ABV* 189, 9. Photo – Museum.

118 New York, Metropolitan Museum 17.230.5, from Vulci. *Para* 78, 1. Photo – Museum.

119 Boston, Museum of Fine Arts 69.1052. *Burlington Magazine* Sept. 1970, Figs. 1, 95. Photo – Museum.

120 Boston, Museum of Fine Arts 61.1073. *Para* 69. Photo – Museum.

121 Copenhagen, National Museum inv. 13966. *Para* 48. Photo – Museum.

122 Berlin, Staatliche Museen 1737, from Vulci. *Para* 72. Photo – Hirmer.

123 London, British Museum B 424, from Vulci. *ABV* 169, 3. Photo – Museum.

124 Würzburg, Martin von Wagner Museum 241. *ABV* 169, 5. Photo – Museum.

125 New York, Metropolitan Museum 47.11.5, from Acragas. *ABV* 174, 1. Photo – Museum.

126 New York, Metropolitan Museum 06.1021.161, Rogers Fund, from Capua. *ABV* 192, 3. Photo – Museum.

127 Taranto Museum 4434, from Tarentum. *ABV* 160, 2. Photo – Museum.

128 Würzburg, Martin von Wagner Museum 413.

129 Würzburg, Martin von Wagner Museum 450.

130 Oxford, Ashmolean Museum 1934.297.

131 Würzburg, Martin von

Wagner Museum 406, from Vulci. *ABV* 166, 1. Photo – Museum.

132 Canberra, University House. *Para* 90, 47. Photo – A. D. Trendall.

133 Princeton University 29.180. *ABV* 167. Photo – Museum.

134 Vatican Museums 350, from Vulci. *ABV* 140, 1. Photo – Museum.

135 Berlin, Staatliche Museen 1686, from Vulci. *ABV* 296, 4. Photo – Museum.

136 London, British Museum W 39, from Vulci. *ABV* 297, 16. Photo – Museum.

137 Berlin, Staatliche Museen 1697, from Caere (?). *ABV* 297, 17. Photo – Museum.

138 Princeton University Museum 168, from Nola. *ABV* 299, 19. Photo – Museum.

139 Munich, Antikensammlungen 1378, from Vulci. *ABV* 299, 17. Photo – Museum.

140 London, British Museum B 212, from Vulci. *ABV* 297, 1. Photo – Museum.

141 Munich, Antikensammlungen 1411, from Vulci. *ABV* 311, 2. Photo – Museum.

142 Boston, Museum of Fine Arts 98.918. *ABV* 306, 41. Photo – Museum.

143 Cincinnati, Art Museum 1959.1. *Para* 134, 23ter. Photo – Museum.

144 Christ Church (New Zealand), University of Canterbury 41/57. *Para* 134, 31bis. Photo – Museum.

145 London, British Museum B 144, from Vulci. *ABV* 307, 59. Photo – Museum.

146 Brussels, Musées Royaux A 130. *ABV* 308, 82. Photo – Museum.

147 Oxford, Ashmolean Museum 1946.182. *ABV* 456, 1. Photo – Museum.

148 London, British Museum B 586. *ABL* 195, 13. Photo – Museum.

149 London, British Museum

B 297, from Caere. *ABV* 218, 16. Photo – Museum.

150 Paris, Louvre F 100, from Caere (?). *ABV* 216, 2. Photo – Museum.

151 Berlin, Staatliche Museen 1805, from Vulci. *ABV* 223, 65. Photo – Museum.

152 Rome Villa Giulia Museum 50735. *ABV* 226, 5. Photo – Museum.

153 Florence Museum 76931, from Orvieto. *ABV* 229. Photo – Museum.

154 Houston, de Ménil Collection. Hoffmann, *Ten Centuries that shaped the West* no. 175. Photo – courtesy of owner.

155 Oxford, Ashmolean Museum 509. *ABV* 239, 5. Photo – Museum.

156 London, British Museum B 150. *ABV* 246, 84. Photo – Museum.

157 Oxford, Ashmolean Museum 1965.126. *ABV* 242, 34. Photo – Museum.

158 Northampton, Castle Ashby, from Etruria. *ABV* 248, 1.

159 Paris, Private. *Para* 113. Photo – Widmer.

160 Palermo Museum V 650, from Chiusi. *ABV* 256, 21. Photo – Museum, and after *JdI* iv, pl. 4.

161 Munich, Antikensammlungen 2301, from Vulci. *ABV* 255, 4. Photo – Hirmer.

162 Paris, Louvre F 204, from Vulci. *ABV* 254, 1. Photo – Hirmer.

163 Moscow, Historical Museum 70, from Tarquinia. *ABV* 255, 8. Photo – Museum.

164 Boston, Museum of Fine Arts 99.538. *ABV* 255, 6. Photo – Museum.

165 Munich, Antikensammlungen 1575, from Vulci. *ABV* 256, 16. Photo – Museum.

166 London, British Museum B 492, from Vulci. *ABV* 256, 19. Photo – Museum.

167 Würzburg, Martin von Wagner Museum 391, from Vulci. *ABV* 262, 45. Photo – Museum.

168 Munich, Antikensammlungen 2302, from Vulci. *ABV* 294, 23. Photo – Hirmer.

169 London, British Museum B 590. *ABV* 294, 19. Photo – Museum.

170 Leningrad, Hermitage Museum. *ABV* 294, 22. Photo – Museum.

171 Würzburg, Martin von Wagner Museum 436, from Vulci. *ABV* 294, 16. Photo – Museum.

172 Athens, Acropolis 2587. *Para* 160. After Graef, *Akr. Vasen* i, pl. 109.

173 Richmond, Virginia 62.1.11. *Para* 109. Photo – Widmer.

174 Oxford, Ashmolean Museum 1966.954. *Para* 86, 8bis. Photo – Museum.

175 New York, Metropolitan Museum 06.1097, Rogers Fund. *ABV* 199, 2; *Para* 197. Photo – Museum.

176 Houston, de Ménil Collection. Hoffmann, *Ten Centuries that shaped the West* no. 170. Photo – courtesy of owner.

177 London, Bomford Collection. Photo – Ashmolean Museum.

178 Baltimore, Walters Art Gallery 48.42. *ABV* 205, 1. Photo – Museum.

179 Taranto Museum 52155. *CVA* iii, pl. 24. Photo – Museum.

180 London, British Museum B 436. *JHS* lxxviii, pl. 5. Photo – Museum.

181 Paris, Cabinet des Médailles 343. *Para* 93, 1. Photo – Museum.

182 Heidelberg University Museum 277, from Athens. *Para* 93, 2. Photo – Museum.

183 Toronto, Royal Ontario Museum 291. *Para* 83, 17. Photo – Museum.

184 Würzburg, Martin von Wagner Museum 428. *Para* 100, 1. Photo – Museum.

185 Berlin, Staatliche Museen 1958.7. *Para* 103, 4bis. Photo – Museum.

186 London, British Museum B 226, from Vulci. *ABV* 273, 116. Photo – Museum.

187 Brussels, Musées Royaux R 291. *ABV* 270, 52. Photo – Museum.

188 Arlesheim, Schweizer Collection. *ABV* 269, 41. Photo – Museum.

189 Capesthorne Hall, Bromley-Davenport Collection. *Para* 120, 92bis.

190 Copenhagen, Thorwaldsen Museum 54. *ABV* 267, 20. Photo – Museum.

191 Würzburg, Martin von Wagner Museum 199. *ABV* 287, 5. Photo – Museum.

192 London, British Museum B 161, from Vulci. *ABV* 279, 47. Photo – Museum.

193 Oxford, Ashmolean Museum 511. *ABV* 282, 20. Photo – Museum.

194 Munich, Antikensammlungen 1407, from Vulci. *ABV* 290. Photo – Museum.

195 London, British Museum B 215, from Vulci. *ABV* 286, 1. Photo – Museum.

196 New York, Metropolitan Museum 41.85. *ABV* 283, 13. Photo – Museum.

197 Vatican Museums 388. *ABV* 283, 9. Photo – Museum.

198 Munich, Antikensammlungen 1493, from Vulci. *ABV* 316, 7. Photo – Museum.

199 Munich, Antikensammlungen 1417, from Vulci. *ABV* 367, 86. Photo – Museum.

200 Munich, Antikensammlungen 1414, from Vulci. *ABV* 367, 87. Photo – Museum.

201 Munich, Antikensammlungen 1700, from Vulci. *ABV* 362, 27. Photo – Museum.

202 Paris, Cabinet des Médailles 255, from Vulci. *ABV* 361, 18. Photo – Museum.

203 Boston, Museum of Fine Arts 63.473. *Para* 164, 31bis. Photo – Museum.

204 London, British Museum B 323, from Vulci. *ABV* 362, 33. Photo – Museum.

205 London, British Museum B 314, from Vulci. *ABV* 360, 2. Photo – Museum.

206 Vatican Museums 422, from Vulci. *ABV* 363, 45. Photo – Museum.

207 Paris, Cabinet des Médailles 260, from Camirus. *ABV* 378, 253. Photo – Museum.

208 Berlin, Staatliche Museen 1851, from Vulci. *ABV* 383, 3. Photo – Museum.

209 Toledo, Museum of Art 1958.69. Gift of Edward D. Libbey. *Para* 168, 2bis. Photo – Museum.

210 New York, Metropolitan Museum 49.11.1, Rogers Fund. *ABV* 384, 19. Photo – Museum.

211 London, British Museum W 40. *ABV* 384, 20. Photo – Museum.

212 Vatican Museums 413. Albizatti, *Vasi antichi del Vaticano* no. 413. Photo – Museum.

213 Karlsruhe, Badisches Lanesmuseum 61.24. *Para* 171, 8. Photo – Museum.

214 Aachen, Ludwig Collection. *Para* 140, D4. Photo – Niggli.

215 Richmond, Virginia Museum of Art 62.1.5. *Para* 150, 3. Photo – Widmer.

216 Berlin, Staatliche Museen inv. 4860. *Para* 150, 4. Photo – Museum.

217 Brussels, Musées Royaux A 712. *ABV* 320, 3. Photo – Museum.

218 Munich, Antikensammlungen 1490, from Vulci. *ABV* 321; *Para* 141. Photo – Museum.

219 Oxford, Ashmolean Museum 1965.97. *ABV* 343, 6. Photo – Museum.

220 Paris, Cabinet des Médailles 355, from Vulci. *ABV* 346,

221 8. Photo – Museum.

Paris, Cabinet des Médailles 251. Philippaki, *Attic Stammos* 19f. Photo – Museum.

222 London, British Museum B 300, from Vulci. *ABV* 324, 39. Photo – Museum.

223 Vatican Museums 418, from Vulci. *ABV* 329, 1. Photo – Museum.

224 London, British Museum B 329, from Vulci. *ABV* 334, 1; *Para* 147. Photo – Museum.

225 Oxford, Ashmolean Museum 212, from Caere. *ABV* 331, 5. Photo – Museum.

226 Oxford, Ashmolean Museum 1965.118. *ABV* 335, 1. Photo – Museum.

227 Toledo, Museum of Art 63.26. Gift of Edward D. Libbey. *Para* 149, 23bis. Photo – Museum.

228 Tarquinia Museum RC 6847, from Tarquinia. *ABV* 338, 1. Photo – Museum.

229 Oxford, Ashmolean Museum 563, from Rhodes. *ABV* 396, 21. Photo – Museum.

230 New York, Metropolitan Museum 46.11.7, Pulitzer Bequest, from Vulci. *ABV* 434, 3. Photo – Museum.

231 Taranto Museum 9125, from Tarentum. *ABL* 197, 7. After Touchefeu-Meynier, *Thèmes Odysséens* pl. 13.1, 2.

232 Boston, Museum of Fine Arts 03.783. *ABL* 197, 15. After Touchefeu-Meynier, pl. 17.3.

233 Berlin, Staatliche Museen inv. 3261. *ABL* 198, 2. Photo – Museum.

234 Agrigento Museum, from Gela. *ABL* 205, 2. Photo – Museum.

235 Athens, National Museum 541. *ABL* 208, 49. After *ABL* pl. 23.2.

236 Vienna, Kunsthistorisches Museum 84. *ABL* 212, 158. After *ABL* pl. 26.1.

237 Cambridge, Fitzwilliam

Museum GR 6–1957. *ABL* 202, 24. Photo – Museum.

238 London, British Museum 1926.4–17.1. *ABV* 471, 117. Photo – Museum.

239 Oxford, Ashmolean Museum 250. *ABL* 216, 2. Photo – Museum.

240 New Haven, Yale University Museum 111. *ABL* 221, 1. After *Ausonia* vii, pl. 1.

241 Edinburgh, Royal Scottish Museum L224.379. *ABL* 217, 19. Photo – Museum.

242 Oxford, Ashmolean Museum 246. *ABL* 217, 20. Photo – Museum.

243 London, British Museum WT 220. *ABL* 219, 65. Photo – Museum.

244 Boston, Museum of Fine Arts 76.42. *ABV* 478, 5. Photo – Museum.

245 Toledo, Museum of Art 63.27. Gift of Edward D. Libbey. *Para* 257. Photo – Museum.

246 London, British Museum 1902.12–18.3. *ABL* 249, 9. Photo – Museum.

247 Athens, Acropolis 1281. *ABL* 250, 29. After Graef, *Akr. Vasen* i, pl. 74.

248 Paris, Louvre F 342. *ABL* 252, 70. After Touchefeu-Meynier, pl. 5.3.

249 Paris, Petit Palais 313. *ABV* 519, 6. Photo – Bulloz.

250 Oxford, Ashmolean Museum 247. *ABL* 255, 19. Photo – Museum.

251 Berlin, Staatliche Museen inv. 3252. *ABL* 255, 28. Photo – Museum.

252 Athens, National Museum 1132. *ABL* 256, 50. After *ABL* pl. 47.3.

253 Boston, Museum of Fine Arts 98.924. *ABL* 260, 129; *ABV* 524, 1. Photo – Museum.

254 Berlin, Staatliche Museen 1933. *ABL* 260, 128. Photo – Museum.

255 London, British Museum B 502. *ABL* 260, 126. Photo

256 Athens, National Museum 1011, from Marathon. *ABL* 221, 1. After *ABL* pl. 30.3.

257 Syracuse Museum 14569, from Gela. *ABL* 222, 22. After *ABL* pl. 30.1.

258 Athens, National Museum 489. *ABV* 500, 51. Photo – Museum.

259 Cape Town, South Africa Museum 6. *Para* 236. Photo – Museum.

260 New York, Metropolitan Museum 41.162.29, from Attica. *ABL* 226, 6.

261 London, British Museum B 639. *ABL* 227, 28. Photo – Museum.

262 Athens, National Museum 552. *ABL* 227, 37. After *ABL* pl. 35.3.

263 Athens, National Museum 2184. *ABL* 228, 53. After *ABL* pl. 34.2.

264 Athens, National Museum 450. *ABL* 229, 59. Photo – Museum.

265 Paris, Louvre MNB 905. *ABL* 229, 58. Photo – Museum.

266 Lausanne, Gillet Collection. *Para* 247. Kurtz and Boardman, *Greek Burial Customs* pls. 37, 38.

267 Athens, Vlasto Collection.

268 Oxford, Ashmolean Museum 1919.35. *ABL* 237, 111. Photo – Museum.

269 New York, Metropolitan Museum 06.1070, Rogers Fund. *ABL* 235, 71. Photo – Museum.

270 Paris, Louvre CA 598. *ABL* 233, 19. After Perrot-Chipiez, *Histoire de l'Art* x, 689.

271 New York, Metropolitan Museum 56.171.25, Fletcher Fund. *ABL* 239, 137. Photo – Museum.

272 Paris, Cabinet des Médailles 219. *ABL* 238, 120. Photo – Museum.

273 Syracuse Museum 12085. *ABL* 241, 8. Photo – Museum.

274 Oxford, Ashmolean Museum 240. *ABL* 245, 93. Photo – Museum.

275 Cape Town, South Africa Museum. *Para* 286. Photo – Museum.

276 London, British Museum B 356. *ABL* 245, 88. Photo – Museum.

277 Athens, National Museum 1129, from Eretria. *ABL* 266, 1. After *ABL* pls. 49, 50.

278 Athens, National Museum 599. *ABL* 268, 56. After *ABL* pl. 53.5.

279 London, British Museum B 658. *ABL* 269, 67. Photo – Museum.

280 Athens, Kerameikos Museum. *ABL* 266, 6. After *ABL* pl. 50.4.

281 Cape Town, South Africa Museum. *Para* 302. Boardman and Pope, *Greek Vases in Cape Town* pl. 2.

282 New York, Metropolitan Museum GR 529. *ABV* 602, 28. Photo – Museum.

283 London, British Museum B 280, from Vulci. *ABV* 589, 1. Photo – Museum.

284 London, British Museum B 499, from Vulci. *ABV* 422, 8. Photo – Museum.

285 London, British Museum B 507, from Vulci. *ABV* 426, 9. Photo – Museum.

286 Stockholm, Throne-Holst Collection. *Para* 183, 22bis. Photo – Medelhavsmuseet.

287 Boston, Museum of Fine Arts 99.527. *ABV* 430, 25. Photo – Museum.

288 Toronto, Royal Ontario Museum 320. *ABV* 442, C4; *Para* 192. Photo – Museum.

289 London, Hamilton-Smith Collection. *Para* 185, 23⁵.

290 Chicago University, from Vulci. *ABV* 632, 1. Photo – Museum.

291 Oxford, Ashmolean Museum 237, from Camirus. *ABV* 643, 150. Photo – Museum.

292 Athens, British School,

from Olynthus. *ABV* 618, 15. Photo – Museum.

293 London, British Museum B 298.

294 Copenhagen, National Museum inv. 13765. *Para* 309. Photo – author,

295 Halle University inv. 560. *ABV* 120.

296 London, British Museum B 130, from Athens. *ABV* 89, 1. Photo – Museum.

297 London, British Museum B 134, from Vulci. *ABV* 322, 1. Photo – Museum.

298 Munich, Antikensammlungen 1453, from Vulci. *ABV* 322, 4. Photo – Museum.

299 Taranto Museum inv. 9887, from Tarentum. *ABV* 369, 113. Photo – Museum.

300 New York, Metropolitan Museum 07.286.80. *ABV* 369, 114.

301 Leiden, Rijksmuseum xv.i.79, from Vulci. *ABV* 404, 9. Photo – Museum.

302 Berlin, Staatliche Museen 1832, from Nola. *ABV* 408, 4. Photo – Museum.

303 Bologna Museum 11. *ABV* 409, 1. After *CVA* ii, pl. 3.

304 London, British Museum 1903.2–17.1, from Benghazi. *ABV* 411, 1. Photo – Hirmer and Museum.

305 London, British Museum B 607, from Caere. *ABV* 415, 4. Photo – Museum.

306 Paris, Louvre MN 704, from Benghazi. *ABV* 415, 12. Photo – Museum.

307 Munich, Antikensammlungen inv. 7767, from Athens. *ABV* 417, 2. Photo – Museum.

308 Berlin, Staatliche Museen 4950. Greifenhagen, *Antike Kunstwerke* pl. 89.

309 Paris, Louvre F 114. *ABV* 226. Photo – Museum.

310 Königsberg University inv. F 198.

311 Warsaw, National Museum (ex Goluchow 32). *ABL* 228, 56. After *CVA* pl. 16.3.

312 Capesthorne Hall, Bromley-Davenport Collection. *ABV* 672. *JHS* lxxviii, pl. 10 b, c.

313 Rhodes Museum. After *Clara Rhodos* iv, pl. 3.

314 Vienna, Kunsthistorisches Museum 1923.

315 Oxford, Ashmolean Museum 1930.168. *ABV* 655. Photo – Museum.

316 London, British Museum 94.7–18.4, from Eretria.

ABV 662, 23. Photo – Museum.

317 Brauron Museum. *Neue Ausgrabungen* (*AK* Beiheft i, 1963) pl. 6.1.

318 Athens, National Museum, ex Empedocles Collection.

319 Cape Town, South Africa Museum 13. *Para* 159, 11.

320 Boston, Museum of Fine Arts 61.1256, from Greece (?). *ABV* 616, 11; *Para* 306.

321 London, British Museum B 378. Photo – Museum.

Front cover Neck amphora, Antimenean. Mask of Dionysos. Tarquinia Museum RC 1804. *ABV* 275, 5. Photo – Hirmer.

Heights of some complete vases are given in centimetres in the captions

The author and publishers are grateful to the many official bodies, institutions and individuals mentioned above for their assistance in supplying original illustration material

INDEX OF ARTISTS AND GROUPS

Principal page references are **bold**. Figure numbers are *italicised*

INDEX OF MYTHOLOGICAL SUBJECTS

Index to text of Chapter Thirteen only; and select figure numbers *italicised*

GENERAL INDEX